W9-ACO-126

COUNTY PUBLIC LIBRARY
GREENUP, KY 41144

JAMES ARCHAMBEAULT'S
HISTORIC KENTUCKY

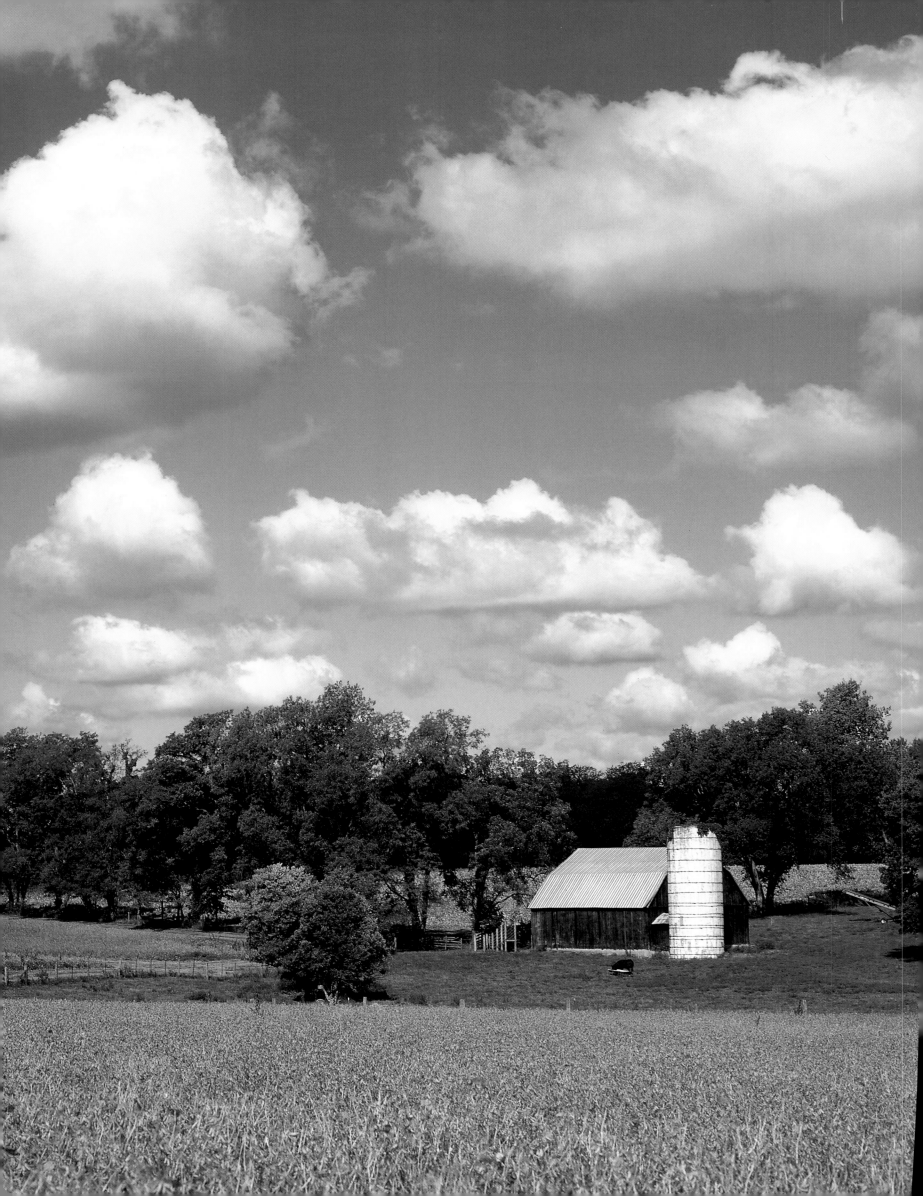

JAMES ARCHAMBEAULT'S HISTORIC KENTUCKY

Foreword by Wendell Berry

The University Press of Kentucky

FRONTISPIECE *Soybean Fields, Pisgah Pike, Woodford County.*
While horse farms dominate the Bluegrass landscape, small
working farms can still be found tucked away on many back
roads. Such farms are visual treasures that are fast yielding to the
strong arm of development. This photograph was taken in 1994.

PAGE VI *Shaker Village of Pleasant Hill, Mercer County.*
The United Society of Believers, or Shakers, was founded at
Pleasant Hill by forty-four converts in December 1806. For
the next half century the Shakers prospered, reaching a peak
population of five hundred in 1830. With its strong work ethic,
the society became the envy of the area, exporting its farm
produce and products to "the world." Exceedingly fine artists
and craftsmen, Shakers built their structures to "last a thousand
years." These spiraling twin staircases were designed and built by
Micajah Burnett for the trustees' office in 1840–41. The restored
Shaker village is open to the public throughout the year.

PAGE VIII *Early Pioneer Crossing, Laurel River.*
The first settlers coming into Kentucky on the narrow path
called the Wilderness Road had to contend with crossing streams
and rivers on foot and horseback, often during freezing winter
weather. Because of the rugged terrain, some streams had to be
crossed and recrossed several times. This view of the Laurel River
gives some idea of the challenges these pioneers faced.

PAGE X *Mt. Pleasant Church, Robertson County.*
The front doors of Mt. Pleasant Church once offered entrance
to sermons, singing, and prayer. The church also served as a
center of social life in rural Robertson County at the turn of
the twentieth century. Closed for decades, the building is still
redeemable, but without public or private interest in restoration,
it will soon go the way of hundreds of similar old structures.

PAGE XIV *Green River at Mammoth Cave.*
Mammoth Cave National Park, northeast of Bowling Green,
covers over 80 square miles of surface area, consisting primarily
of steep hills, narrow valleys, and numerous sinkholes. The cave
is the longest known cave system in the world, with more than
360 miles of underground passages. The Green River bisects the
park east to west and offers numerous recreational activities for
the two million people who visit the park annually.

Publication of this volume was made possible in part by
a grant from the National Endowment for the Humanities.

© 2006 by James Archambeault
Published by The University Press of Kentucky

Scholarly publisher for the Commonwealth, serving
Bellarmine College, Berea College, Centre College of Kentucky,
Eastern Kentucky University, The Filson Historical Society,
Georgetown College, Kentucky Historical Society, Kentucky
State University, Morehead State University, Murray State
University, Northern Kentucky University, Transylvania
University, University of Kentucky, University of Louisville,
and Western Kentucky University.

Map by Dick Gilbreath at the
University of Kentucky Cartography Lab

All rights reserved.

Editorial and Sales Offices: The University Press of Kentucky
663 South Limestone Street, Lexington, Kentucky 40508-4008
www.kentuckypress.com

10 09 08 07 06 5 4 3 2 1

Library of Congress Cataloging-in-Publication Data

Archambeault, James.
 James Archambeault's historic Kentucky /
by James Archambeault ; foreword by Wendell Berry.
 p. cm.
 Includes index.
 ISBN-13: 978-0-8131-2420-9 (hardcover : alk. paper)
 ISBN-10: 0-8131-2420-4 (hardcover : alk. paper)
 1. Photography—Kentucky. 2. Photography, Artistic.
3. Archambeault, James. I. Title.
 TR24.K4A73 2006
 779'.99769—DC22 2006012090

This book is printed on acid-free recycled paper meeting the
requirements of the American National Standard for Permanence
in Paper for Printed Library Materials. ∞

ⱯⱯⱯ Member of the Association of American University Presses

Publishing Services by Wilsted & Taylor
 Project Management: Christine Taylor
 Design and Composition: Tag Savage

Manufactured in China

For Thomas D. Clark,

friend and teacher

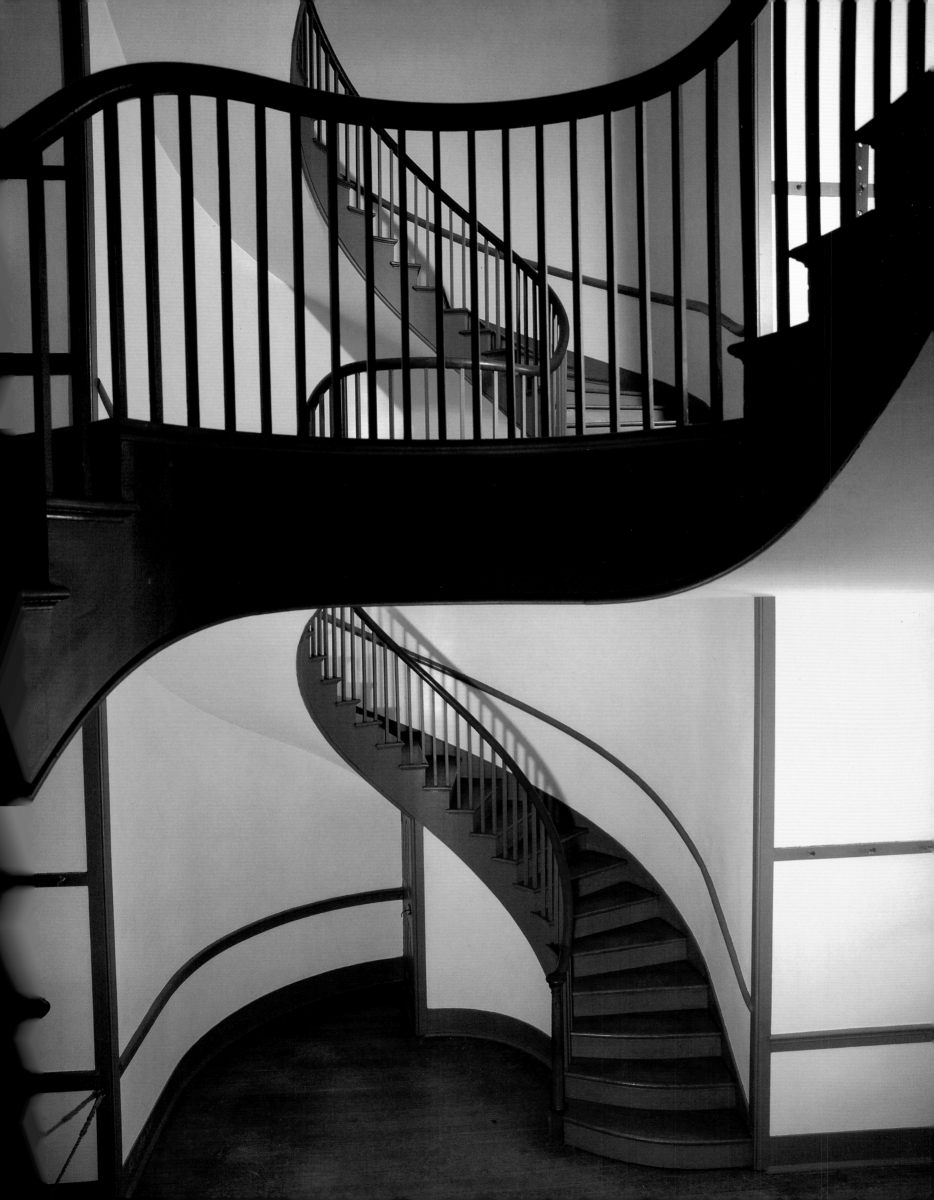

CONTENTS

SHAKER VILLAGE OF PLEASANT HILL, MERCER COUNTY

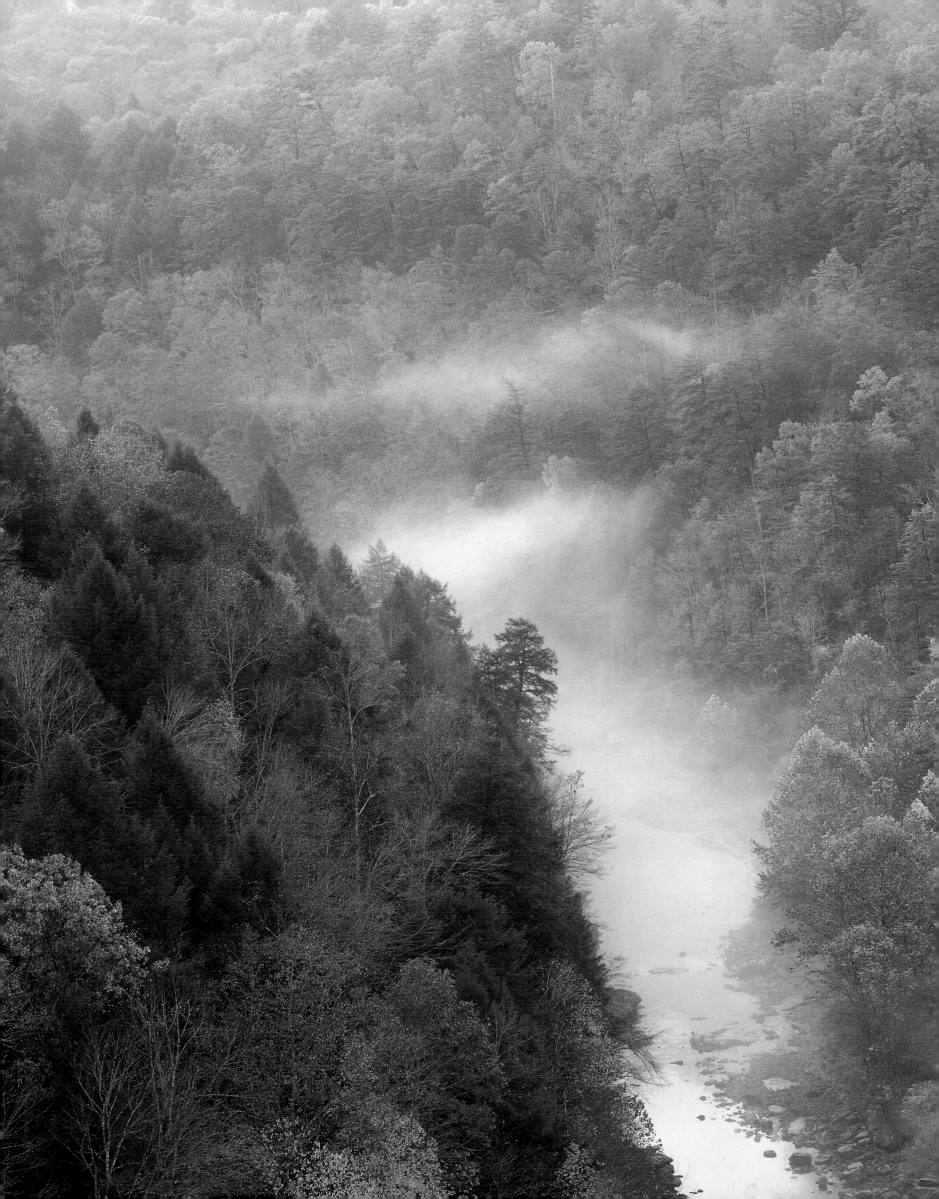

Foreword by Wendell Berry

Photography surely is the most temporal of the arts. Even music and dancing permit rehearsal and multiple performances, but a photograph is limited to a single moment. The photographer can mull and ponder at length, but the camera imposes finally the constraint of one blink. The picture that results is the realization of a unique instant. Looking at it, we are aware of an implied insistence: This picture could not be made again. The light that made it is past. The photographer cannot return even tomorrow, even later today, and make the same picture.

Because it is so insistently temporal, photography is also insistently historical. It records instants in the history of subjects that are passing through time. They are seen or pictured at some point in their passage from appearance to disappearance.

Landscape photography, in a time such as ours when the disappearance of subjects can be unnaturally accelerated, thus becomes extraordinarily poignant and telling. Not so long ago Guy Davenport wrote: "Every building in the United States is an offense to invested capital. It occupies space which, as greed acknowledges no limits, can be better utilized."[1]

Davenport's startling sentence, startlingly true, applies not just to buildings and other human artifacts, but also to entire landscapes. In the eastern Kentucky coalfields, with the approval of every public institution in the state, whole mountains are now being "removed" for the sake of the coal under them, and whole valleys are being obliterated by the debris of the removed mountains.

Under the total rule of industrial capitalism, nothing is so valuable as anything theoretically more valuable that might replace it. Anything we may look upon with interest or approval must be regarded as potentially in the way of something more valuable, and therefore as potentially doomed.

And so James Archambeault, roaming through Kentucky, photographing its human and natural landscapes, has been working as both a historian and an elegist. These beautiful pictures are records of intelligent vision. They show us our state as

we have cherished it and lived in it, grown used to it and taken it for granted. He has been recording scenes and sights, buildings and landscapes, that are passing, not just on the current of time, but also under the influence of a malignant economy. Some of the subjects in these photographs are already gone. Some visibly are going, and going with them are the associations and memories that once clustered about them. We are becoming a people with a destroyed past and a future, therefore, that is merely conjectural.

This book becomes another occasion to ask, as we now almost habitually ask, "Can something be done to lift our state out of the shadow of this doom?"

Well, we have done a little. We have saved a few scenic natural places, and a few places of historical or artistic interest, and we have put up "historical markers" where things once worth saving once were. But even these remain at risk because our economy continuously destabilizes the relationship between people and land. People always in motion at the bidding of the economy do not develop protective connections with places.

Our idea of an economy is to turn wealth loose to destroy whatever stands between it and greater wealth. "Money," as Davenport went on to say, "has no ears, no eyes, no respect; it is all gut, mouth, and ass."[2]

There is, however, another kind of economy: an economy made in the likeness of what we used to call "household economy." This would be an economy oriented to local domestic life and based upon thrift and care. Its purpose would be to protect and use well all things of value. It would be a truly conservative economy. Under such an economy the rate of change would be set by time and wear, not by economic vandalism.

1. "Making It Uglier to the Airport," in *Every Force Evolves a Form* (San Francisco: North Point Press, 1987), p. 156.
2. Ibid.

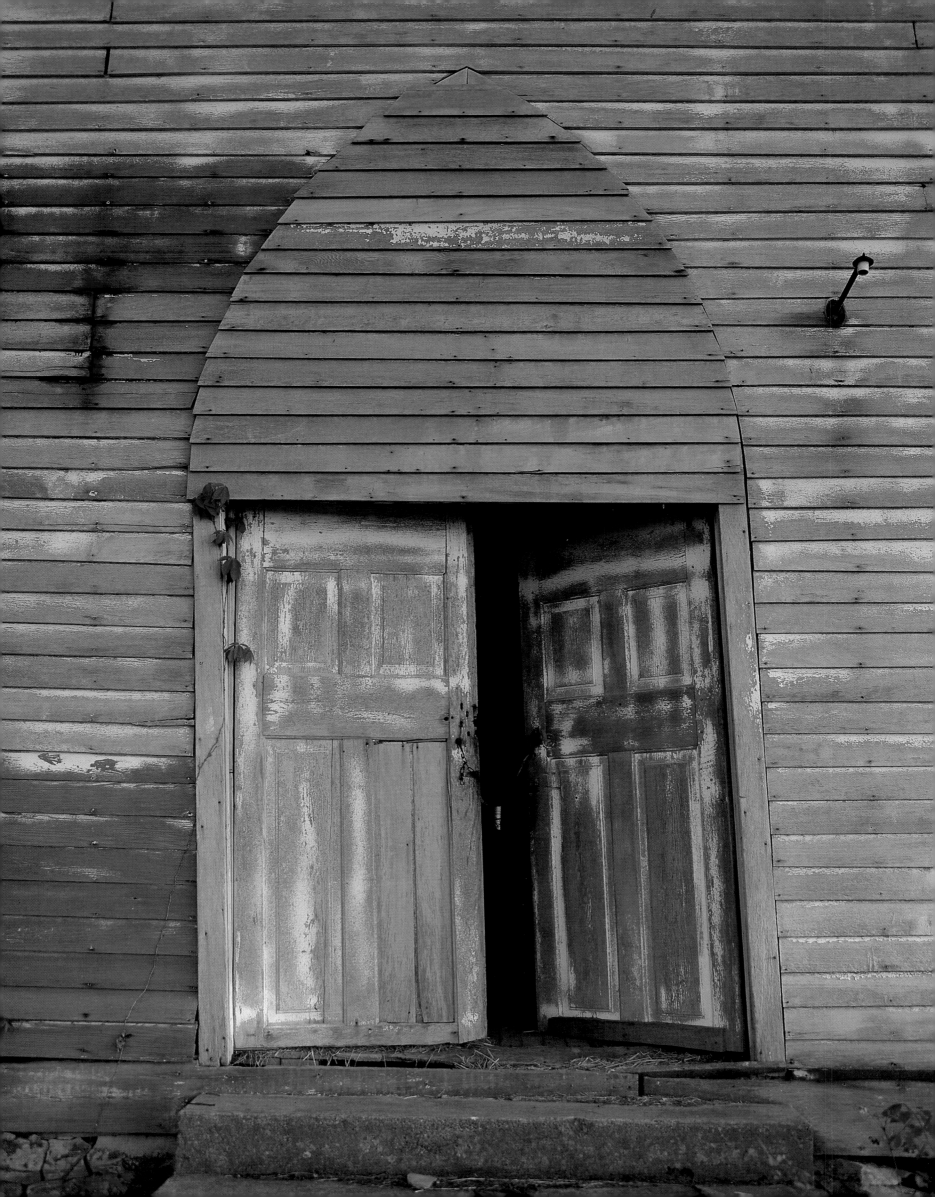

Preface

This book is a collection of photographs I have taken during the past thirty years. While not all-encompassing, the images reflect on the passing of an era in Kentucky history and what we, as a largely rural society, have preserved, what we have lost, and what we are losing. While known historical sites take precedence, the photographs attempt to depict a slice of the social and cultural heritage that Kentuckians take for granted. From the Revolutionary War battle at Blue Licks to the last general store at far west New Madrid Bend, the photographs are meant to evoke a feeling for what Kentucky has meant to us as we begin a new century.

The idea for this book had been forming in my mind for many years. My interest in history was enhanced by my love of nature and the landscape. My first Kentucky books were dominated by natural areas and the environment. During this time I began accumulating photographs of historical subjects that I perceived as disappearing. In the beginning, I was casual about stopping to photograph barns, old farmhouses, and country stores. As late as 1975, many of these structures were still standing, if not still in use. In the mid- to late 1980s, I became more conscious of the patterns of extreme change in social and cultural traditions that were taking place across the Commonwealth. Locations that I had photographed only a few years before were gone. This realization gave me a greater sense of urgency in recording these soon-to-be-forgotten buildings and sites.

No one historian or historical novelist could possibly read every word written and saved by our forebears that resides in federal, state, and private archives. One single episode of historical significance can be researched over and over and formed into a volume or volumes of rich detail. Depending on the bent of the author and the episode discussed, many of these details may be emphasized or as many left out as have been used. It is then left up to future historical writers to plunge into the same or newly discovered material and craft another version of the same event.

In these photographs and words I do not pretend to be a historian. I do love history, probably more than most, but nothing like the full-time academic historians who haunt the Margaret I. King Library at the University of Kentucky, the State Library and Archives in Frankfort, or the Filson Historical Society in Louisville. My own research for the photo captions and text was culled from a dozen or so books on early Kentucky history. I have chosen to confine the historical narrative to the first twenty-five years of settlement, 1775 to 1800, for two reasons: it is my favorite period of Kentucky history, and I believe the events of that time set the social and cultural tone for the two centuries that followed.

In my photographs, wherever possible, I have preferred original, genuine, unrestored subjects. Of course, this is not always possible. For example, most original log cabins have vanished. Among others, the Lincoln cabin inside the Hodgenville Memorial has been reconstructed in an attempt to show the structure as it would have looked at the time of his birth. The "new" log cabins occasionally seen along the highways tend to romanticize and to dissipate the crude conditions in which Kentucky's early settlers lived.

The Kentucky that our parents, grandparents, and great-grandparents knew is largely gone. This era began in the 1890s and continued through two world wars, with isolated pockets of old ways still to be experienced in the early twenty-first century. During this roughly one-hundred-year period, most Kentuckians lived life close to the land. It was an agrarian society of thousands of family farms ringing small communities. In many ways it was a closed culture that left Kentuckians in the backwater of even the pretence of major social, educational,

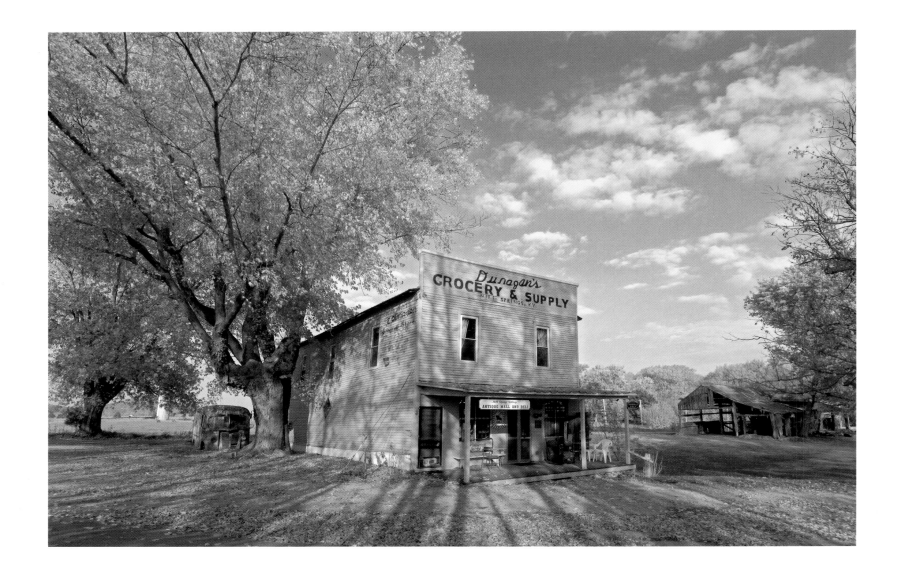

DUNAGAN'S GROCERY & SUPPLY, WAYNE COUNTY

For more than a century, Dunagan's Grocery & Supply served the people of Wayne County along the Cumberland River near the old gristmill at Mill Springs. Like most country stores, it sold virtually everything necessary to fill the wants of the hundreds of small farms in the area. For many years it was the local post office. Now it barely serves a practical purpose, having succumbed to the larger, cheaper stores on the main highways.

technological, or industrial development. But as I point out in the text of this book, rural Kentucky life contains much to be appreciated.

ACKNOWLEDGMENTS

I would like to express my gratitude—

To the native people of this continent who tried desperately to keep early settlers from taking their land.

To the early settlers who believed the land was theirs by right and braved incredible hardships to keep it.

To the historians and preservationists who have kept the past and its lessons alive.

To my wife, Lee, for her love, intelligence, ideas, and support of my photographic endeavors.

Also, to Gena Henry, Melinda Wirkus, and Stephen Wrinn and the entire staff of the University Press of Kentucky; to Yvonne Giles, who keeps the fires burning; to Dan Silvestri; and to Kathy and Bennett Chamberlin for their long and constant encouragement.

Lastly, to the hundreds of Kentuckians who unselfishly give me directions, suggestions, and wonderful stories along the way.

All of the photographs in this book, except for the spiral staircase and the Lincoln cabin, were made using natural light and are shown as composed at the moment of exposure free of computer manipulation or enhancement.

Although many pairs of eyes have critiqued the text and captions contained in this book, any omissions or factual errors are mine.

—— J. A.

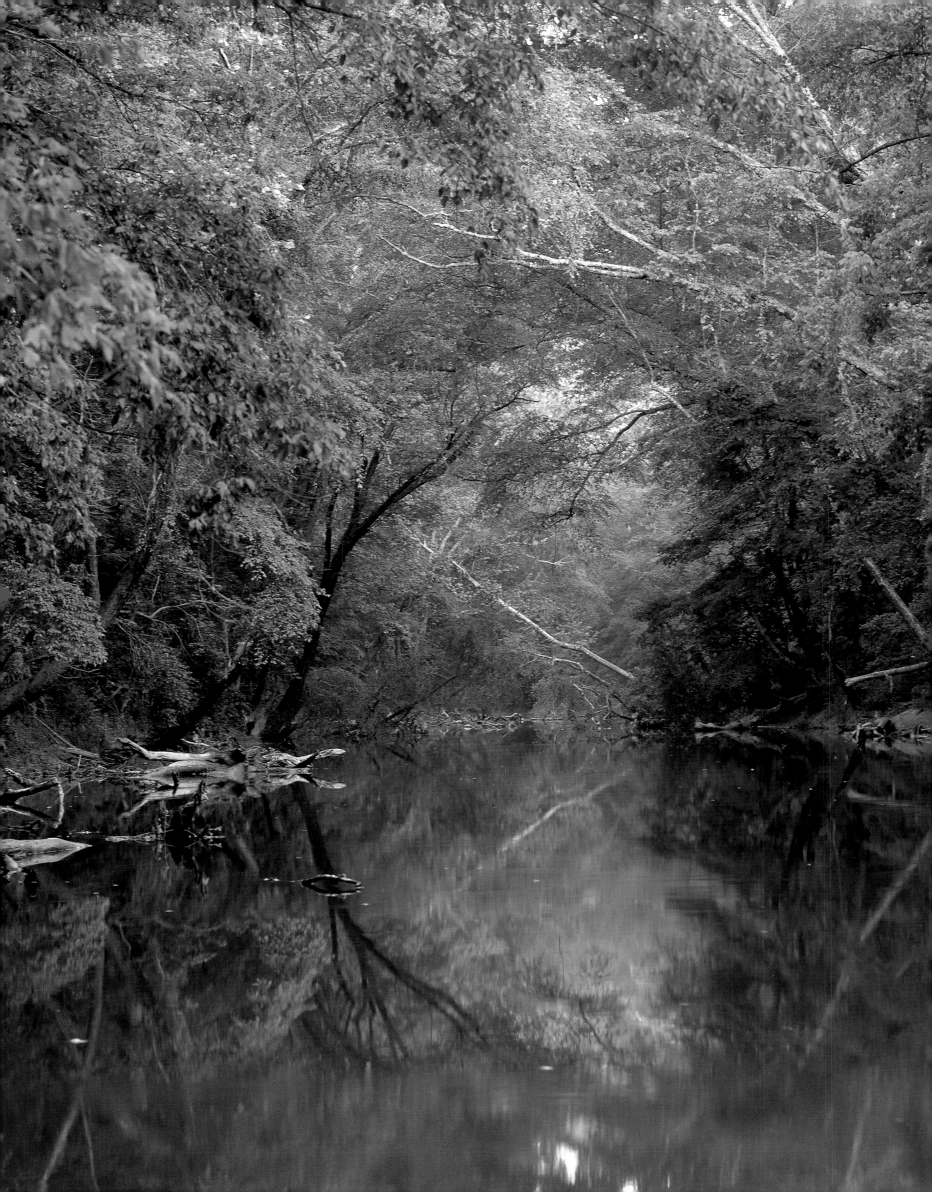

Historic Kentucky by James Archambeault

BEFORE KENTUCKY

The occupation of North America was one of the most massive movements of people from several continents to another in the history of the world. In the 1500s, the Spanish settled parts of the Carolinas, Florida, the Caribbean, Mexico, and Central America. English settlements began in 1607 with the establishment of Jamestown in Virginia and with the landing of the Pilgrims at Plymouth Rock in present-day Massachusetts in 1620. Thousands of ships would follow, bringing new English, Scots-Irish, and German immigrants to the Atlantic coast. During the first 150 years of migration to America, settlement was confined to the thirteen original colonies east of the Appalachian Mountains.

By 1770, the population of the British-controlled colonies was about three million people. The migration from Europe to America was not without its cost in blood. Native peoples, of many different tribes, were at first curious about and somewhat friendly toward the strangers. However, the Indians soon became alarmed at the never-ending flood of immigrants to the shores that they and their ancestors had occupied for thousands of years. Settlers called the native peoples Indians after Christopher Columbus's assumption that, upon his first landing in America, he had reached the east coast of India. For the next century, colonists and Indians struggled for control of the land to which each group thought they had a right.

Decimated by war and the diseases brought by Europeans, Native American tribes were either wiped out, or their survivors, pressured by the continuing influx of new immigrants, forced to move west over the Appalachian Mountains. At the same time, the seemingly impenetrable wall of the mountains discouraged westward settlement by the colonists. In addition, in 1763, the British forbade the crossing of the Appalachian Mountains for settlement. They wanted to solidify their claims following their defeat of the French in the French and Indian War. They also feared that contact with native peoples would cause more war and more death.

In the mid-1700s, saturated by rumors of fertile land and abundant game that even mountains could not discourage, some colonists began to think of moving west. Just before the start of the Revolutionary War, their thoughts turned to action. The new land was waiting and the British government could not stop them. The great western migration had begun, and Kentucky was first on the list.

DR. THOMAS WALKER

In the spring of 1750, Dr. Thomas Walker and five companions left Charlottesville, Virginia, for Kentucky. The group traveled by horseback south of the Appalachian mountain range and in a month's time had crossed the Cumberland Gap into Kentucky. A physician and explorer, Walker in his diary first recorded the experiences of early explorers in the western lands of Kentucky. But they were not the first people to set foot in Kentucky.

In the centuries before the time of European settlement, Native Americans hunted and traded in Kentucky but did not live there. They agreed among themselves that Kentucky would remain unoccupied and that its great abundance of wildlife would be shared. Its hides and meat would be for all of their people for the taking.

In the 1600s, French trappers explored the area, followed in the early 1700s by British long hunters, who made lengthy hunting trips to collect animal hides. In Europe, the demand for fur was high. The French tried to meet the demands by trapping beaver and mink and by trading goods, sometimes guns, for pelts with Indians. The later long hunters concentrated on taking the hides of deer, elk, bear, and buffalo.

Typically, long hunters would be five to ten in number and would stay in an area for as long as three years, hunting animals,

skinning them, and preserving their hides. The carefully protected and hidden skins would eventually be packed by horseback over the mountains to be sold in the Colonies and often resold to Europe. The challenge for these early hunters was not so much killing the animals, which were plentiful, as getting the pelts and hides out of Kentucky without their being taken by Indians, who were competing with the hunters for food and skins. Many two-year excursions by the long hunters were abruptly ended by Indians who attacked them, took their hides, and in many cases their lives. It was the inevitable beginning of a war in Kentucky between settlers and Indians that would last through the latter part of the 1700s, finally ending by the first decade of the nineteenth century. By then the Indians were simply overwhelmed by the sheer number and determination of settlers pouring into Kentucky. In 1775, it is estimated, no more than 200 pioneers lived in Kentucky. Three years later only 280 persons could be counted. But by 1790 the population was 73,000; in 1800, 221,000; and by 1810, 406,500—an incredible increase in just thirty years. During this period almost 20 percent of Kentucky's population were black slaves. Eventually, the battle for territory and supremacy between settlers and Indians extended across the continent to the Pacific Ocean. By 1900, most Indian resistance in North America had been subdued. Tribes that had not been eliminated by war and disease were forced onto reservations, where many of their descendants remain today.

But in 1750, Dr. Thomas Walker and his small party of five were not looking for wild game. Under the employment of the Loyal Land Company of Virginia, they were to explore and find land suitable for settlement. Ultimately, the Loyal Land Company wished to profit quickly and handsomely from the sale of this land to newcomers. After crossing through the Cumberland Gap, Walker and his men reached a site near present-day Barbourville in the valley of a river that Walker would name the Cumberland. The party built a rough eight-by-twelve-foot log cabin and planted a crop of corn. These acts were the early requirement for the staking of a land claim.

Why Walker stopped in this valley is unknown. Perhaps he was seduced by its beauty, or just tired out from his epic journey to Kentucky, which had been full of innumerable hardships. Walker's site was still in a mountainous region of southeast Kentucky. For a short while, the Walker party explored north of the area, but they found only rough land and more mountains. In the end, Walker and his men did not go far enough. Having come almost six hundred miles, Walker's party fell short of their goal by a mere seventy miles. They never viewed the rich land of the Bluegrass Region that rumors and stories had touted. Frustrated and discouraged, Walker returned east after a four-month journey to report that he had seen and killed much wild game but had not found the good land he had set out to locate.

DANIEL BOONE

It would be another nineteen years before the thirty-four-year-old North Carolina farmer and woodsman Daniel Boone would lead a party of six, including John Finley, John Stuart, and three men hired to keep camp, through the Cumberland Gap. The group had probably never heard of Walker's earlier excursion into Kentucky, nor of surveyor Christopher Gist's journey through Kentucky in 1751. Boone's party camped on Station Camp Creek in present-day Estill County, a full sixty miles north of where Walker and his party had stopped in 1750. One of Boone's companions was his friend Finley, who as early as 1752 had traded with Indians at a small village in present-day Clark County near Winchester. The site was named Eskippakithiki or Kentake and had been established by Shawnee Indians in 1718 as a trading post for themselves and other Indians hunting and traveling through Kentucky. Disbanded in 1754, this Shawnee town was the last occupied Indian town in Kentucky. Today it is referred to simply as Indian Old Fields.

Boone and Finley had been wagon drivers in British General Edward Braddock's disastrous attempt to take Fort Duquesne, now Pittsburgh, from the French in 1755. It was Finley who most probably first told Boone of the fertile land and abundance of game he had seen in Kentucky three years earlier. Now, in early June 1769, Boone was close to realizing a dream. From their camp on Station Camp Creek, the party traveled north along the Kentucky River and then to the site of the old Indian town. Boone and Finley climbed a nearby mountain, now called Pilot Knob State Nature Preserve, which at 1,400 feet is the highest point in present-day Powell County. The precipice of Pilot Knob rises 700 feet above the valley floor, affording a magnificent view. The land Boone saw from this lookout he would later describe as "the great level of Kentucke." Some historians believe Boone climbed another "pilot knob" near present-day Berea to get his first sight of the Bluegrass. Explorers like to climb mountains, so it is probable Boone scaled both. The author can testify that the view from Pilot Knob State Nature Preserve is worth the long hike.

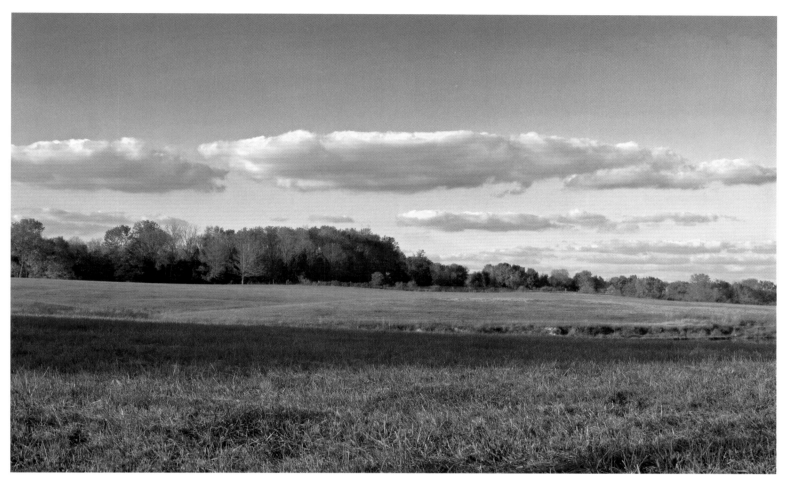

INDIAN OLD FIELDS, CLARK COUNTY Between 1718 and 1754, Shawnee Indians occupied this ground as a meeting place for traders and Indian hunters along the Warriors' Path. Named Eskippakithiki, or sometimes Kentake, it was inhabited by up to two hundred families and was the last of the Kentucky Indian towns. John Finley, an acquaintance of Daniel Boone, traded here in 1752. Finley was possibly the first to tell Boone of the rich lands of Kentucky.

Daniel Boone was not the only early frontiersman who made the permanent settlement of Kentucky possible. Other courageous men tested their skills and risked their lives during this period, including Simon Kenton, James Harrod, Benjamin Logan, William Whitley, and George Rogers Clark. Boone was a multifaceted man whose skills, actions, intelligence, energy, even temperament, and unbounded luck propelled his name to the top of a long and distinguished list of trailblazers. His fame was well deserved. He was a friend and protector of early settlers. He helped build stout defenses against the frequent Indian attacks of the difficult first ten years. Even though Indians were the dreaded enemy, Boone greatly respected their cultures and understood, perhaps better than anyone at the time, the anger the Indians felt at having their homeland invaded, their game wiped out, their honor as peoples violated, and their ways of life systematically destroyed. Although Boone never sought publicity, his name was spread eastward by early frontier writers to an indelible future in the minds of Americans then as now.

For the next six months, Boone and the others hunted and trapped in Kentucky, accumulating large piles of compressed skins that they hoped to sell back east. But in late December of 1769, Boone and Stuart were captured by a Shawnee hunting party. The other four men escaped capture, but all of the party's skins and horses were taken. Boone and Stuart were set free with a warning never to return. While their four companions returned to North Carolina, Boone and Stuart remained in Kentucky and were joined by Daniel's brother, Squire Boone. Over the next sixteen months, the brothers (Stuart disappeared in January 1770) would continue to hunt and prepare hides. In the spring and fall of 1770, Squire Boone made two successful trips east to sell their pelts and to bring back fresh supplies. Left by himself for a total of four months, Daniel traveled and learned as much as he could of the area. He explored both the Licking and Kentucky river valleys of the Bluegrass Region and journeyed along the Ohio River to the Falls at present-day Louisville. He would later call these times some of the happiest of his

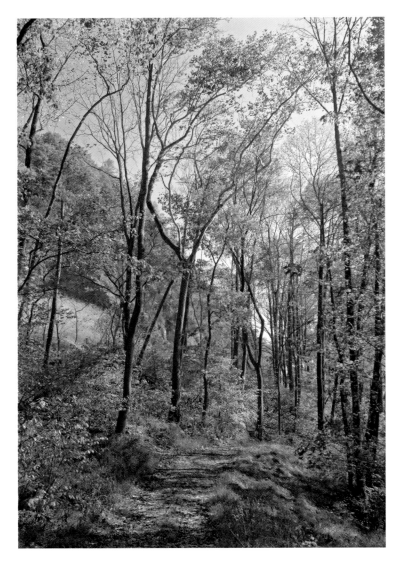

ORIGINAL WILDERNESS ROAD AT THE SADDLE OF
CUMBERLAND GAP Most of the early settlers who used
the Wilderness Road came from Virginia and North Carolina.
Before reaching Cumberland Gap, they had to sell their wagons
and large household goods, as the early Wilderness Road was no
more than a footpath, accommodating only people and horses.
Their goal was to reach what they had heard was the rich land
of the Bluegrass Region to the north. Once in Kentucky, they
would still have to travel over one hundred miles through rug-
ged mountains and cross countless streams to reach that region.

life. His solitary hours and days were filled with both excite-
ment and danger as his mind took in the still-untrammeled
natural beauty at each bend in the river and turn in the for-
est. Boone's good luck held: he kept off the major paths and
was never confronted by Indians. Through his explorations
he learned more about the future state than any white man.
Legend has it that Boone was once asked if he had ever been lost.
He reportedly said that he had never been lost but, on occasion,
had gotten confused for a week or two.

At this time he decided to bring his family to Kentucky. A

first attempt in 1773 ended in tragedy when his son James was
killed by Indians. In 1775, at the brink of the American Revolu-
tionary War, Boone formed and led a group of thirty woodsmen,
with a female slave to do the cooking. They were hired by an
aggressive North Carolina entrepreneur, Richard Henderson,
to widen the narrow path of the Wilderness Road into Ken-
tucky. Henderson had formed the Transylvania Land Company
and negotiated, with Boone's help, to acquire a large part of
Kentucky for ten thousand pounds' worth of trade goods from
the Cherokee tribes of Virginia and North Carolina. Despite
the fact that such a transaction was illegal by British colonial
law, coupled with the Cherokees' doubtful ownership of the
land, Henderson proceeded with his plan of creating a country
with a British-patterned government, but under his and his
company's control.

Leading a large group of settlers and forty to fifty pack-
horses carrying supplies, Henderson managed to reach Boone's
party of woodsmen at Fort Boone, on the south bank of the Ken-
tucky River in present-day Madison County. In May 1775, at
an open-air meeting beside the river, delegates were chosen and
a temporary government was formed. The name of the site
was changed to Boonesborough and plans for a fort were made.
From there, Henderson's audacious land scheme began to fall
apart. Other local settlers, including the first pioneers, who had
founded Harrodsburg a year earlier, had protested the Tran-
sylvania Land Company's claims from the beginning. In the
autumn of 1775, the British government and the governors of
North Carolina and Virginia voided Henderson's claims, but he
was eventually granted land near present-day Henderson, Ken-
tucky. In spite of the demise of the Transylvania Land Com-
pany, settlers still occupied Fort Harrod, Fort Boonesborough,
and other scattered stations in the Bluegrass Region. Permanent
European settlement of Kentucky had begun.

THE WILDERNESS ROAD
AND THE OHIO RIVER

Early Kentucky settlers came from New York, Philadelphia,
Williamsburg, Virginia, the Piedmont of North Carolina, and a
hundred small towns, villages, and farms along the East Coast.
They came because good land was getting relatively scarce and
new immigrants kept pushing daily against the Atlantic shore,
seeming to crowd the existing inhabitants. Originally they came
from England, Ireland, and some from Germany. They came
to America seeking land, independence, and freedom of social

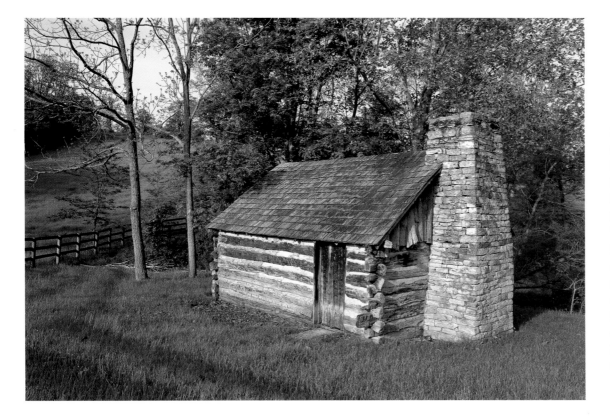

LAST KENTUCKY HOME OF DANIEL AND REBECCA BOONE, NICHOLAS COUNTY
By the late 1700s, Daniel Boone had lost much of the land he had come to Kentucky to seek. Through conflicting claims and Boone's own lack of formal education, the lawyers and the courts took away most of it. In 1799, he and Rebecca moved to Missouri, where they would live out their days in peace near the bank of the Missouri River, at the edge of the new frontier.

opinion, to live their lives as they saw fit, with the right to practice the religion of their choice without government interference. Once they decided to migrate west to Kentucky, the early pioneers had to choose between two routes: by foot on the old Warrior Road or by flatboat down the Ohio River. The Warrior Road was an ancient Indian path that extended from the Potomac River of eastern Virginia and Maryland, southwest to present-day Kingsport, Tennessee, then west and north through the Cumberland Gap and into Kentucky. The journey from the East Coast to central Kentucky covered five to six hundred miles and, depending on circumstances, took from one to two months.

The Wilderness Trail, as it was called then, was essentially two different roads. The first, from the Potomac to the Holston River valley in southwest Virginia, was wide enough to accommodate wagons over a mostly earthen surface, subject to extreme conditions of seasonal temperature and weather.

At Martin's Station in the Holston valley, pioneers had to sell or trade their wagons and large possessions for packhorses. From this point, the Wilderness Trail was nothing more than a narrow, winding footpath, much as one might hike in the Red River Gorge of eastern Kentucky. Today an original section of the path, called the Dr. Thomas Walker Trail, can still be walked at Cumberland Gap National Historical Park. The Wilderness Trail had been cut over centuries, first by wild animals, followed by native peoples who used it to hunt, trade, or make war. Pioneer travel on the trail was a harrowing experience. The path wound over steep mountains and through marshes and dense canebrakes, crossed rivers and streams, and passed through dark, almost impenetrable forests. Every step brought the threat of attack from wild animals and Indians. During the initial migration, from 1775 to 1800, tens of thousands of people and many livestock made their way over the Wilderness Trail through the Cumberland Gap into Kentucky. An entry in the diary of Virginia Colonel William Fleming, who was sent along the road in 1779 to settle Kentucky land disputes, gives some idea of what the pioneers encountered:

May 19th: We went up a bad run and bad road all the days march, passed a verry bad and Slippery hill as bad as any of the Mountains passed Flats Lick where the road comes in from the Rye Cove, the road down Stock Creek verry bad and long, crossed Clinch which was rising so deep some of the horses were swimming in the middle of the River a swarm of Flies settled on my horses head and set him a plunging however I got safe over. We halted when we got over the River, then crossed several steep hills stoney road and Miry places a fresh Indian Tract was discovered, which brought our company into a little Order encamped two miles from Moccasin.[1]

1. "Colonel William Fleming's Journal of Travels in Kentucky, 1779–1780," in *Travels in the American Colonies*, ed. Newton D. Mereness, pp. 649–50 (New York: Macmillan, 1916). Available at http://kdl.kyul.org.

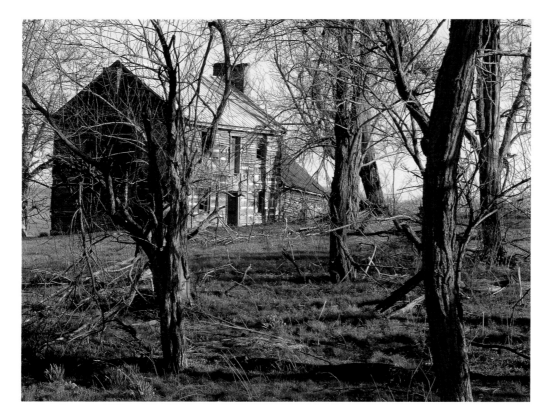

JOSEPH EWING LOG HOUSE,
SCOTT COUNTY

Built around 1800, this is one of
the few remaining log houses in
Kentucky that has not been restored.
The building probably survives
because of the early weatherboard-
ing of some of the better dwellings
of that era, which preserved the
structure and provided greater
warmth for the inhabitants. The
city of Georgetown plans an
industrial park on the site, and the
status of the house is in limbo.

The Wilderness Road, as it was eventually called, was not a one-way path. Thousands of early settlers left Kentucky the same way they came, many victims of or witnesses to Indian attacks they could not or would not endure. On some days as many terrified people were returning east as hopeful settlers were pushing west. Hearing of the atrocities they might face, many of the hopeful settlers turned around and went home.

Traveling the Wilderness Road was a severe, almost inhuman hardship. Pioneers endured living outdoors for weeks, subject to the dictates of harsh and often bitterly cold weather. Whatever food they brought often ran out, leaving many on the brink of starvation and dependent on hunting wild animals for their food. Most pioneers had to sleep on the ground, in the open, often without adequate clothing or blankets. Disease was a common cause of death along the road, particularly among infants and young children. There was also the constant fear of Indians, and later of white outlaws, where an attack from the dark forest or thick canebrakes could come at any time with sudden and deadly swiftness. There is no accurate record of the number of settlers captured, tortured, or killed by native warriors along the Wilderness Road. During the first twenty-five years of migration to Kentucky, the figure was probably at least in the several hundreds, if not thousands. Thus, the lasting legacy of the early Wilderness Road is one of both hope and despair.

The Ohio River was the other route for reaching Kentucky. Beginning in Pittsburgh at the confluence of the Allegheny and Monongahelia rivers, those who traveled by flatboats were generally more well-to-do than the foot travelers on the Wilderness Road. These pioneers nevertheless faced a journey of several hundred miles on the beautiful, dangerous, and unpredictable Ohio. In order to reach Pittsburgh, most had already traveled three hundred miles over the rugged mountains of central Pennsylvania, hauling their belongings in heavy wagons over "roads of stone" so steep that walking a team or leading a horse was the only safe way to navigate the terrain. Once in Pittsburgh, the would-be settlers either had to buy a ready-built flatboat or had to have one made to their specifications. Flatboat construction became big business until sometime after the invention of steam power. Flatboats varied in size from as small as twelve by twenty feet to twenty-five by fifty feet or even larger. A passenger cabin was usually built on the deck and often a stable or pen for livestock as well. Steering was accomplished by a crew, tending one long rear oar and two or more shorter oars on the sides.

Once launched, there was no turning back. A smooth trip down a cooperative river to Limestone, now Maysville, or to Louisville took fourteen to twenty-one days. But, in addition to the threat from Indians living on the north shore, the untamed river was always a danger. In its natural state, the Ohio River

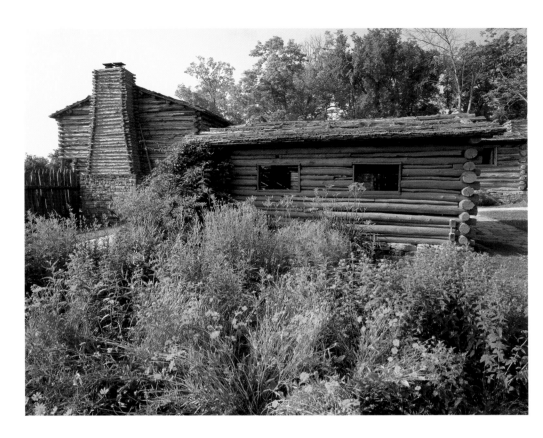

OLD FORT HARROD, KENTUCKY'S BEGINNINGS In June 1774, John Harrod established the first permanent settlement in Kentucky at Harrodstown (now Harrodsburg). The survival of early pioneers depended on a strong defense from attacks by Indians, who were often led by British regulars. The construction of Fort Harrod began in 1775 and was completed in 1776. The heavy timber twelve-foot-high stockade covered one and one-half acres and enclosed twenty cabins, a spring, and a powder magazine. Each corner of the fort was anchored by a blockhouse from which riflemen shot through portholes. Although besieged many times, Fort Harrod was never taken. Shown is a twentieth-century reproduction.

was full of boulders, tree snags, floating debris, sandbars, and rapids that had to be navigated. Weather was also a major factor. Lack of rain could cause flatboats to sit for days or even weeks in shallow eddies, unable to move. Most pioneers chose seasons of high current, speeding the journey and avoiding many hidden pitfalls in the water. Some travelers on flatboats would tie up at night on the south bank, while others risked travel in the dark. The worst danger to befall a boat and its passengers was attack by Indians paddling swift canoes. From their cover along the north shore, Indians could strike and overwhelm a boat in minutes, killing or wounding all aboard and taking their horses, livestock, and possessions. As on the Wilderness Road, there is no accurate record of the number of flatboats seized or passengers killed by Indians. It is estimated that hundreds of flatboats a year used the Ohio River during the first twenty-five years of settlement. Some three hundred large boats tied up in Louisville in the spring of 1780 alone. Upon reaching Maysville, many flatboats were dismantled. Their timber was carried overland into the Kentucky heartland, to be reused in constructing forts, stations, and cabins.

FORTS AND STATIONS: THE LIVES OF EARLY SETTLERS

A stout fort was a pioneer's best line of defense during the first years of settlement. Large and small bands of Indians regularly crossed the Ohio River from their villages into Kentucky to harass or kill, in their attempts to drive away early settlers. During the American Revolution, until late 1782, Indians were often led and aided by British troops. Settlers who chose to build their own cabins away from forts and stations did so at enormous risk. During the earliest years, hundreds of cabins were burned, livestock stolen, crops destroyed, and families killed or captured. A fort, however, was built of heavy log timbers and was nearly impregnable. Settlers were housed in cabins within a rectangular fort, which usually covered an acre or more of ground and was anchored at each corner by high blockhouses from which riflemen could shoot at attackers through small portals, with little danger of being wounded or killed. The fort also held a powder magazine and, if very fortunate, an inside water source, a spring or small stream. At most forts, however, the source of water, even though close, required frequent and dangerous trips outside the walls. If attacked, water seekers caught outside rushed for cover to the gates of the fort, protected by rifle fire from within. Hunting for game was also a treacherous enterprise. As the killing of game for food increased, so the game decreased or moved farther away from settlements, requiring longer forays from the forts. Many hunters never returned.

Stations were not forts but sometimes simply a large, well-built log house with portholes out of which to shoot. Most of these stations could withstand a small Indian siege but would be

overwhelmed by a larger force. The more common stations were a group of cabins, organized into a square or rectangle, leaving a central enclosure much like a miniature fort. The rate of survival of stations is unknown, but more than 150 sites have been documented in the Bluegrass Region. After 1785 and the end of the Revolutionary War, when Indian attacks diminished and the urgent necessity for forts and stations ceased, many were abandoned. Some of the most famous forts were Boonesborough, Fort Harrod, Logan's Fort, Fort Nelson (Louisville), and Fort Lexington. In spite of repeated sieges, none of these forts were ever taken. In effect, forts kept the early settlers from abandoning Kentucky by saving them from almost certain death.

However, two large stations, Ruddle's Station in Harrison County and Martin's Station in Bourbon County, surrendered in June 1780. Under the command of British Captain Henry Byrd, a combined force of six hundred troops and their Indian allies brought two cannons from Detroit and threatened to fire them. Once the station gates were opened, Byrd could not control the native warriors, and many settlers at both sites were either killed or captured.

The communal living in the forts and stations had its difficulties. People of varying social, moral, and behavioral values often clashed in the close quarters. Public health conditions were at best barely controlled and at worst nearly intolerable. Crowding, poor sanitation, general filth, troubles with the storage and handling of food, and unsafe water supplies confronted settlers daily. Some left the forts because they couldn't stand their "neighbors" or the "horrific conditions inside." Newcomers to forts were often the most shocked, describing conditions inside as "engendering sedition and discord," filthy places where half-naked, half-starved people were surrounded by "indolence, rags and poverty." The thought of lurking Indians was constantly on the settlers' minds, creating an almost unimaginable fear that resulted in cowardice and inaction. Many men stopped hunting or tending to what few crops could be grown. One frustrated occupant of a Kentucky station described living with "a dastardly set of people" so afraid of native warriors that they refused to go out. Fortunately, there were enough men and women with the strength and courage to get the others through this initial period.

For many of the first ten to fifteen years of settlement, fighting between settlers and Native Americans was widespread, with graphic episodes of death and torture. Both sides suffered terrible pain. On the one hand, the Indians were trying to hold

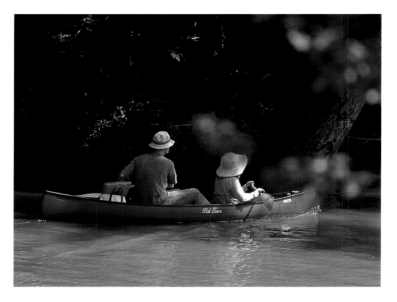

ALONG HARRODS CREEK, LOUISVILLE
Long before Europeans came to this continent, native peoples canoed this stretch of what would be called Harrods Creek, having crossed the Ohio River to Kentucky in search of game. French trappers would later appear on these waters, followed by early frontiersmen in search of both game and land.

on to the land that had been theirs for centuries. While their methods of killing, scalping, and torture were extreme to the settlers and their slaves, to the Indians it seemed their only course of action. All earlier treaties signed by whites and Native Americans had been systematically ignored by whites. The moderate voices within the Indian tribes were silenced by empty promises, the militants winning out. The settlers, on the other hand, were attempting to tame the wilderness, to take and inhabit the land they considered it their "divine right" to possess. Decades later, this belief would be named "manifest destiny," the whites' justification for all their actions.

The Indians were not alone when it came to slaughter and mayhem. Atrocities were committed by both sides, and revenge was the order of the times. For each atrocity committed by one group, there was some form of counter-atrocity. As the population of settlers increased, militias were formed to chase marauding warriors to the Ohio River. As militias grew in size, they began to cross the river, attacking Native American towns and villages, killing, burning homes, and destroying crops. At times, unscrupulous whites would lure friendly Indians into their camps, only to attack and kill them all. In one such infamous episode, the unsuspecting family of Chief Logan of the Mingo tribe, a respected man among both his own people and most whites, was murdered at Yellow Creek along the Ohio River. Chief Logan then rampaged against the whites, joining in raids on settlements and personally taking many scalps. And so it

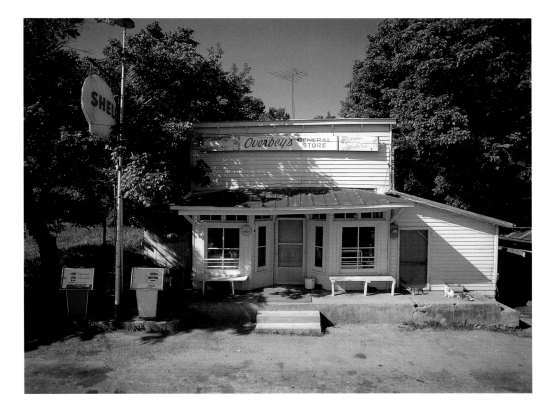

Mama and her kittens gather on the porch of Overbey's Store in the small village of Piqua. Photographed in 1982, the store was still serving the local population of this rural north-central Kentucky county. Like hundreds of similar enterprises, the store is now closed and the building in disrepair.

went for more than twenty years, until Anthony Wayne's 1794 defeat of the Indians at Fallen Timbers in Ohio effectively ended the Indian threat in Kentucky.

Abandoned more than two hundred years ago, all original forts and stations have disappeared, destroyed by weather and time. Though modern reproductions of Fort Boonesborough and Fort Harrod have been constructed, many of the original sites are covered over by asphalt, courthouses, law offices, chambers of commerce, police stations, and Dollar General Stores. Now only the tall bronze signs of the Kentucky Historical Society, seen along our highways, mark the locations of these early fortresses.

CONSERVATION PRACTICES AND THE LACK THEREOF

Sadly, there was almost no conservation ethic among the Kentucky pioneers. Meaningful conservation practices did not begin until the 1930s, when some forward-thinking people became fearful of the Commonwealth's woeful environmental record. By then nearly all of Kentucky's primal forests had been axed and sawed and Kentucky's streams and rivers were in a polluted, deplorable condition. The concept of creating state parks as a means of saving the few pristine areas left was put into action. Today, Kentucky can be thankful for its state parks and its many state-owned forests and wildlife management areas. The creation of the Daniel Boone National Forest, together with Mammoth Cave National Park and Cumberland Gap National His-

torical Park, has also helped tremendously to stabilize and protect some of the state's most beautiful natural areas. Through the tireless work of private foundations such as The Nature Conservancy and the Kentucky State Nature Preserves Commission, efforts have led to the purchase and preservation of thousands of acres of important and once-threatened environmentally sensitive areas. In 2005, the international World Monuments Fund declared an area spanning seventeen Bluegrass counties, more than a million acres, one of the one hundred most endangered cultural sites in the world. Other designated sites include the Taj Mahal and the Great Wall of China. But in the early years of settlement, only a few voices were raised regarding the uncontrolled and indiscriminate killing of game. To the pioneers, the vast herds of buffalo sweeping across the land must have seemed an inexhaustible supply of meat and hides. In addition to the buffalo, great herds of elk and deer were so plentiful and unafraid that they may have seemed to hunters just to stand there, waiting to be killed. Other game native to Kentucky were bear, panther, mink, beaver, and pheasant. Wild turkeys were described as being so numerous that they could be seen almost everywhere in the forest.

Before the settlers, Indians had used Kentucky as a hunting ground, where game was harvested for food and skins, but the land itself was unoccupied by permanent villages. The conservation ethic was natural to the Indians. They used everything they killed and wasted nothing. Having only spears and bows and ar-

SIGN ON FEED MILL, BOURBON COUNTY

To many, the term "Bluegrass State" conjures in the mind a vast carpet of rich blue-tinged grass covering the entire state from east to west. While bluegrass is prevalent on horse farms, pastures, parks, and lawns, it is not the only grass to cover Kentucky soil. Among the more common is Kentucky 31 fescue, used by farmers throughout the Commonwealth because of its toughness and ability to hold soil in hilly conditions.

rows as weapons, they relied on skill and stealth to take their game. Even after acquiring guns from white traders, they generally maintained their ethic, taking only what game was needed.

But early white settlers began blasting away from the start. They did not stop until there was practically nothing more at which to shoot. By 1790, pioneers had decimated or chased away all the great herds of buffalo. The buffalo were easy targets not only for those hunting for subsistence, but also for commercial hunters and those who shot purely to kill. The latter group might shoot several animals as proof of their prowess, leaving the bodies to rot. Because of the apparently unlimited quantity of game available to early settlers, men sent out from forts and stations to hunt for food would often bring back only the choice

cuts of meats. Eventually, game near the forts diminished or moved to more remote and therefore safer areas. Hunters thus had to go farther for game, increasing the danger of being discovered and killed by Indians. This situation resulted in food shortages that became critical, often contributing to disease and starvation.

Daniel Boone was one of the first whites to propose limiting the hunting of game to make its long-term preservation possible, an ideal the Indians had carefully nurtured over the centuries. Boone was a perceptive backwoodsman who respected the wilderness. He witnessed with increasing frustration the indiscriminate slaughter of game by early settlers, while his voice went unheard. The conservation of limited natural resources was not a priority in the western expansion into Kentucky or, for that matter, in the expansion throughout the rest of North America. Game animals native to Kentucky, including elk, bear, and panther, would over time become extinct in the Commonwealth. The once-plentiful deer became scarce, while beaver and mink were practically trapped out. Also, the cattle, hogs, and sheep introduced by pioneers competed with game for the same food and space. Another later reason for the demise of game was the cutting of the great forests, which had protected and provided food for many of the native species.

No one now living in Kentucky can conceive of the vastness of the virgin wilderness that covered the state and the human feelings it evoked. One can only begin to imagine its scope while standing in the few pockets of original, uncut forest that remain. Three of these are the 252-acre old-growth portion of Lilley Cornett Woods in Letcher County, the 3,090-acre Blanton Forest in Harlan County, and a smaller stand of virgin growth in Tight Hollow in Wolfe County. While comprising only a few acres, Tight Hollow is perhaps the most singularly impressive of the three, for it contains poplars and hemlocks that rival in height and circumference those of the most remote parts of Great Smoky Mountains National Park.

In his later writings, Daniel Drake recalled assisting his father in clearing their new land that was "covered with an unbroken forest" near Mayslick, Mason County, around 1800. They "charged on the beautiful blue ash and buckeye grove," taking appreciation in a tree only "in proportion to the facility with which I could destroy it."[2] This honest, firsthand account reflects the attitude of most settlers at the time.

2. From Craig Thompson Friend, ed., *The Buzzel About Kentuck: Settling the Promised Land* (Lexington: University Press of Kentucky, 1998), p. 134.

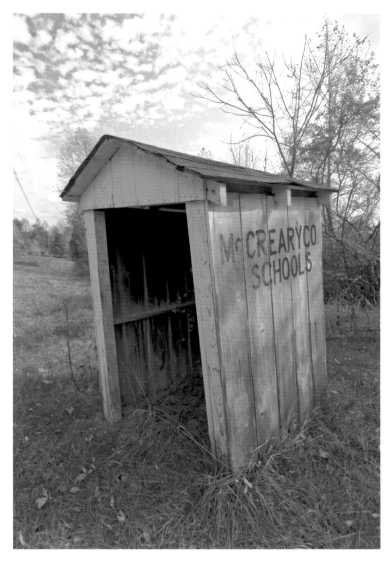

SCHOOL BUS STOP, McCREARY COUNTY
Seemingly abandoned near Kentucky's southern border with
Tennessee, this old school bus stop symbolizes to many the status of
education in the Commonwealth over the last 215 years. Kentucky's
first constitution of 1792 provided no tax money for public schools
for the first fifty years, throwing the state into an educational
backwash from which it is still trying to recover.

THE AGRARIAN TRADITION

The roots of Kentucky's agrarian society go back to the begin-
ning of its first permanent settlements in 1774–75. Pioneers
came primarily to seek their own land and for the promise of
some independence from government authority. After the new
American government was installed following the Revolution,
pioneers still came to Kentucky for the same reasons. When
most of the best land had been claimed, Kentucky was the
vanguard of the inevitable push westward. Those settlers who
remained in Kentucky developed a deep bond with the land,
forming agrarian-based social and cultural traditions.

One could argue that the failure of the state to provide any

money for public education in its first constitution placed the
state at a disadvantage from which it is still trying to recover.
Even some of the better-educated settlers from the east would
forgo educating their own children, calling it unnecessary to life
as a farmer. With little or no formal education, Kentuckians em-
braced their land, living for the most part in small towns, iso-
lated crossroads, or simply "in the country." Only in Louisville,
strategically located at the Falls of the Ohio River, and Lexing-
ton, in the heart of the Bluegrass, the state's first cities of conse-
quence during early settlement, was education more valued.

In those days, people formed small communities and busi-
nesses to serve their needs. They often shared facilities. They
did not overdo themselves in the construction of roads. A bridge
was built to join one rural town or community with another. A
store was stocked with just the provisions necessary to accom-
modate simple wants. One gristmill was enough. Barns and silos
were built to protect local harvests while pens were constructed
to hold livestock, giving order to all in the community.

The agrarian tradition in Kentucky continues to this day,
although it is evolving in disturbing directions. Rural sprawl is
changing the face of the Kentucky countryside. The appetite of
Kentuckians to be close to the land has caused a chaotic pattern
of rural growth that is blighting the landscape. Such uncon-
trolled development satisfies the need for a house or trailer, five
acres with a garden, and Sunday afternoons riding on the seat of
a lawn tractor. These are not small family farms, but rural re-
treats from day jobs at Ford, Humana, Toyota, Lexmark, and
state government. Then there are the pop-up housing develop-
ments of closely spaced, inexpensive, look-alike frame dwellings
that seem to fill a valley or hillside almost overnight. Often,
these projects are unattached to any urban area and are far from
the nearest village or small town. While such uncontrolled land
use goes on, old homes, barns, schools, and stores stagger and
sway on their foundations, inevitably falling down through ne-
glect. Why maintain a once-stout barn when there is no crop to
put in it, no livestock needing shelter, no people who depend on
the structure's existence?

The eventual demise of country stores in Kentucky could
not have been stopped; the same is true for the covered bridges,
once numbering more than four hundred. There are now thir-
teen bridges left, and only one is still in operation. Once closed,
the bridges became targets for vandalism and love notes, a high-
light of late-night teen parties.

By the end of the pioneer period, most of the best land
in Kentucky was gone. While some people made fortunes in

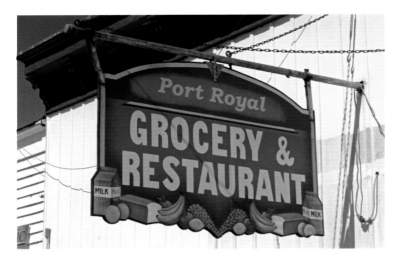

PORT ROYAL GROCERY & RESTAURANT, HENRY COUNTY
Kentucky essayist, novelist, and poet Wendell Berry farms and writes on his Henry County land near Port Royal. Author of more than forty books, Berry is a philosopher-activist and a staunch advocate for peace, community, a return to agrarian values, and support of the small family farm.

land and kept them, others made fortunes and lost them. Fully 50 percent of the settlers never owned land at all. Early claiming methods included building a cabin and planting a crop of corn. The frontiersman Simon Kenton used the axe method to claim his land by making his mark on trees. The axe method was flawed, with old marks ignored by new axe wielders or through unintentional overlapping of marks. Whichever of these early land claim methods was used, they were no match for the men who made marks on pieces of paper beside a stack of law books. Disputed land claims clogged Kentucky courts for years. Both Daniel Boone and Kenton lost much of their land. Kenton eventually prospered in Ohio, while Boone lived out his days peacefully on the Missouri frontier.

OLD KENTUCKY

If one is willing to search, remnants of Old Kentucky can still be found. It is most often seen and survives on the farthest back roads and along county boundaries. However, Old Kentucky can thrive within sight of the interstate or just over a hill or a few hundred yards down a country lane connecting to a major highway. A set of county maps is a helpful tool. Sometimes just "getting lost" works well, resulting in surprising finds.

In many ways Kentucky has been a forgotten state, not for those who live here and know it, but to most who live outside its borders. One reason for this is the state's geographical location, hemmed in on three sides by the natural physical barriers of the Mississippi River to the west, the Ohio River to the north,

and the Appalachian Mountains in the east. While modern-day transportation has broken down the effect of these barriers, the barriers, until recently, influenced Kentucky's place among the states.

Perhaps this has been, in some ways, a good thing. Due to history, geography, and lack of education, many Kentuckians have been reluctant to enter the seemingly chaotic world around them. Through such unwillingness, we have involuntarily preserved old ways and traditions. In spite of our problems, Kentuckians are a proud people, perhaps the proudest of any state. Many people who leave Kentucky for jobs or family find their way back. And those who choose to live elsewhere never forget their Kentucky roots. Active Kentucky social clubs have been formed in some of the nation's largest cities to nurture their own Kentucky expatriates. The majority of our citizens like living here, where lives are run at a slightly slower pace than in much of the rest of the United States. One can feel the change just crossing a bridge over the Ohio River from Cincinnati to northern Kentucky.

While the old traditions are quietly passing, they are not being suddenly yanked away from us. In the simplest terms, the images we hold in our minds and the land we still cherish are ways for us to remember and invigorate our spirits. Kentuckians have been fortunate that many of our most significant historic sites and buildings have been preserved. This has been due to the untiring efforts of thousands of people, in both the government and private sectors, who have dedicated themselves to saving and maintaining our rich historical heritage. Most of these historical sites and structures are available to the public.

In addition to the highly visible places shown in this book, thousands of older, private homes and structures and many smaller, less-known historical properties have been saved and restored or maintained mainly through private efforts, sometimes assisted by government or private foundations. All of these past and present efforts are to be saluted and supported in the future.

Many of us, myself included, still revere the old ways. We frequently visit historical sites in Kentucky and elsewhere, seeking an emotional connection to a place or event. We still slow down when passing an old country store, looking for flickering signs of life. We cling to the memory of our own past experiences in Kentucky and of the experiences of Kentuckians gone before, and we regularly find time to take a long drive in the country where regeneration is waiting.

CONCLUSION

Our social gathering places are shifting dramatically. Over the past half century, we have gone from telling stories around pot-bellied stoves and attending church ice-cream socials to the new and ever-expanding venues of giant malls, HD television, computers, E-mail, iPods, cell phones, and the Internet. Tomorrow's list of gathering places will be longer, broader, newer, and probably a little scarier.

Our goal is to get from here to there with utmost speed, giving scant if barely conscious attention to who or what is around us. We live in self-imposed bubbles of gated communities and fast cars complete with state-of-the-art GPS programming. Our new reality is found inside the screens of computers and TVs. We put the landscape on mute, dimming its colors and shapes, as its significance has become a mostly irrelevant nuisance.

It seems the only time the earth has any meaning to us is when it rebels, momentarily blocking our way to the next technological quest. An ice storm stops traffic, a tornado rips through a small town, a far-away hurricane delays our flight, heavy rain brings mudslides and flooding, fires ravage tinder-dry land. Since nature is seen as an inconvenience, we want to control it, to move it around to accommodate our plans and our pocketbooks. We build more roads, high-density housing projects, sprawling subdivisions, and mega shopping centers. In the eastern Kentucky coalfields, mountaintops thousands of years old are chopped off, leaving flat, barren scars one has to see to be shocked.

In an increasingly complicated world, it is hard to know what issues to back, what to protest and what to let go. Some of the major headlines screaming for our attention are war, disease, the environment, civil rights, religion, education, politics, and hunger. Every day we are besieged with requests for money to fund what are termed urgent, noble, or worthwhile causes. They come to us unsolicited via mail, E-mails, phone calls, newspapers, television, Internet, faxes, and door-to-door solicitations. Because we cannot contribute to all requests, we usually choose to donate time or money to causes that hit close to home, giving us time to know the facts of an issue. Although perhaps not the most pressing need facing us today, historical preservation is a local cause that can affect how future generations will look at us and our past.

In some ways we are all stewards of history. The saving of things old and of value constitutes a form of preservation. Great-grandmother's gold and pearl locket, your family's early-1800s silver serving set, Civil War letters, your father's World War II military uniform, a shoe box full of 1950s baseball cards —all constitute the preservation of our heritage for future generations to hold, study, and ponder. On a larger, more visible scale is the century-old double-bent barn on your uncle's farm, the stone icehouse by the bend in the creek, Miss Maggie's boarded-up country store and post office at the crossroads, or the long ago closed clapboard missionary church on the old river road.

Sites and structures obliterated, torn down, or allowed to fall through decay are the equivalent of a loss of memory and lessons never learned. But opportunities for involvement in preservation efforts are just down the street, around the corner, or over the hill. Kentuckians are a proud people who love their history, land, and traditions. I hope the photographs in this book will inspire interested persons to become active in contributing the skills and money necessary to preserve and maintain the old buildings and historical sites with which we are still blessed. To those willing to become involved in this endeavor, there are many private and public organizations willing to give help, advise, and yes, even provide grants to assist in the cause of preservation. I encourage people to become more aware of the history that surrounds us.

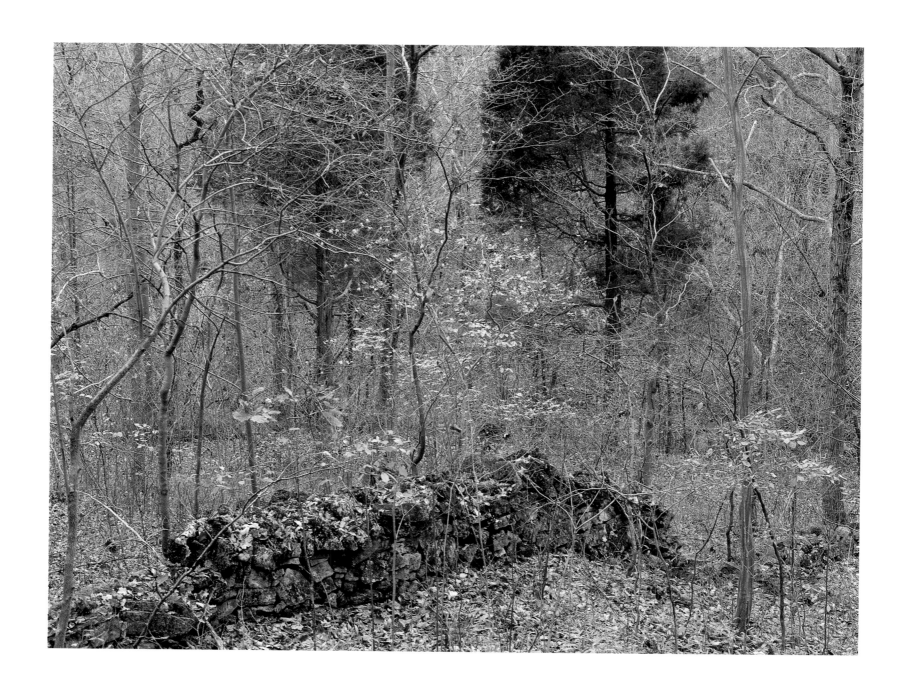

ORIGINAL PIONEER STONE WALL, OLDHAM COUNTY

In central and northern Kentucky, the earliest settlers used the abundant field stones to mark their properties and to control their cattle, hogs, sheep, and other livestock. The pioneers were resourceful out of necessity, making optimum use of the materials at hand.

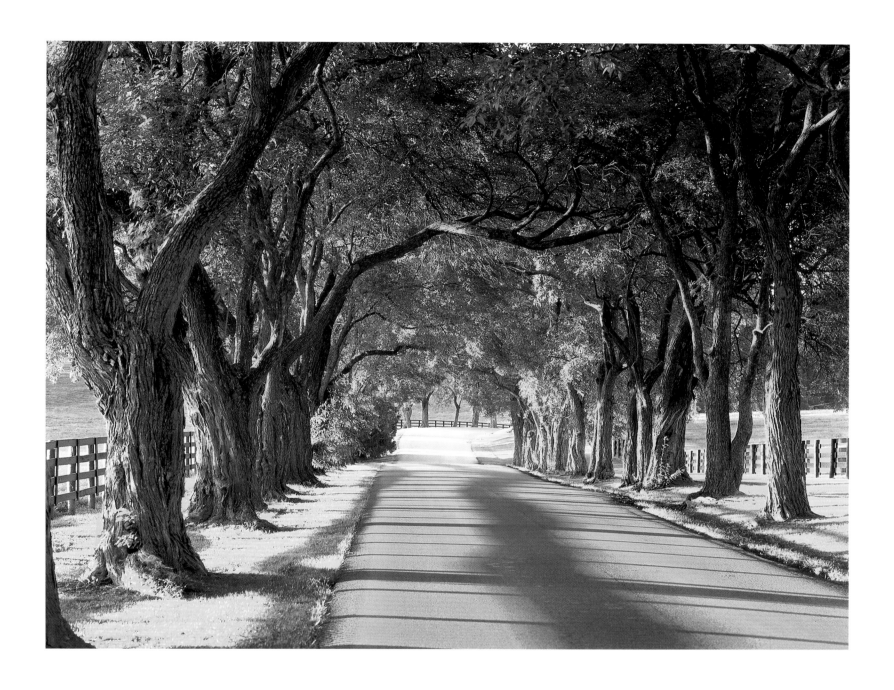

OSAGE ORANGE TREES, WOODFORD COUNTY

This canopy of old Osage orange trees is as much a part of the history of Pisagh Pike in Woodford County as the road and the farms that border it. Long ago someone planted these trees, visualizing how they might look in fifty or more years.

◄ CALUMET FARM, LEXINGTON Of the hundreds of horse farms in the Bluegrass Region of central Kentucky, Calumet Farm is probably the most recognized name. Its 850 acres of pastures and barns are a pleasant visual introduction for travelers between the Blue Grass Airport, Keeneland, and downtown Lexington. Still a working farm, Calumet has produced six Kentucky Derby winners, more than any other horse farm in the world. ▲ FARMHOUSE, BATH COUNTY This old farmhouse sits in the shelter of a steep ridge along the upper Licking River. The original house may have been built of logs and covered later with weatherboard. The unoccupied house can plainly be seen on the south side of Interstate 64 East, between Owingsville and Morehead.

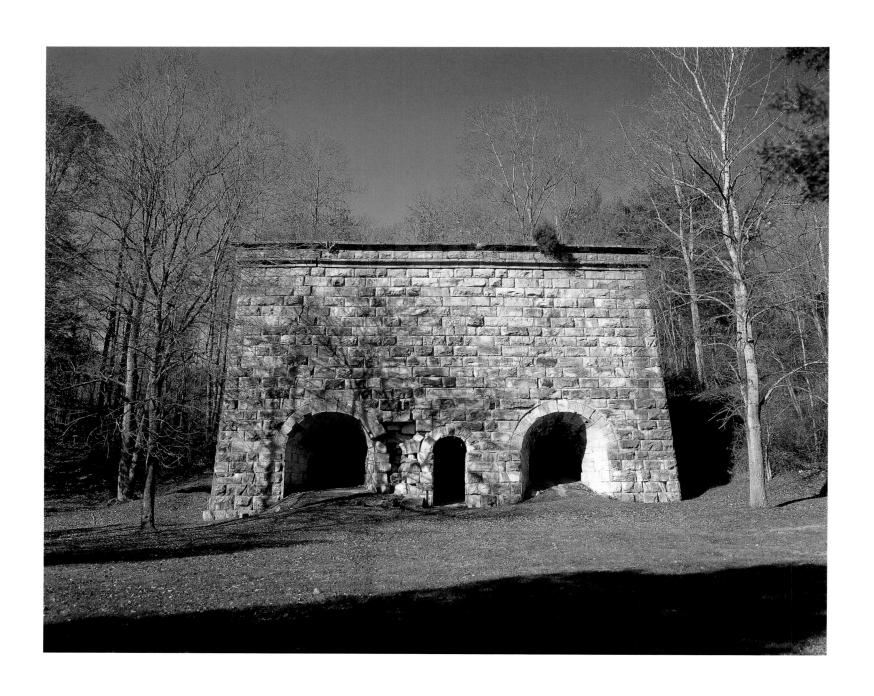

FITCHBURG IRON FURNACE, ESTILL COUNTY

Built in 1869, the Fitchburg Furnace produced high-grade iron that was used primarily in the making of railroad car wheels. At one time, it was the largest iron furnace of its type in the world. Located in the Daniel Boone National Forest, the furnace was abandoned in 1895. It is slated for major renovation in the coming years.

BRIDGE OVER BEARGRASS CREEK, CHEROKEE PARK, LOUISVILLE

Louisville boasts some of the finest city parks in America. In the late 1800s, early visionaries set aside hundreds of acres of prime real estate to be used by present and future generations. Frederick Law Olmstead, the architect of New York's Central Park, was a driving force in the design of the Louisville park system.

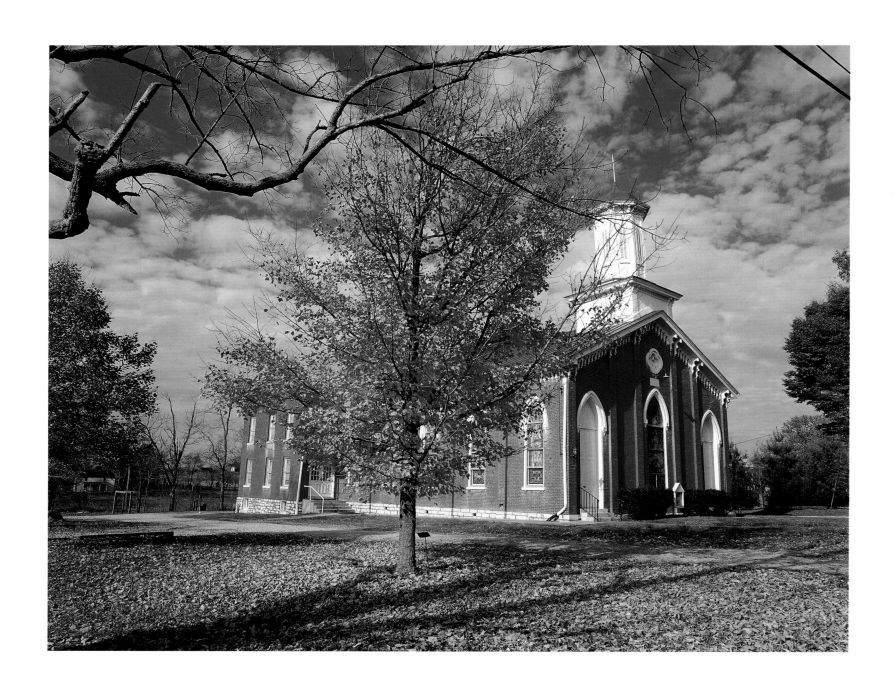

ST. FRANCIS DeSALES CATHOLIC CHURCH, SCOTT COUNTY

Begun as a wilderness mission in 1799, this building was constructed in 1820 at a cost of $3,600. It is said to be the second-oldest Catholic church west of the Appalachian Mountains. The church rests on high ground along U.S. 460 between Georgetown and Frankfort. Its eastern European–like steeple still stands after braving the storms of almost two centuries.

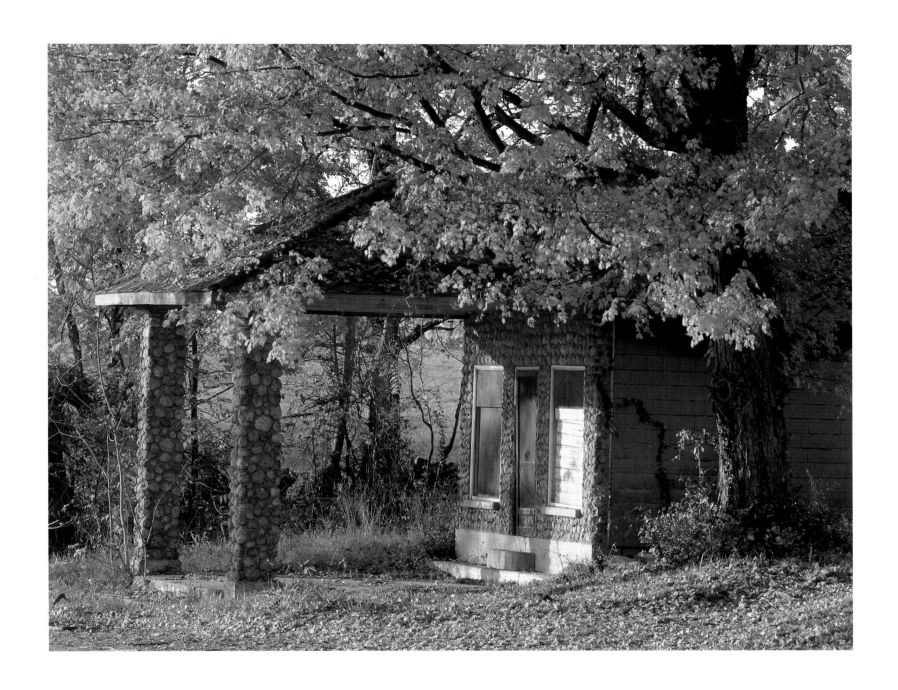

OLD STONE FILLING STATION, MERCER COUNTY

In the early part of the twentieth century, filling stations were built right at the edge of the highway. Like this old stone building, these relics of the past served as rest stops for travelers, where gasoline and food could be purchased, tires could be repaired, and the local gossip was free. Located along U.S. 68 between Lexington and Harrodsburg, this building is now in a serious state of deterioration.

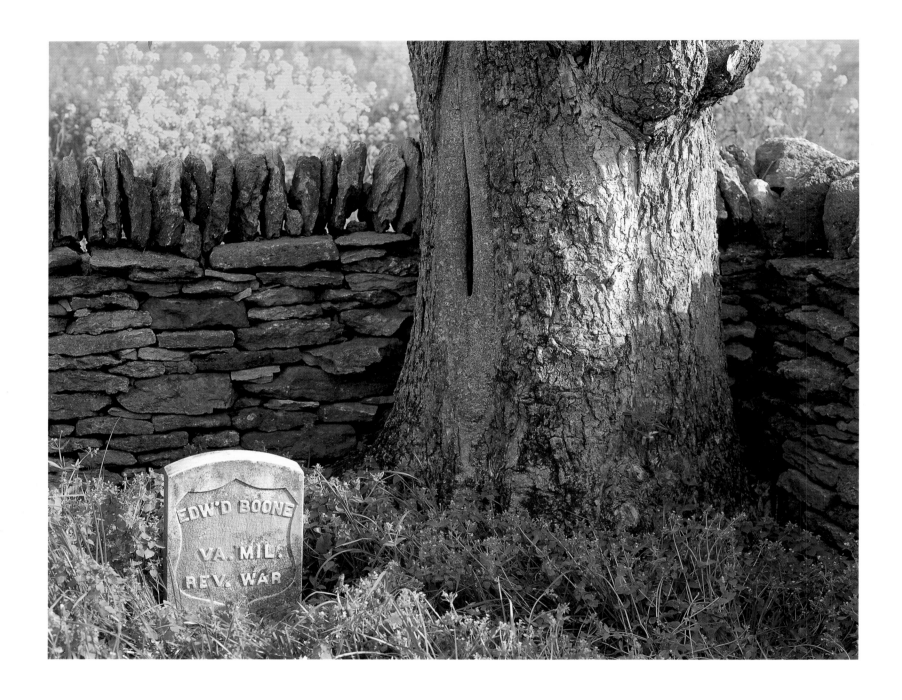

GRAVE OF COLONEL EDWARD BOONE, BOURBON COUNTY

Through acquired skill, cunning, and abundant good luck, Daniel Boone survived into his mid-eighties. Several of his family members were not as fortunate. On October 6, 1780, Daniel and his brother Edward were stalked and attacked by Indians while returning from a hunt to their families' compound in Athens (present-day Fayette County). Boone and others returned to the site the next day to bury his brother. This gravestone was erected by the Daughters of the American Revolution in the 1920s.

SITE OF THE BATTLE OF BLUE LICKS, AUGUST 19, 1782

Against the advice of Daniel Boone, a force of 182 pioneer militia crossed the Licking River at Lower Blue Licks (present-day Robertson County) in pursuit of British regulars and Indians said to number about 250. The pioneers were ambushed and slaughtered in these woods, resulting in over 70 dead, including Boone's son Israel. Boone himself survived, but the unnecessary disaster haunted him for the rest of his life.

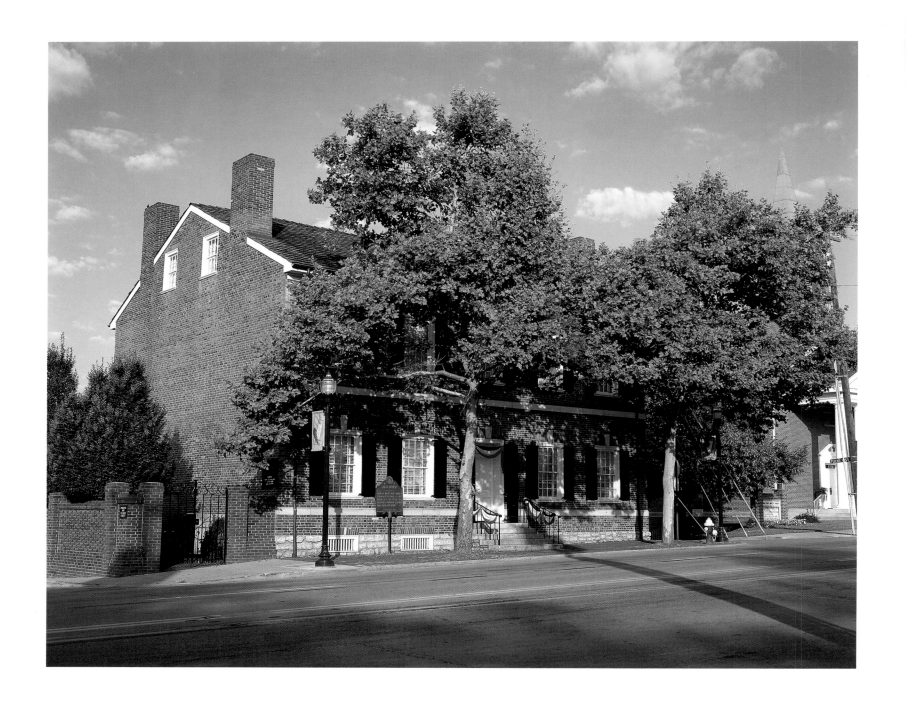

HOME OF MARY TODD LINCOLN, LEXINGTON

Unusually well-educated for her time, young Mary Todd moved to Springfield, Illinois, to live with her married sister, Elizabeth. Here "the belle of the town," as she was called, met, was courted by, and married Abraham Lincoln in 1842. She was twenty-three years old. The Lincolns visited the Todds' Lexington home on several occasions. At his side throughout his political career and presidency, she witnessed Lincoln's assassination at Ford's Theater in April 1865.

LINCOLN'S BOYHOOD HOME, KNOB CREEK FARM, LARUE COUNTY

Abraham Lincoln was two years old when his father, Thomas, moved the family to this more fertile farm ten miles up the road from the Sinking Spring Farm, Abraham's birthplace. For the next five years, the young boy roamed the fields, wooded knobs, and creeks and began his schooling. Lincoln later wrote, "My earliest recollection … is of the Knob Creek place." Due to a land dispute in 1816, the family moved to Indiana, never to return to Kentucky. The Knob Creek Farm remains essentially as it appeared then and is operated by the National Park Service.

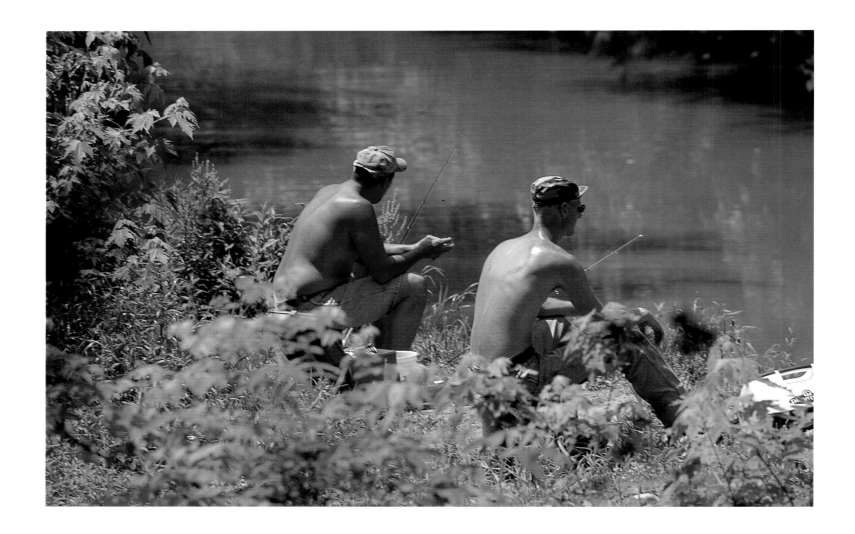

BOYS OF SUMMER, BRECKENRIDGE COUNTY

These young men take an early summer afternoon to warm their backs and cast lines in Cloner Creek, a tributary of the Ohio River in Breckenridge County west of Louisville. Catching fish is not so important. Like thousands of Kentuckians since pioneer days, they are performing almost a rite of passage, bonding to each other and to the land on which they are fortunate to live.

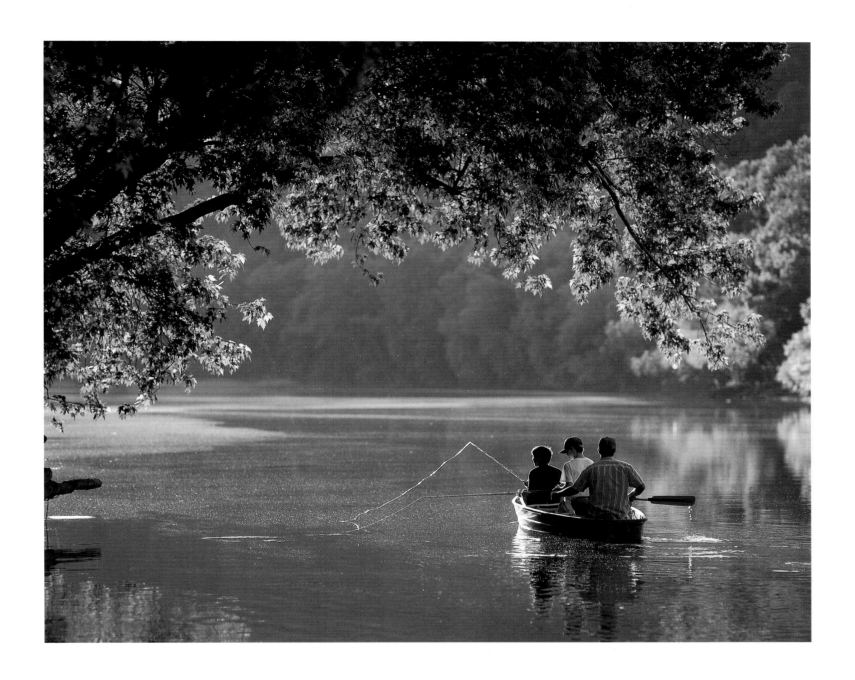

EVENING ON THE KENTUCKY RIVER, GARRARD COUNTY

For centuries, humans have fished the abundant rivers and streams of Kentucky, for both food and livelihood. Native peoples first probed these waters for daily sustenance, as did the early settlers. In the late 1800s, a third reason to fish began to take hold. The pleasures of angling for recreation, for moments of peace and solitude, are found in this scene on the Kentucky River in Garrard County.

FARMINGTON HISTORIC HOME, LOUISVILLE

Based on a design by Thomas Jefferson, the Farmington Home was built in 1815–16. It was the center of a 550-acre hemp plantation tended by as many as sixty slaves who performed the backbreaking work of cultivation and harvesting. Abraham Lincoln spent three weeks at Farmington in 1841, visiting his best friend, Joshua Fry Speed, son of the plantation owners. This home was restored and opened to the public for tours in 1959.

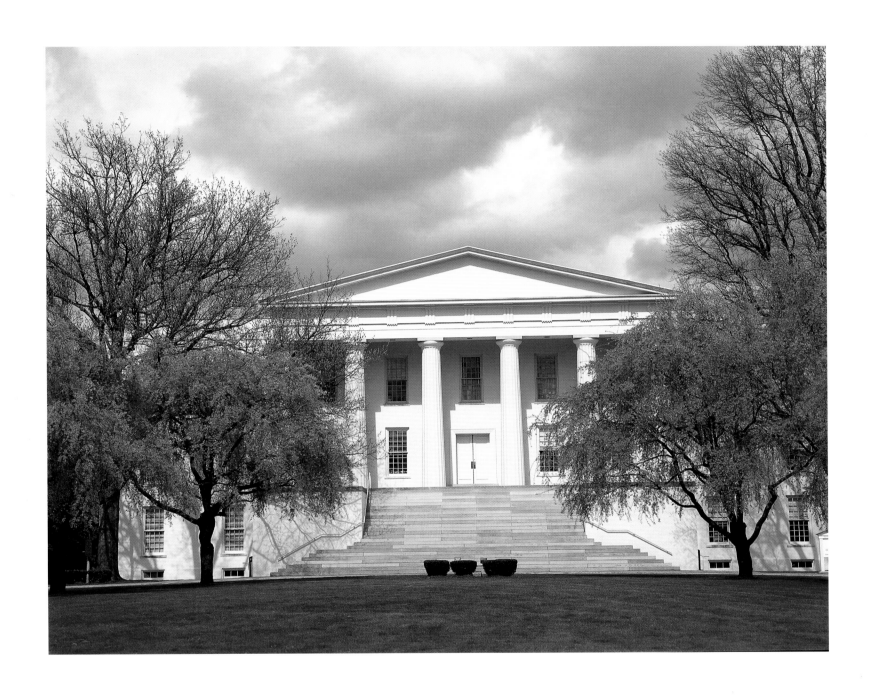

▲ OLD MORRISON, TRANSYLVANIA UNIVERSITY, LEXINGTON Founded in 1780, Transylvania University was the first school of higher education west of the Appalachian Mountains. Despite the obstacles the early frontier provided, dedicated trustees and administrators led Transylvania to early national prominence, particularly in the fields of law and medicine. The neoclassical Old Morrison was designed by Kentucky architect Gideon Shryock and completed in 1833. ► STATE CAPITOL BUILDING AND THE KENTUCKY RIVER AT FRANKFORT The first state legislature meeting at Lexington in 1792 chose Frankfort as the state capital of Kentucky. The first and second state houses burned. The third, designed by Lexington-born architect Gideon Shryock, has outgrown its usefulness, though it remains standing. In the early 1900s, the present capitol building was built on a hill overlooking the city and the river.

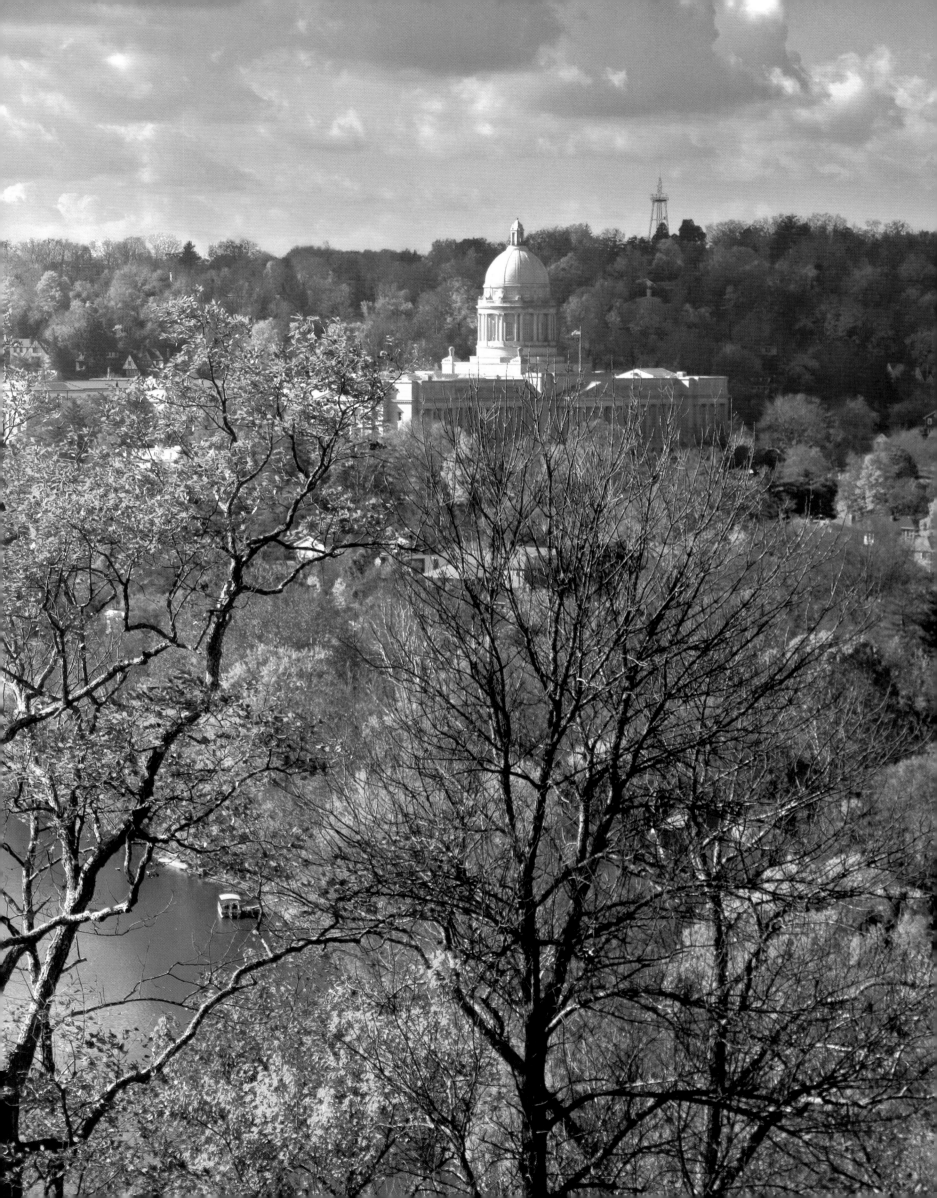

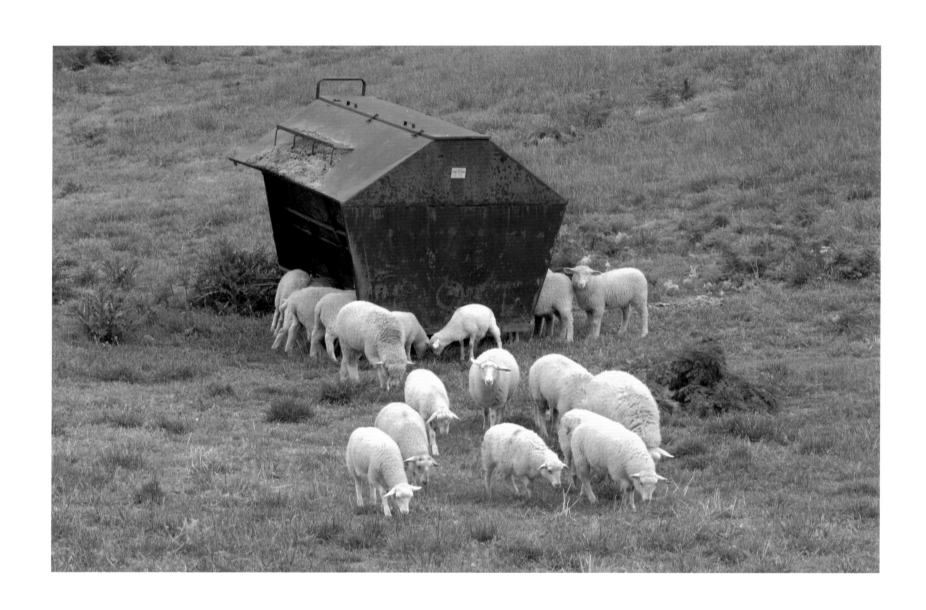

SHEEP AT THEIR FEEDER, NORTH-CENTRAL BLUEGRASS

Raising sheep for their wool and meat still plays a small but significant role in Kentucky's
livestock industry. Early settlers brought sheep through Cumberland Gap or down the Ohio
River on flatboats. Wool was indispensable for making homespun pioneer clothing.

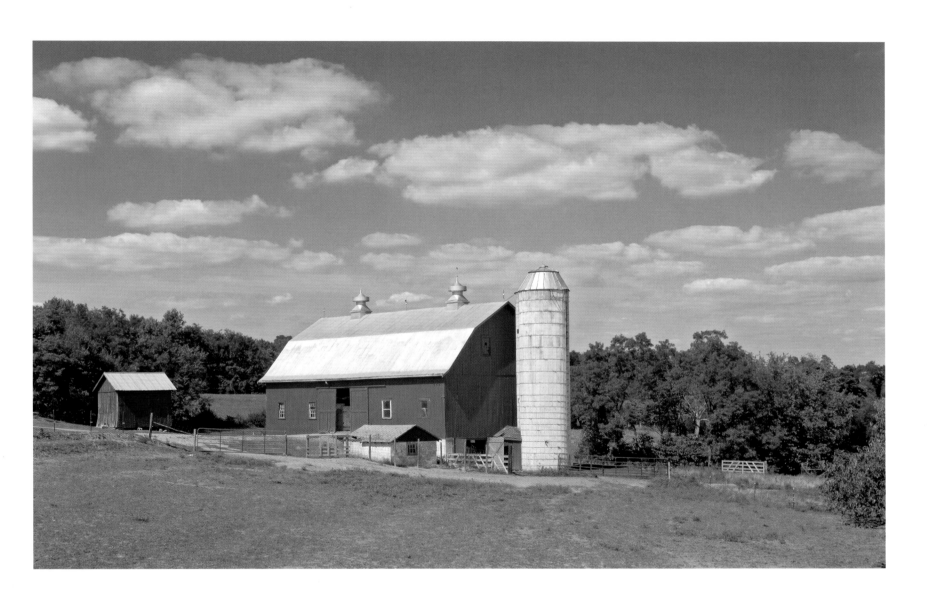

BARN AND SILO, CIRCA 1895, CAMPBELL COUNTY

The owner of this barn in northern Kentucky's Campbell County proudly told me a little of his family history and how the generations have maintained and preserved the barn for more than a century. The owner, now in his seventies, still farms his land, an increasing rarity. He said that he would probably be the last of his family to do so. The impact of urban sprawl is most evident in northern Kentucky, owing to its Ohio River border with Cincinnati.

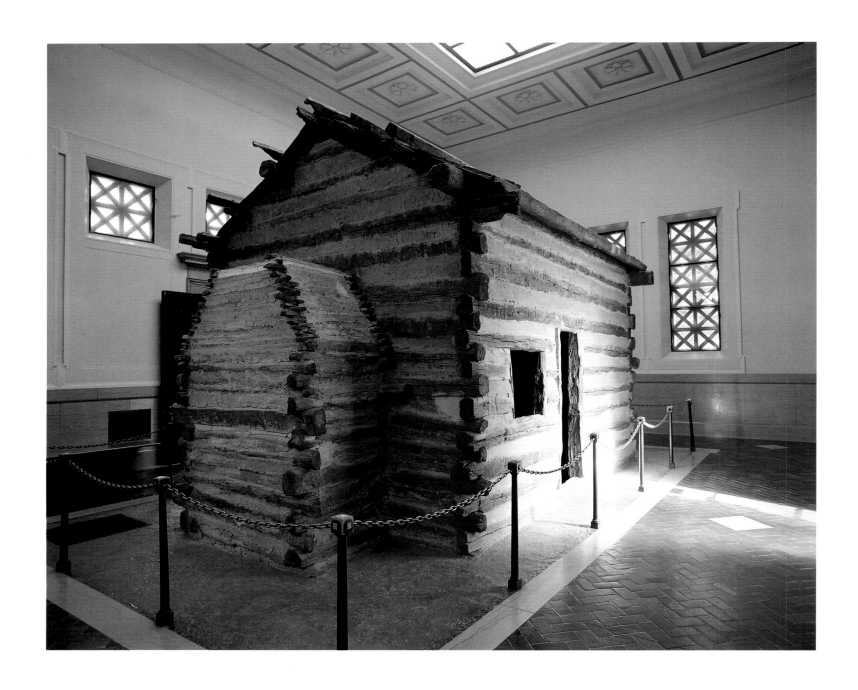

LOG CABIN AT ABRAHAM LINCOLN'S BIRTHPLACE, LARUE COUNTY

On February 12, 1809, Sarah and Thomas Lincoln's son, Abraham, was born on their Sinking Spring Farm in Larue County. Their son would become the sixteenth president of the United States, free the slaves, and preserve the Union through the dark and bloody days of the Civil War. The reconstructed cabin is housed within the granite memorial at the Abraham Lincoln Birthplace National Historic Site at Hogdenville. It is operated by the National Park Service.

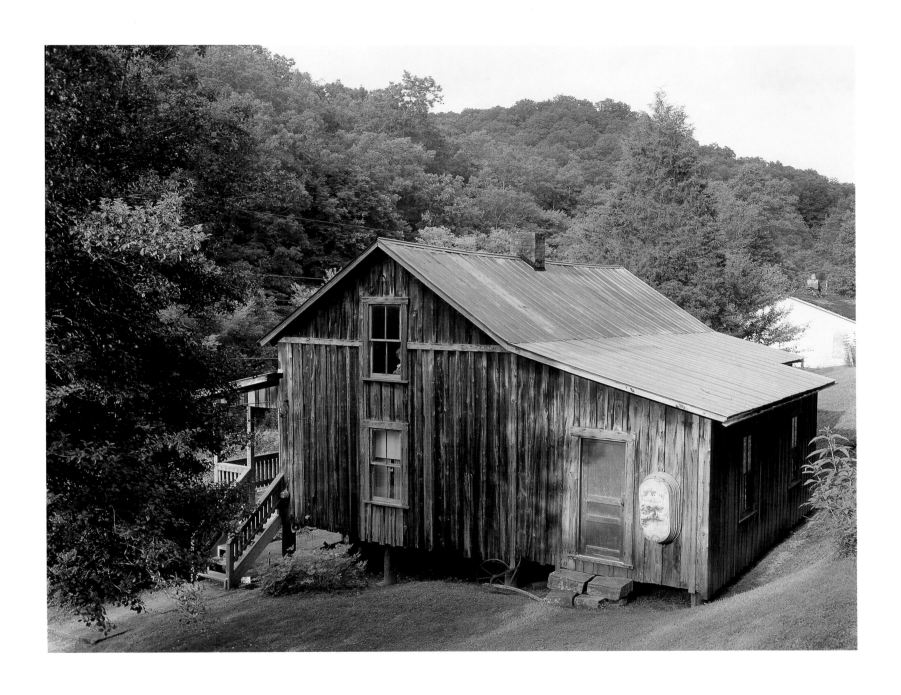

BIRTHPLACE OF SINGER LORETTA LYNN

Loretta Lynn was born and raised in this house at the head of Butcher Holler in Johnson County, Kentucky, on April 14, 1935. She would grow up to become "the first lady of country music." Many of her own compositions have become classics in the music industry. In addition to her long list of honors and awards, Lynn's life was chronicled in the acclaimed 1980 movie *Coal Miner's Daughter*.

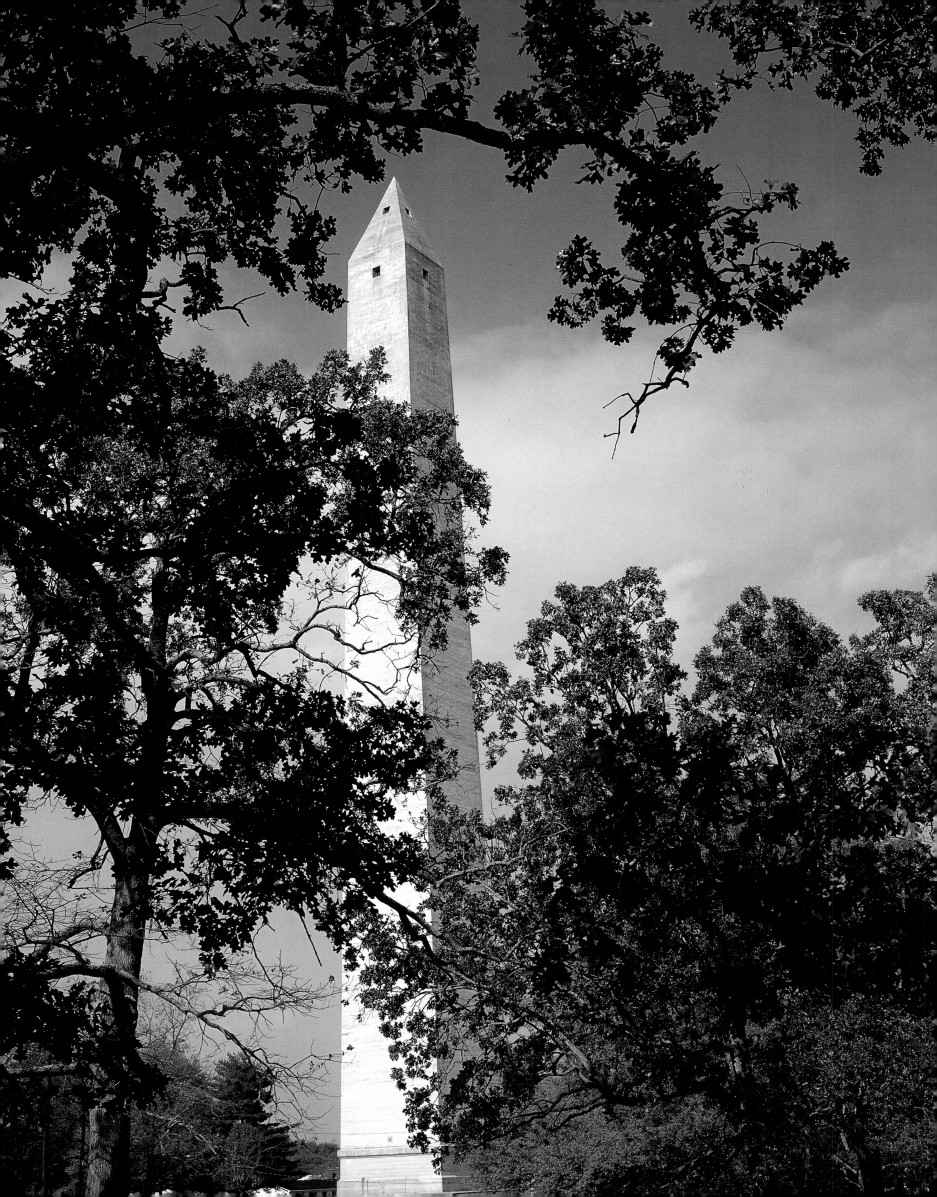

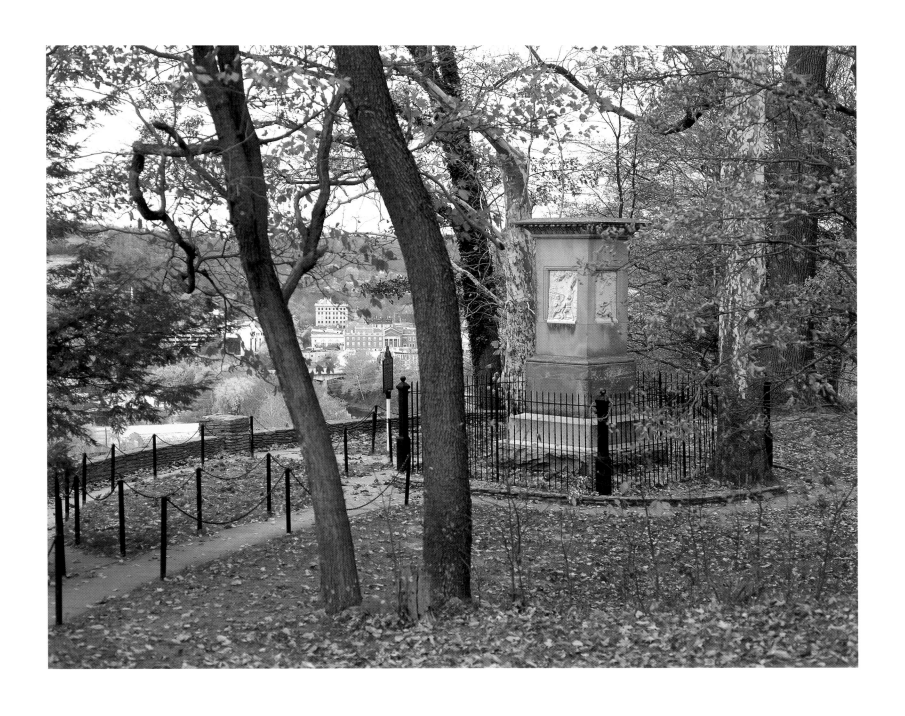

◄ MONUMENT AT THE BIRTHPLACE OF JEFFERSON DAVIS, VILLAGE OF FAIRVIEW, TODD COUNTY
In 1808, Jefferson Davis was born to a well-to-do family in southern Kentucky. Shortly thereafter his family moved to Mississippi, where as a young child he was raised on a cotton plantation. He attended Transylvania University in Lexington and graduated from West Point. In 1861, he became president of the Confederate States of America at the start of the Civil War. Although a reluctant president, he performed his duties admirably in a cause that would eventually be lost. After the war, Davis repeatedly told his southern compatriots to accept the war's result and to live in peace with all persons for the sake of the Union. ▲ DANIEL BOONE'S GRAVE, FRANKFORT CEMETERY
Daniel Boone and his wife, Rebecca, lie beneath this monument overlooking the city of Frankfort. The Boones spent their final years in Missouri. Daniel outlived his wife and was buried next to her there following his death at age eighty-five in 1820. The state of Missouri, at the request of the Kentucky Legislature, moved the bodies to Frankfort in 1845. Rebecca and her daughter were possibly the first pioneer women in Kentucky in 1775.

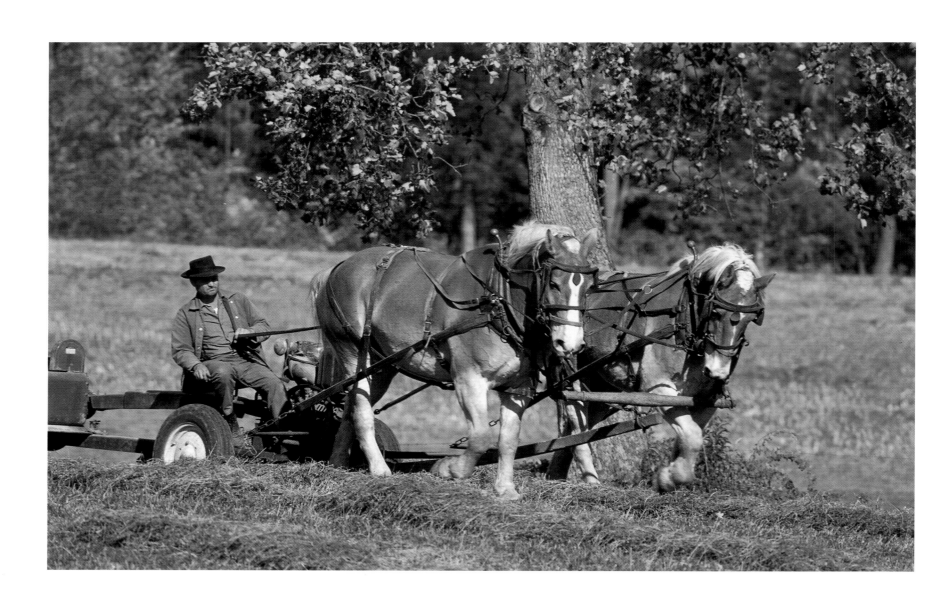

HARVESTING HAY, MENNONITE COMMUNITY, CASEY COUNTY

It is rare to see draft horses or mules assisting farmers in the fields of Kentucky. Only in remote areas of the state and in Amish and Mennonite communities are animals still used for plowing and harvesting. These two matched draft horses are actually pulling a gasoline-powered threshing machine in 1985.

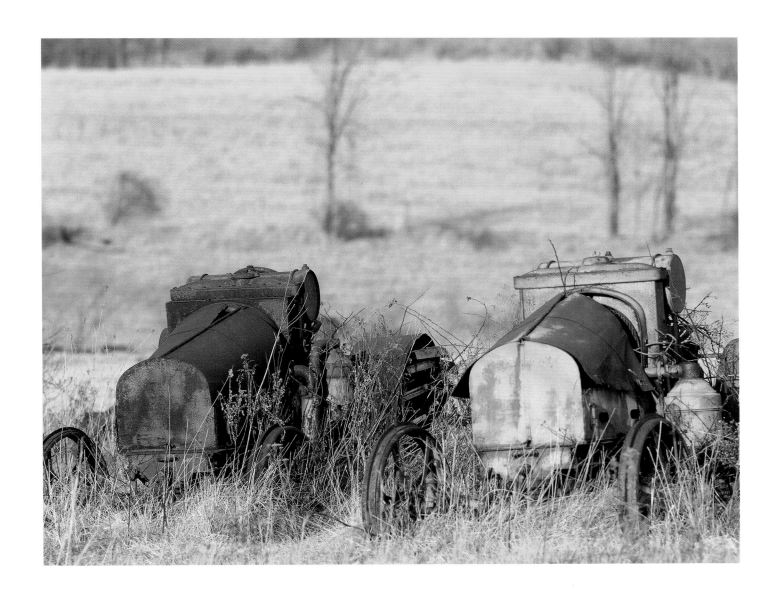

EARLY FARM MACHINERY, MONTGOMERY COUNTY

Tucked off a gravel road north of Mt. Sterling, these iron-wheeled tractors were found rusting in a graveyard of old farm machinery. While their exact classification is unknown, they appear to be early models of gasoline-powered agricultural vehicles. By now, time and rust have probably returned them to the soil, since the photograph was taken in 1979.

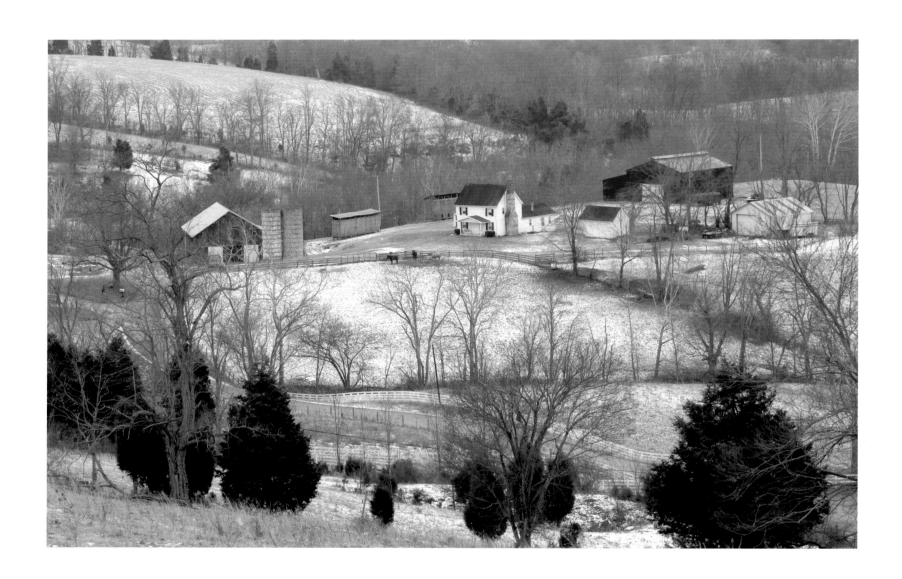

FARMSTEAD NEAR FALMOUTH, LICKING RIVER VALLEY

From pioneer days to the present, the Licking River has played a major role in Kentucky's history. Joining the Ohio River at Covington and Newport, the Licking provides a direct, navigable waterway for more than one hundred miles into the heart of east-central Kentucky. Its banks were the scenes of numerous and bloody raids by Indians trying to dislodge the settlers from their territory. This family farm is one of hundreds that still cling to the fertile soils the Licking River provides.

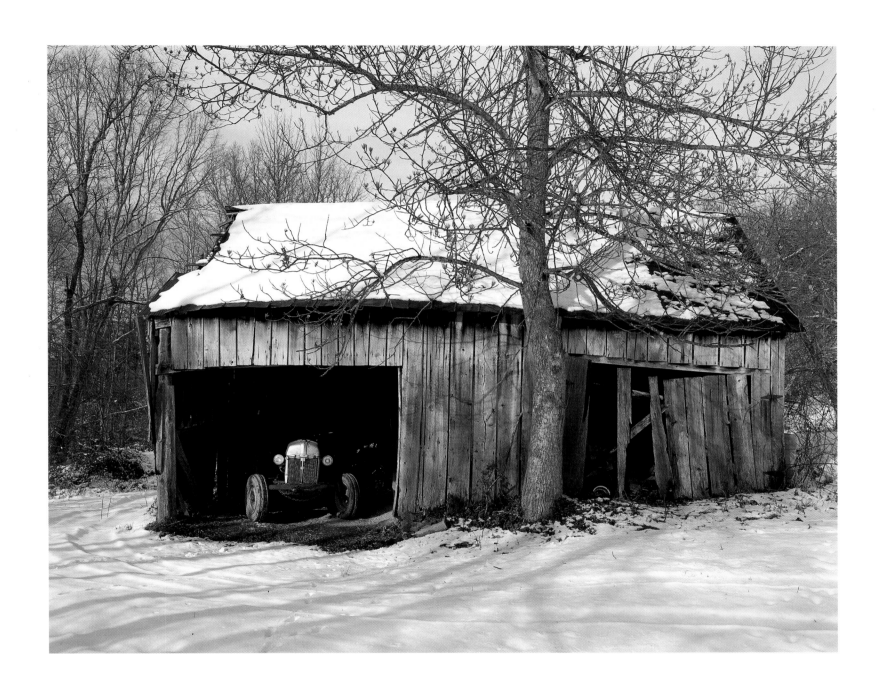

BARN NEAR LONDON, LAUREL COUNTY

A retired 1940s Ford tractor waits out another winter in the Appalachian foothills
east of London. Kentuckians seem to have an aversion to disposing of their old vehicles,
making the state a rich source of antique cars.

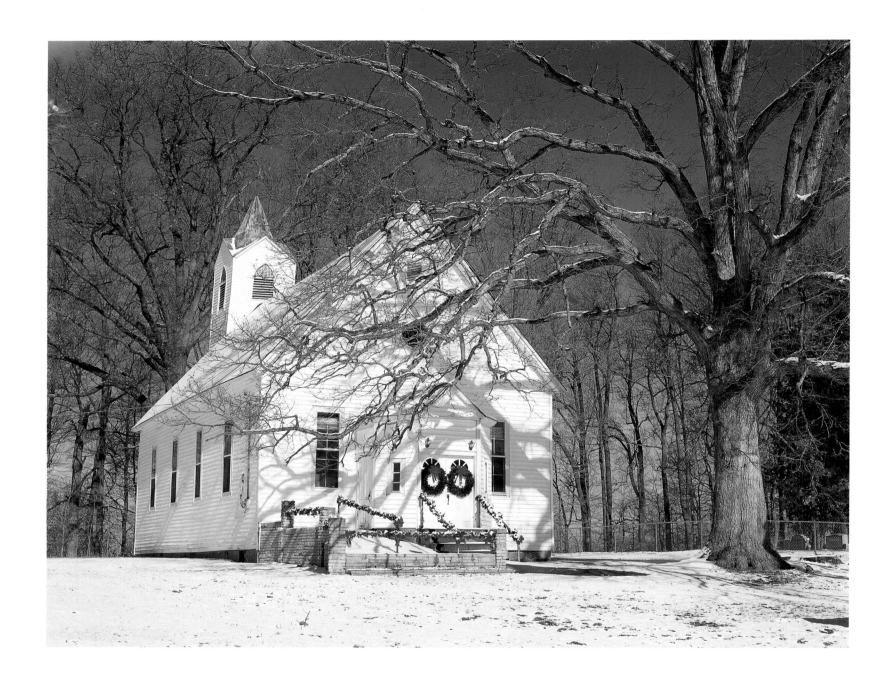

IMMANUEL LUTHERAN CHURCH, LINCOLN COUNTY

Dating from 1886, this structure in the village of Ottenheim was one of the first Lutheran churches built
in Kentucky. Founded by German and Swiss immigrants, the church was restored in 1983. Regular services
ceased in 2002. The building is still maintained and cared for by members of the local community.

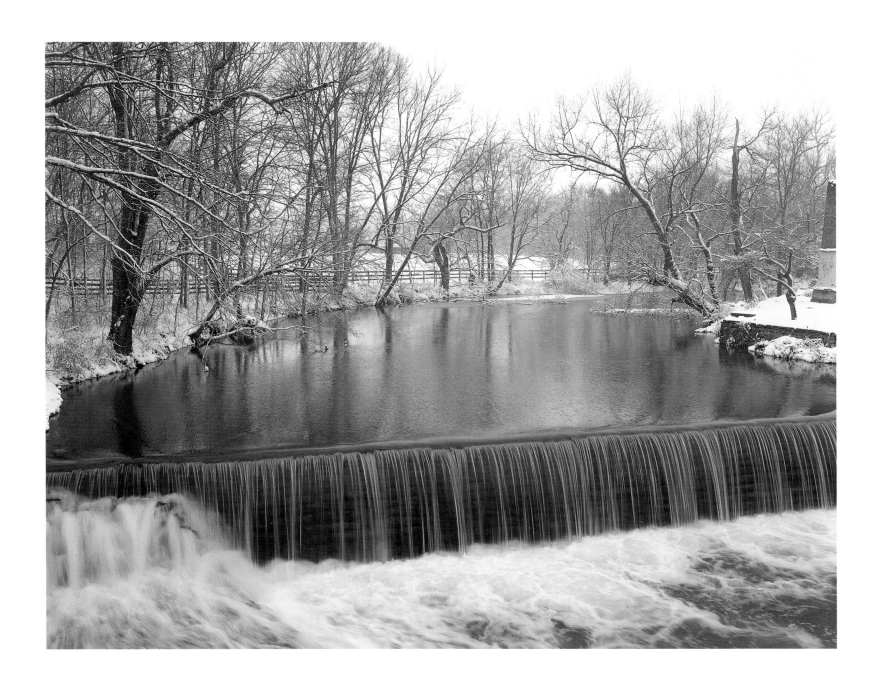

DAM AT JOHNSONS MILL, NORTH ELKHORN CREEK, SCOTT COUNTY

Land along North and South Elkhorn creeks was coveted by early settlers for its dependable flow of water. Dams and gristmills were established at various points, providing service to local farmers. At one time, the famous frontiersman Simon Kenton "owned" thousands of acres along the Elkhorn, only to lose them in the morass of land disputes that resulted from conflicting claims.

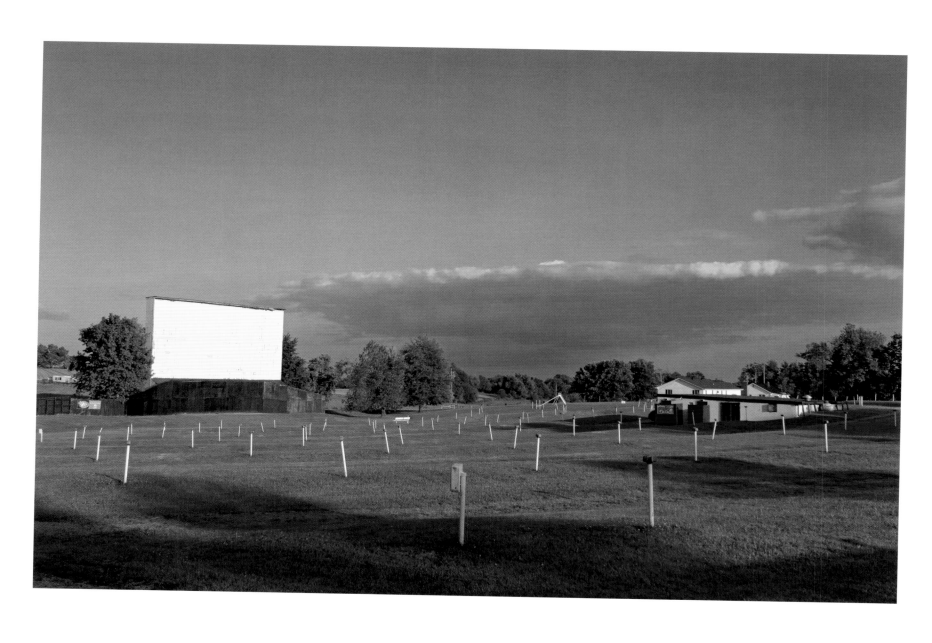

JUDY DRIVE-IN THEATER, MONTGOMERY COUNTY

The drive-in theater in the village of Judy, north of Mt. Sterling, still serves movies, popcorn, and Jujubes to the rural population of east-central Kentucky. While a few outdoor theaters manage to survive statewide, they have virtually disappeared from the Kentucky landscape.

▲ MILKING COW, SOMEWHERE IN CENTRAL KENTUCKY While I was photographing an abandoned piece of farm machinery, this cow wandered into the scene. Not being a farmer, I wasn't sure if she was just curious or pleading for me to give her a good milking. Bored with my nonresponse, she finally wandered off, leaving this image of our brief encounter. ► CUMBERLAND GAP, BELL COUNTY Below the shadowed forests in the foreground of this photograph lie Cumberland Gap and the Wilderness Road. Through this narrow cut in a wall of mountains, early settlers poured through to the "Promised Land" of Kentucky. Once through the Gap, the Wilderness Road was a torturous path that tested the courage of even the hardiest settlers. Many died on the way due to disease, Indian attacks, drowning, and starvation. Thousands turned back to safer eastern climes. But from 1775 to 1800, tens of thousands of pioneers fought the trials of Kentucky's Wilderness Road to reach the land they hoped would be theirs.

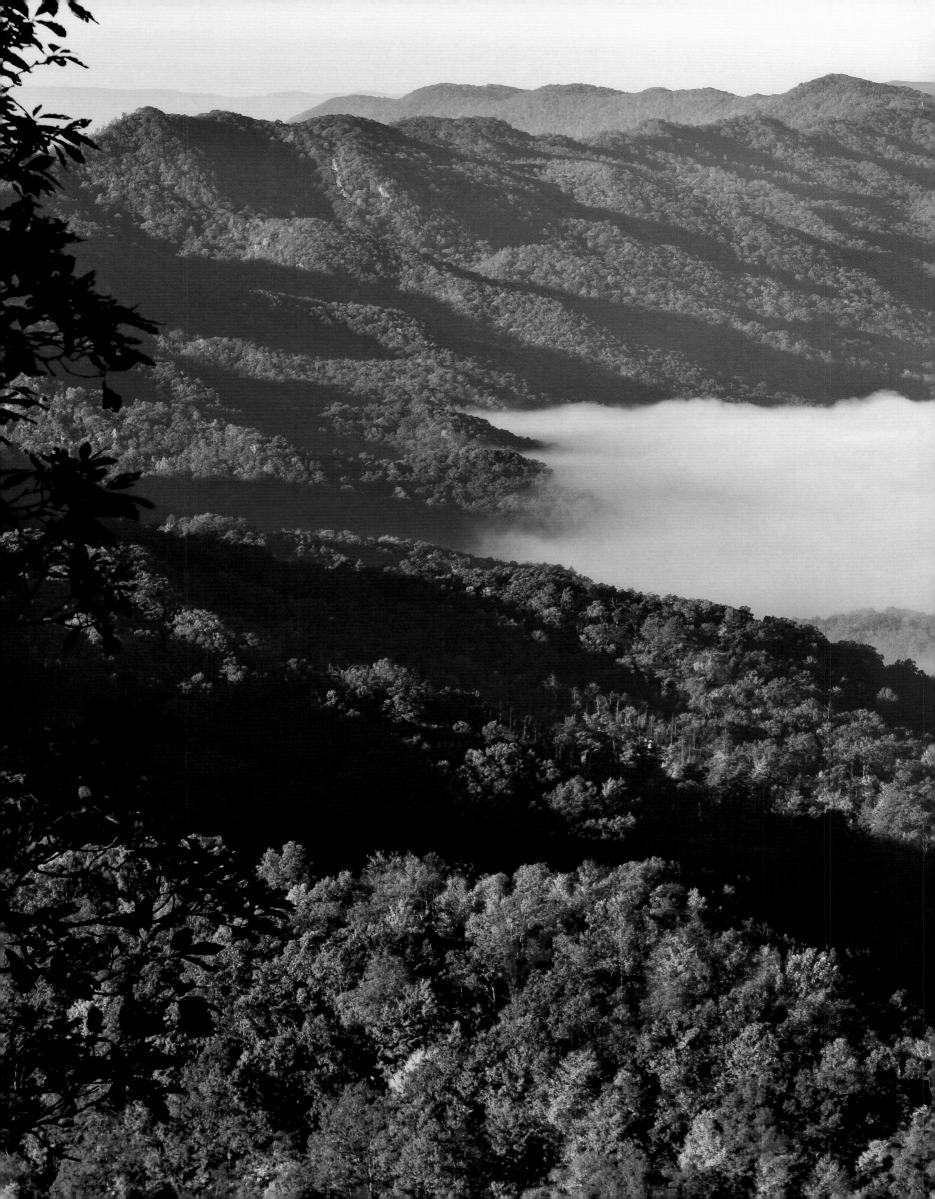

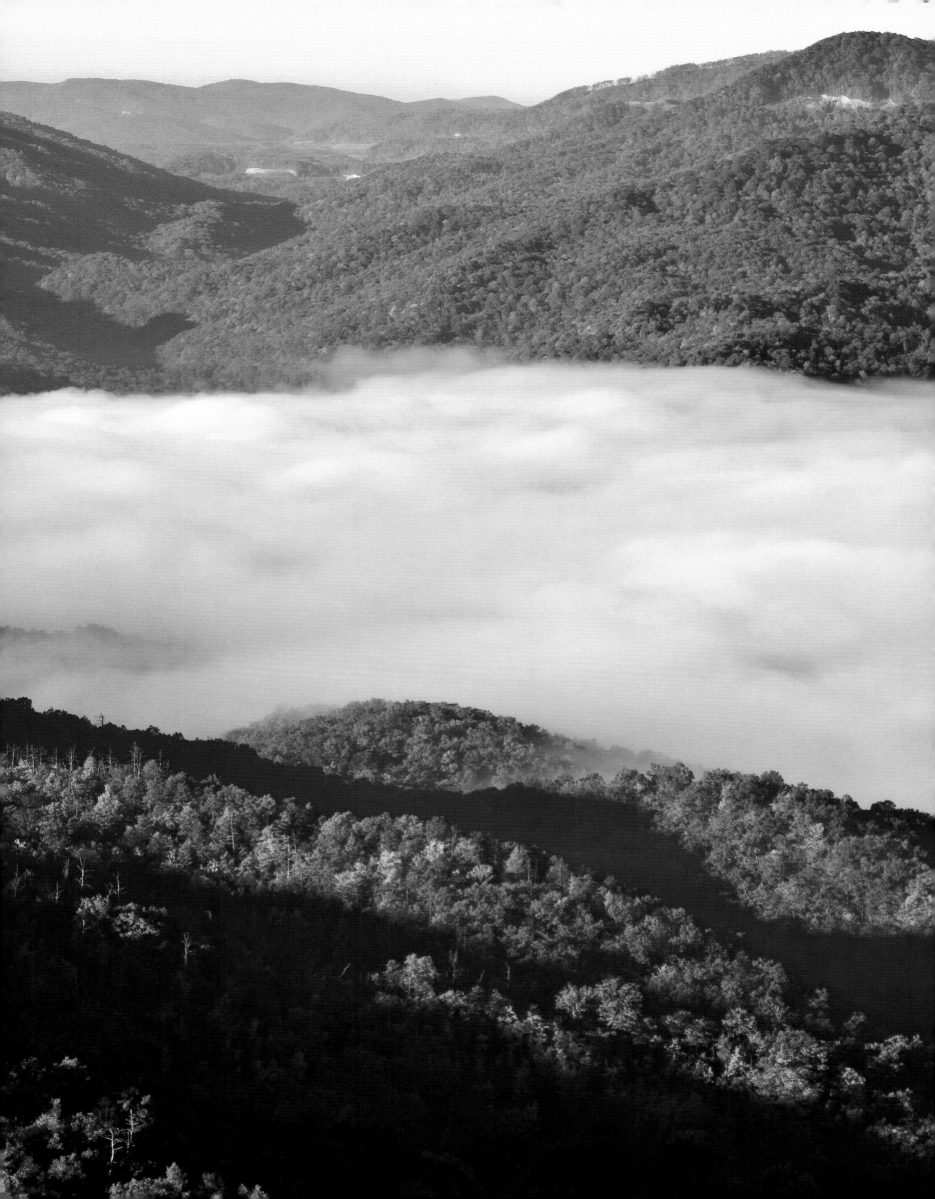

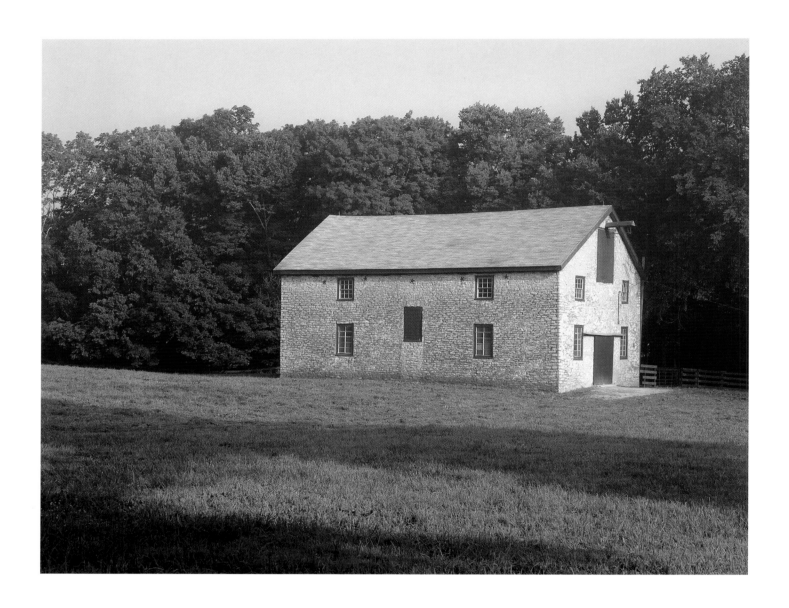

COOPER'S RUN BAPTIST MEETINGHOUSE, BOURBON COUNTY

Built in 1803, this imposing two-story structure still stands about one-half mile east of the Paris-Cynthiana Road (U.S. 27). The church served one of the earliest Baptist congregations in Kentucky. It was replaced in 1816 and sold for $800 to James Garrard Jr. It served as a hemp factory, but since 1900 it has been used as a horse barn.

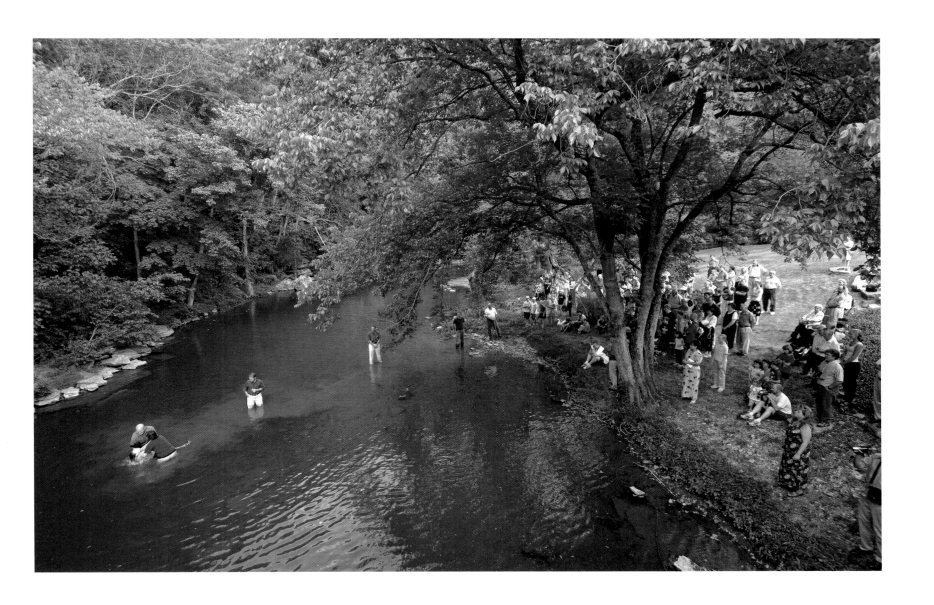

BAPTISM ON JESSAMINE CREEK, NEAR WILMORE, JESSAMINE COUNTY

One by one, young and old, members of an area church are baptized in the cool summer waters of Jessamine Creek following Sunday service. For more than two hundred years, thousands of scenes like this have been played out in Kentucky's abundant rivers and streams, a testimony to the influence of religion throughout the Commonwealth.

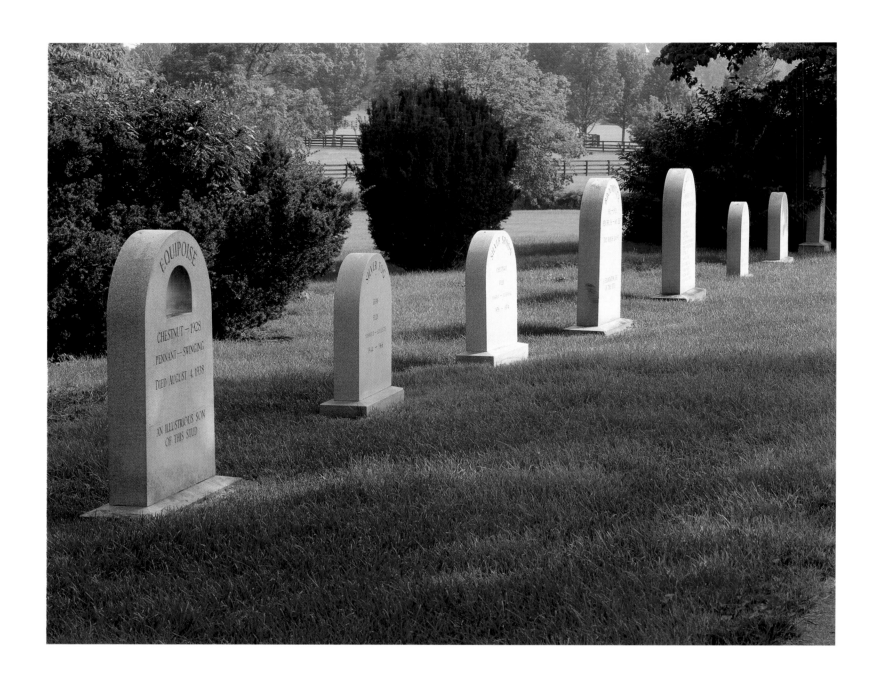

THOROUGHBRED GRAVES, GAINESWAY FARM, FAYETTE COUNTY

Great racehorses are revered by their owners and honored by the farms where they were raised or spent their last years. On the Gainesway Farm, famous thoroughbreds from the past are memorialized by stone markers engraved with their accomplishments. One of these is the grave of Regret, who in 1915 became the first filly to win the Kentucky Derby.

MAN O'WAR'S STALL, FARAWAY FARM, FAYETTE COUNTY

Considered by most to be the greatest racehorse of the first half of the twentieth century, Man O'War won all of his twenty-one races but one and captured the hearts of millions of fans who followed his career. Shown is his original stall as it appeared at the time of his death in 1947. These photographs were taken in 2002 prior to renovation.

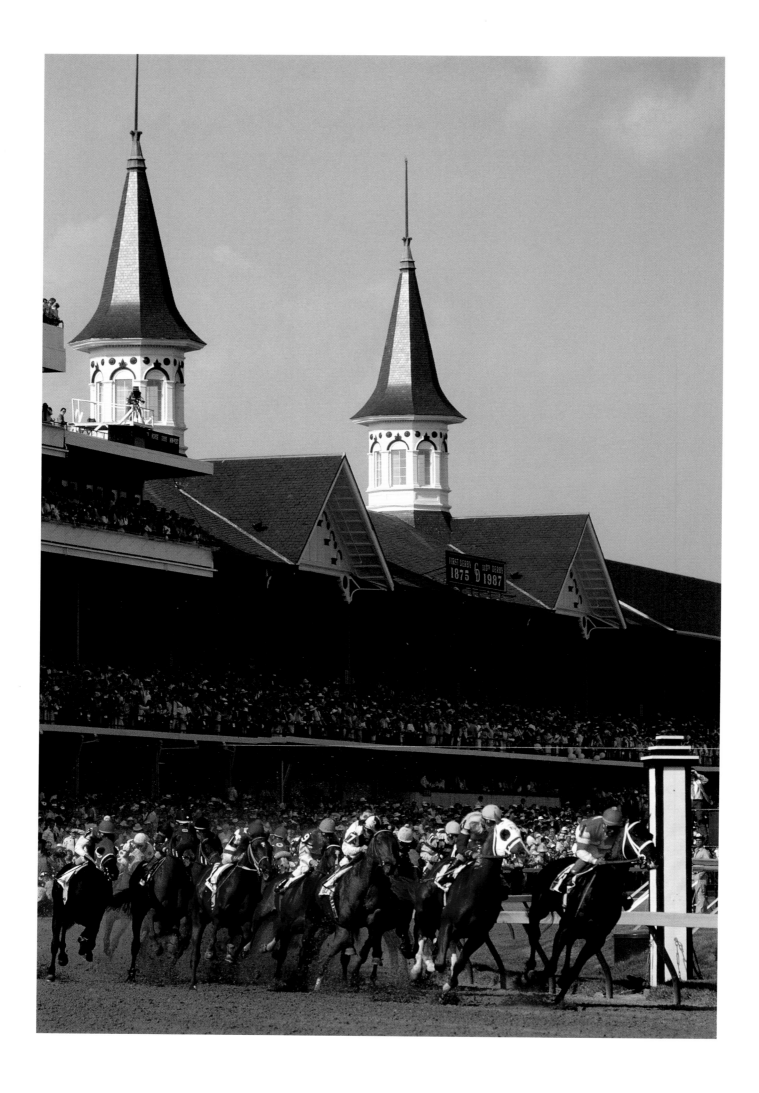

◄ KENTUCKY DERBY, CHURCHILL DOWNS, LOUISVILLE On the first Saturday in May, millions of viewers watch the most famous thoroughbred horse race in the world, the Kentucky Derby. It is the first of the three prestigious Triple Crown races. Since its inception in 1875, the Derby has given excitement, pleasure, and inevitable disappointments, not only to participating owners, but to horse lovers everywhere. In addition to its worldwide television audience, Churchill Downs can accommodate more than 160,000 fans on race day. ▲ OPENING DAY AT KEENELAND, 1975 A chauffeur dozes on a bench in the warmth of early April sunshine outside the main entrance to the Keeneland Race Course in Lexington. He quietly keeps company with the bees and the flowering crab apple, while thousands of racing fans make merry, hope, and roar inside the old stone walls. The Keeneland Race Course was built in 1936 and is renowned for its intimate atmosphere.

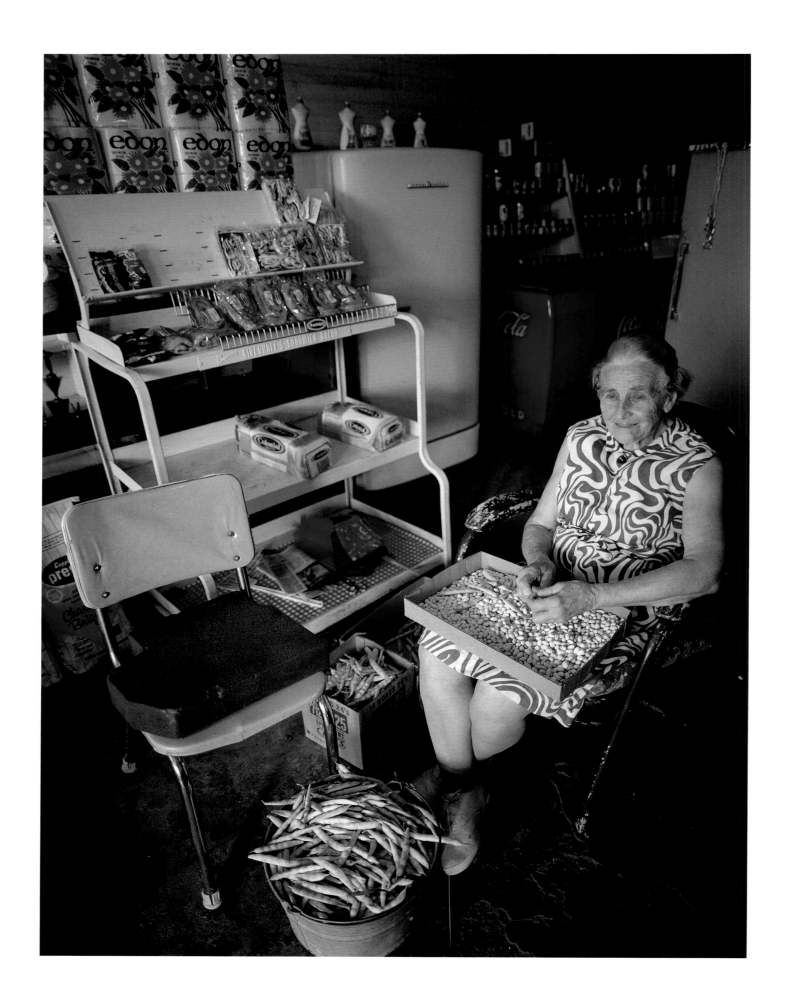

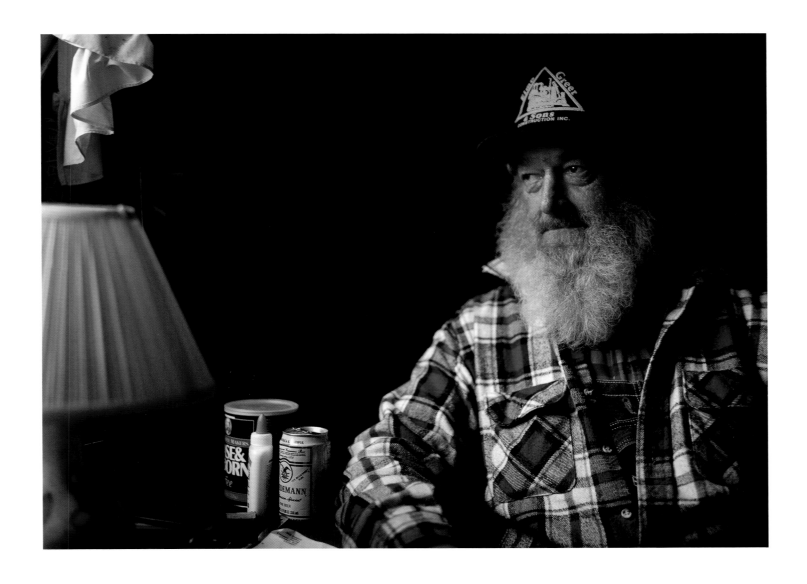

◄ EMMA MITCHELL, OSCAR, KENTUCKY, 1979 Emma Mitchell lived the last years of her life shelling beans and selling Rainbo Bread and sodas at her store in far west Ballard County. In addition to other economic factors, the sharp decline of the geese population along the Mississippi River flyway and subsequent loss of income from seasonal hunting have contributed to the decay of many small villages in western Kentucky.

▲ HILL FARMER, GRANT COUNTY In 1986, this Grant County farmer approached me on an old dirt road driving a four-wheeler and asked what I was doing. When I replied that I was photographing, he said that it was his farm and asked me to leave. Before parting, I gave him one of my calendars. After looking at it thoughtfully, his attitude changed, and he invited me to his farmhouse, where we talked for an hour at his kitchen table. After a while, I asked if I could take his photograph, and he consented.

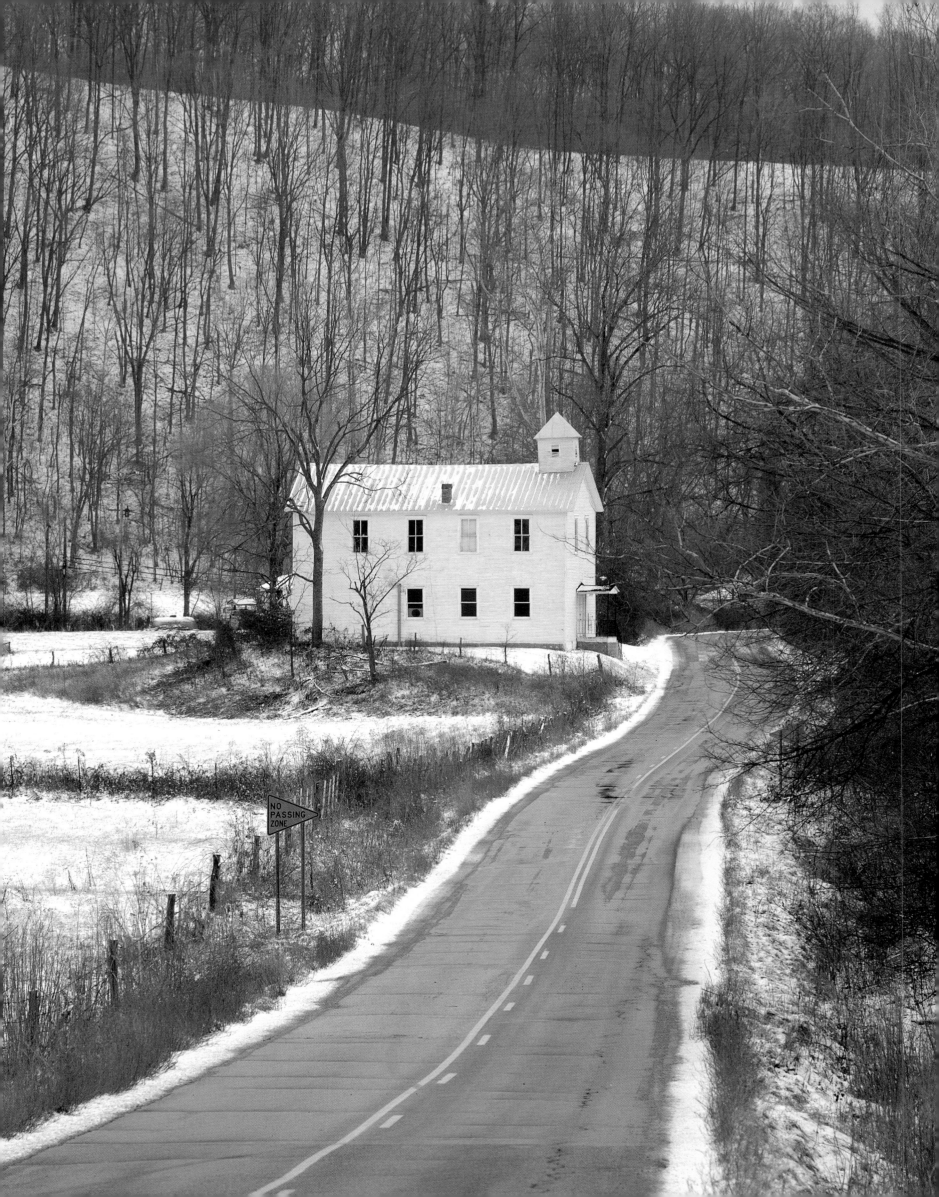

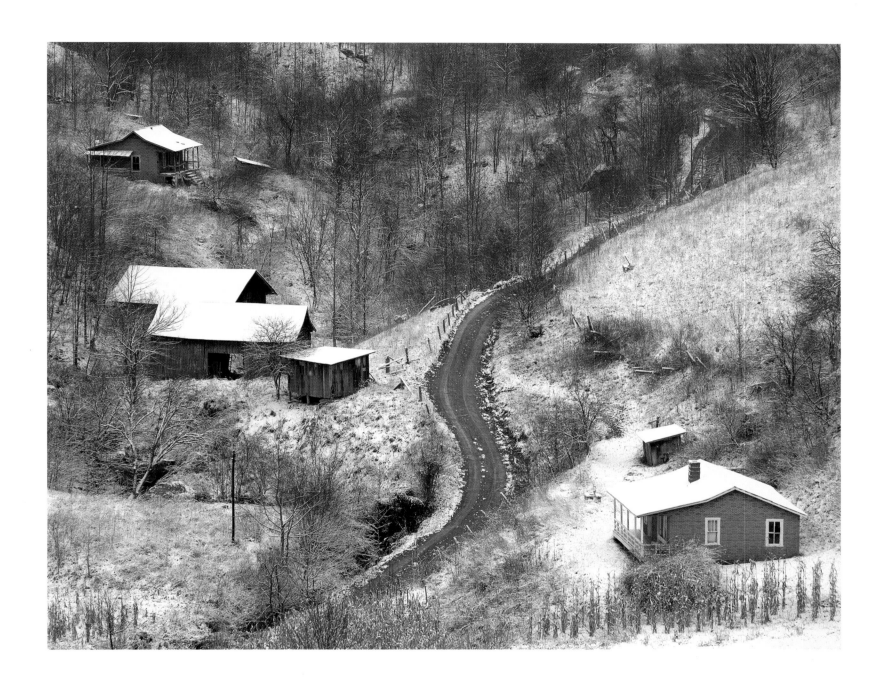

◄ CHURCH IN WINTER, GREENUP COUNTY A light snow accentuates the rough hills surrounding this rural church in northeast Kentucky's Greenup County. The church was photographed in early 1980 and torn down that same year. It was replaced by a modest brick building that lacks any of the character of its predecessor. ▲ MOUNTAIN HOLLOW, KNOTT COUNTY The mountain hollows of eastern Kentucky were settled by English, Scots-Irish, and Irish immigrants in the late 1700s and early 1800s. They came to America from yeoman stock wishing to own and cultivate their own small pieces of land, away from most government systems and controls. This winter hollow near Hindman evokes the feelings of both romanticism and isolation.

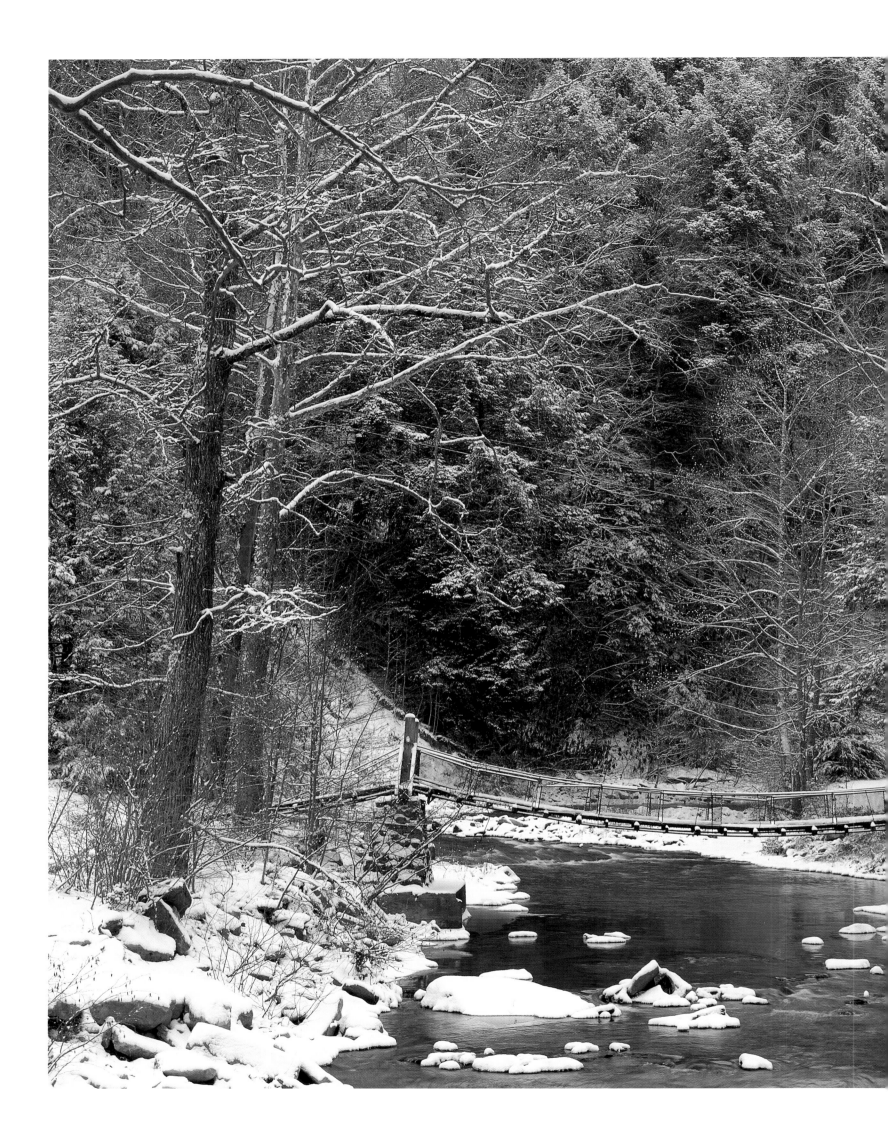

FOOTBRIDGE OVER CLEAR CREEK,
BELL COUNTY Until recently, footbridges,
sometimes called swinging bridges, were common
throughout the eastern half of Kentucky. They
enabled thousands of residents to reach their
homes from the roads over the region's countless
streams and rivers. Some footbridges are still in
use, but most have been replaced by crude wood
or concrete bridges that allow vehicular access.

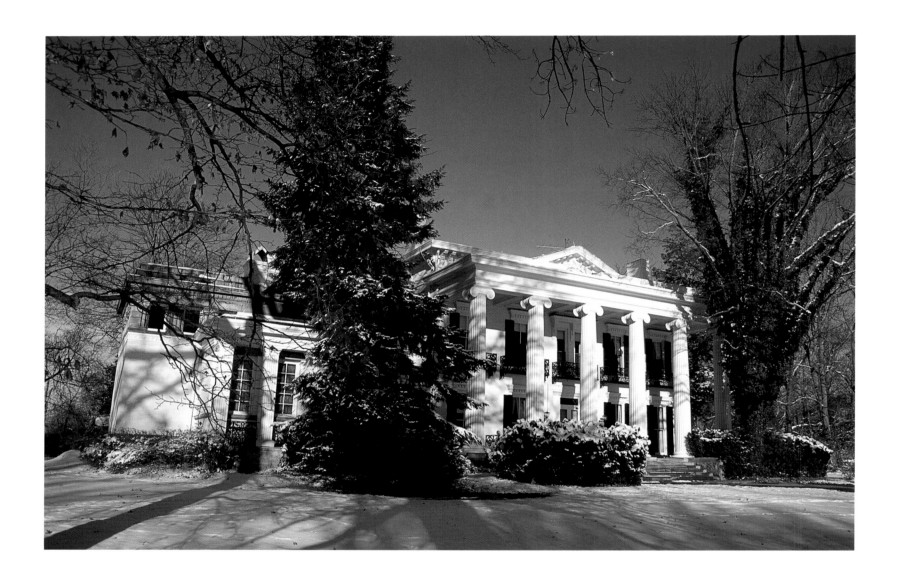

WOODBURN FARM MANSION, WOODFORD COUNTY

In the 1850s, R. A. Alexander transformed his three-thousand-acre Woodburn Farm in Woodford County into a model of the art of equine breeding. While horse farms had existed since colonial times, Alexander was the first to develop an intelligent, disciplined approach to horse-breeding and its supporting farm operations. His ideas included the use of genetics and, through the study of European horse farms, the complete design and purposeful landscaping of Woodburn to accomplish his ends. Alexander published his first yearling catalogue in 1857. The Woodburn standards would be followed by other Bluegrass horse farms that survived the Civil War and would eventually revolutionize the horse industry worldwide. Part of the historic farm is being considered for a permanent conservation easement.

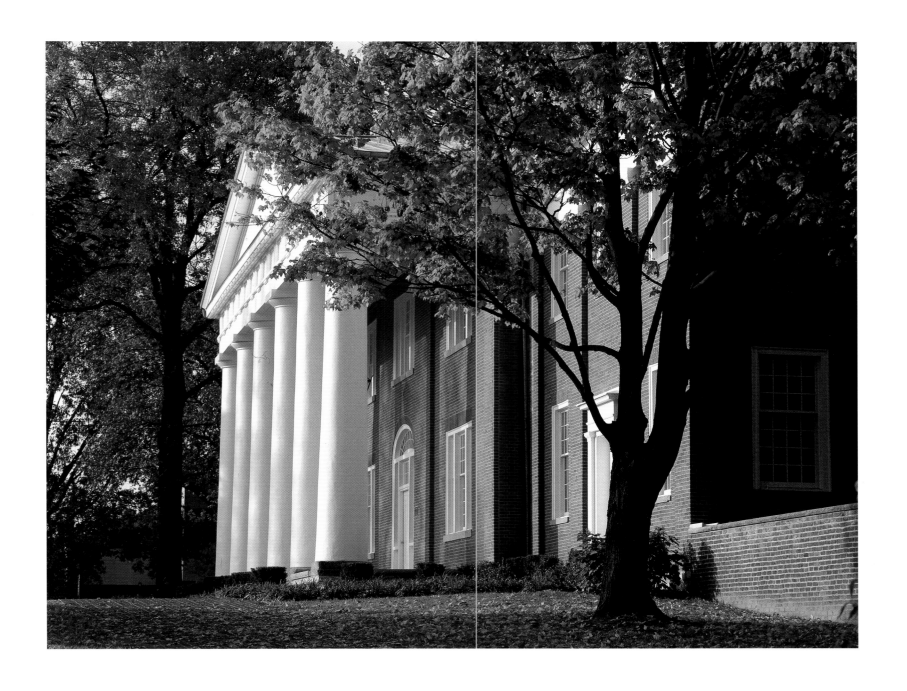

OLD CENTRE, CENTRE COLLEGE, DANVILLE

Founded in 1819, Centre College is one of the premier institutions of higher learning in Kentucky. The original building, now called Old Centre, was completed in 1820. The thousands of alumni include two United States vice presidents and two United States Supreme Court justices. The percentage of alumni donations to Centre is one of the highest of any college or university in the United States.

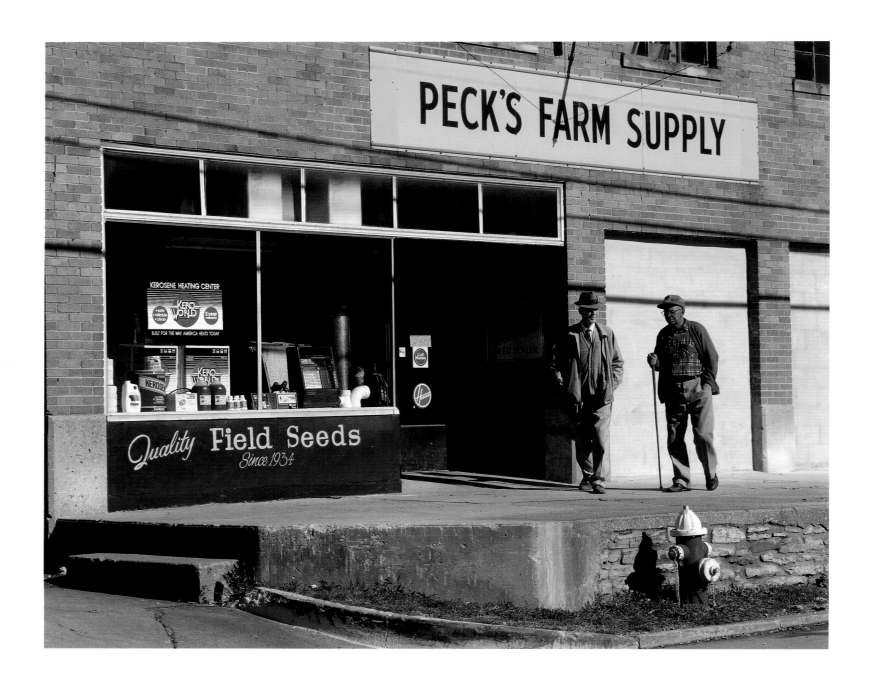

PECK'S FARM SUPPLY, SHARPSBURG, BATH COUNTY

In Kentucky, the promise of spring often comes early. These two men chose the sunny sidewalk in front of Peck's Farm Supply to share their thoughts on the balmy February weather and to discuss the general state of local and world affairs. Elsewhere in town, fishermen oil their reels, farmers tinker with tractors, and crocuses bloom in a hundred yards.

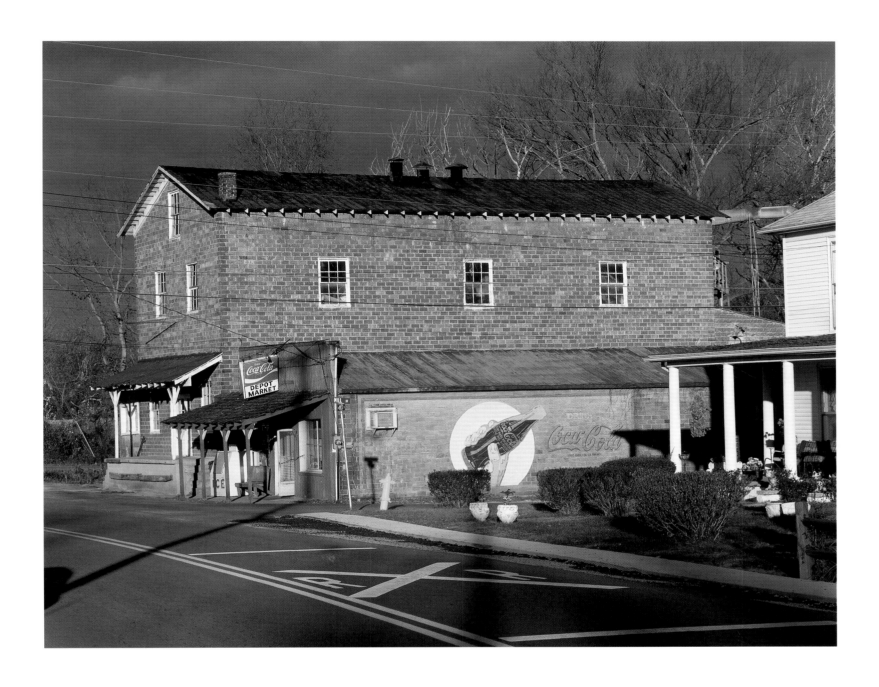

▲ DEPOT MARKET, MUNFORDVILLE, HART COUNTY In the early 1990s, the Depot Market was still operating next to the tracks and across from the train station in Munfordville, near the geographic center of the state in Hart County. In the nineteenth century, stores like this sprang up to serve the railroads. It is doubtful whether a train stops here anymore. Nearby, in 1862, Confederate troops burned the only rail bridge over the Green River. It has since been reconstructed. ▶ MAIN STREET, MT. OLIVET, ROBERTSON COUNTY Mt. Olivet, county seat of the state's smallest county (population 2,500), has changed little since it was founded on a hilltop in 1869. Far from a major highway, few people come here, and not much happens. There is little need to change. On this typical Sunday morning, some of Mt. Olivet's residents have gone to church, leaving the town looking like an empty movie set.

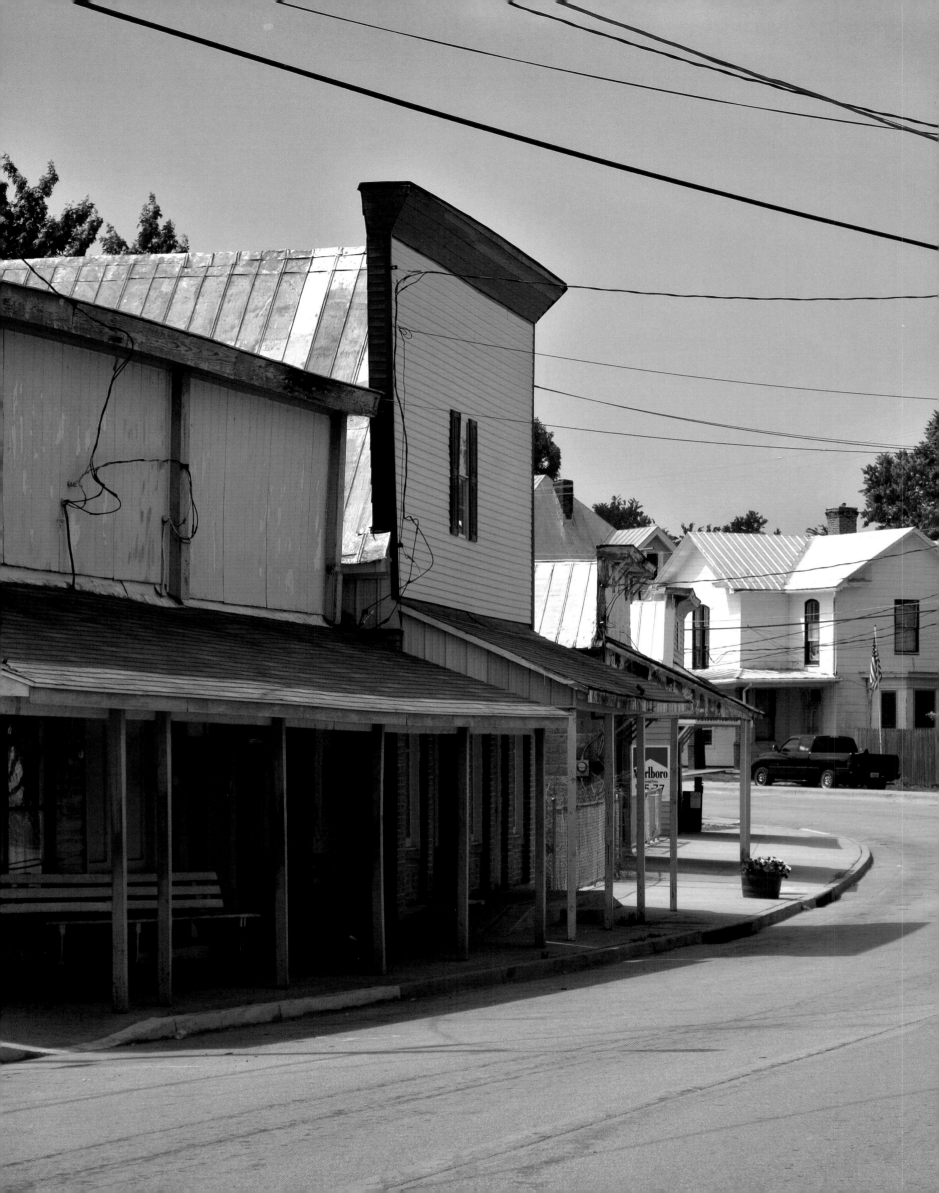

▲ GATES AT ASHFORD STUD, WOODFORD COUNTY These old stone pillars frame the main entrance to Ashford Stud along the Versailles-Frankfort Pike. They are emblematic of Kentucky's historic leadership in the breeding and raising of race horses. As early as the 1790s, good breeding stock was being brought into the state's fertile Bluegrass Region. ➤ ROUND BARN, RED MILE TROTTING TRACK, LEXINGTON Constructed in 1880, this three-story octagonal building stands at the entrance to and is symbolic of the Red Mile. Originally built to display floral exhibits, the Round Barn, as it came to be called, was converted and used as a stable for many years. For almost a century, the Red Mile has been on the Grand Circuit with the annual Kentucky Futurity, part of harness racing's Triple Crown.

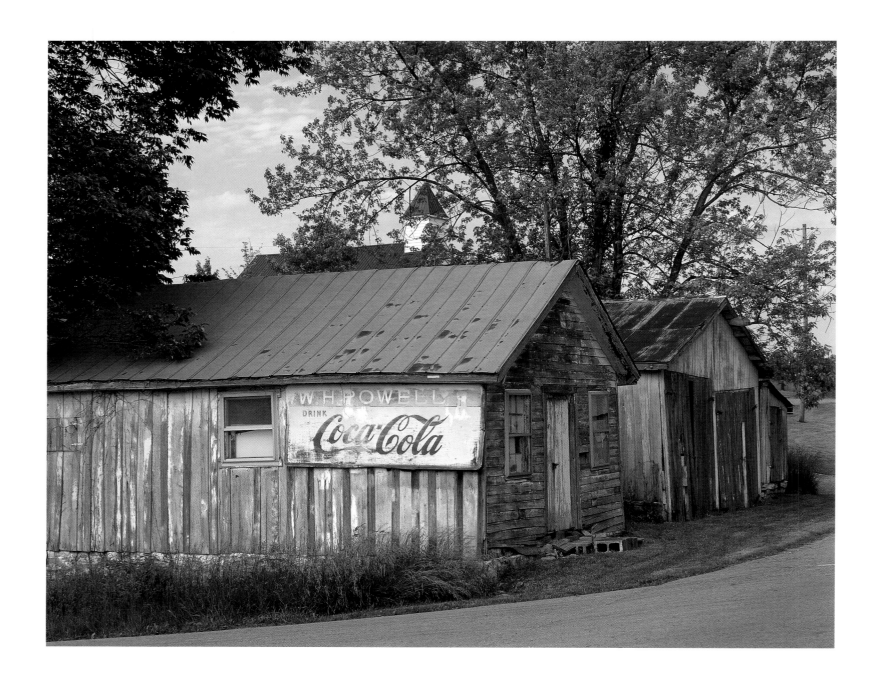

BUILDINGS AT A CROSSROAD, WEST-CENTRAL KENTUCKY

Old Kentucky can often be found at its thousands of rural crossroads. In small places like this, farmers were supplied and agrarian ways nurtured in country stores and churches. These isolated places are now forgotten by the old and cut off from the consciousness of the young. There is no returning to these times except through historical writing, art, and personal memoirs.

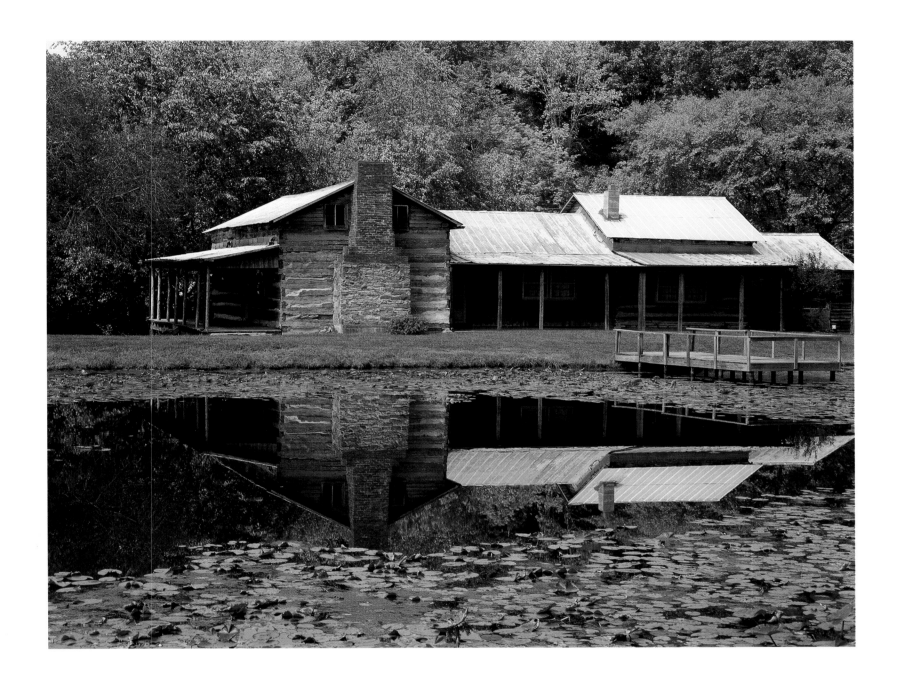

HOME OF AUTHOR JANICE HOLT GILES, ADAIR COUNTY

From 1945 until her death in 1979, author Janice Holt Giles wrote more than twenty-four books, primarily about the everyday lives of people struggling to make a living in the hard hills of south-central Kentucky. Giles and her husband, Henry, built this home in 1949 near the Green River, where she lived and wrote most of her stories and novels.

▲ PICKING OKRA, LA CENTRE, WEST KENTUCKY These men can already taste the fresh-cooked okra they will be having for dinner. Kentucky's climate provides nearly ideal growing conditions. Tens of thousands of rural Kentuckians depend on their gardens for food. Excess harvests are sold locally at farmers' markets and larger produce outlets. ► LOWER BLUE LICKS, NICHOLAS COUNTY In the shadow of an old general store, burley tobacco ripens along the plain of the Licking River in the hamlet of Lower Blue Licks in north-central Kentucky. The end of government price supports for tobacco has greatly diminished the growing of the crop, especially on small farms. Most tobacco is now sold on contract to big tobacco companies.

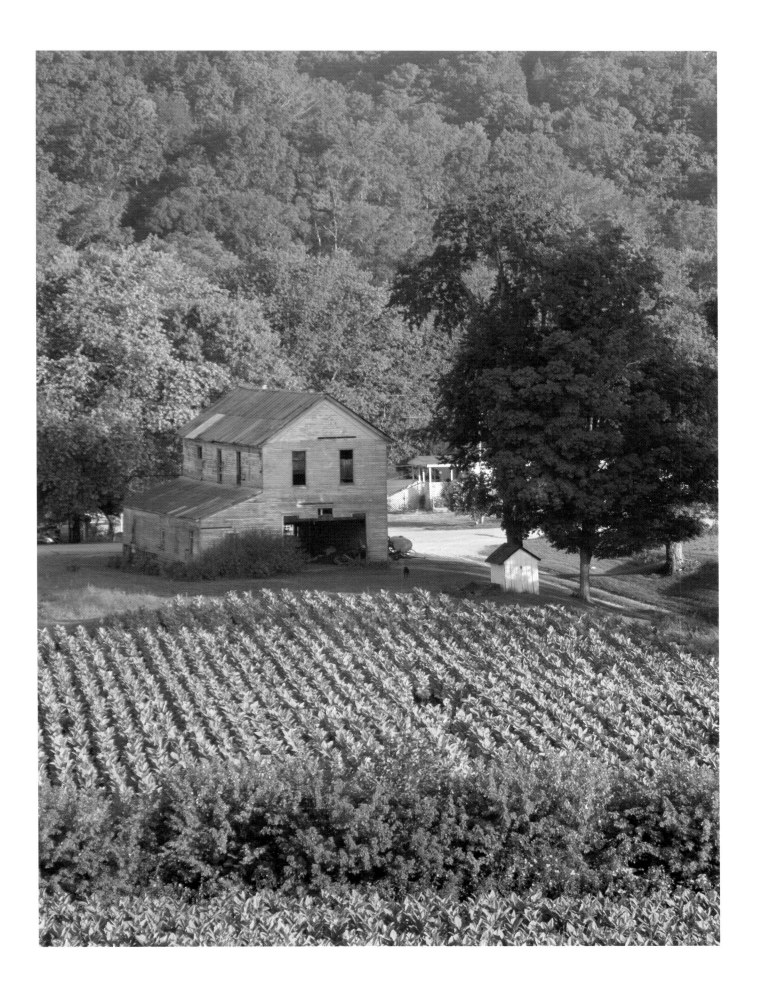

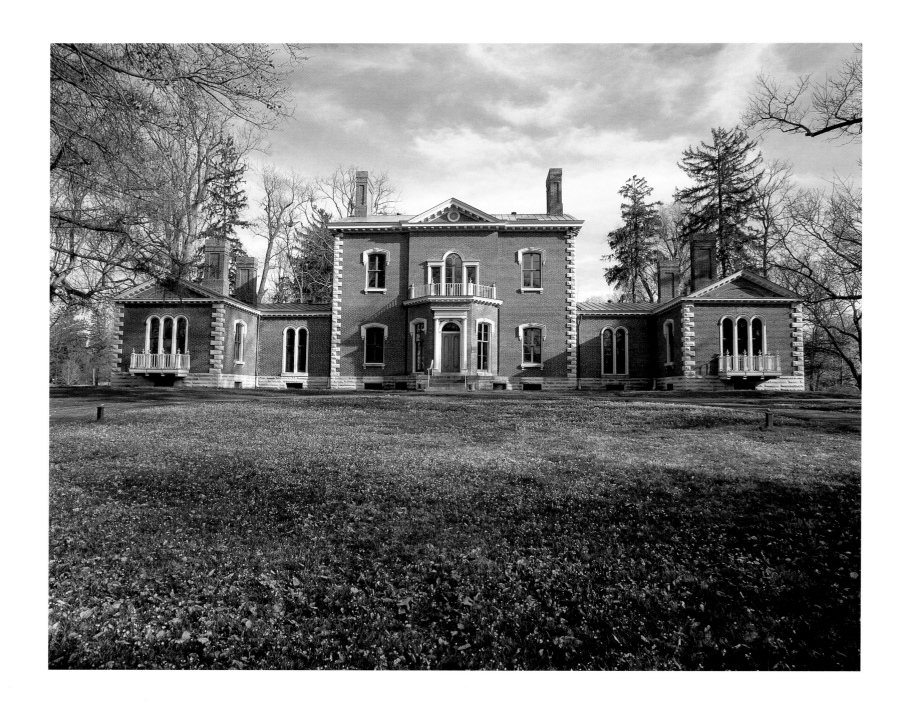

ASHLAND, THE ESTATE OF HENRY CLAY, LEXINGTON

Known as "The Great Compromiser," United States Senator Henry Clay was a national political giant in the early to mid-1800s. An influential statesman and great orator, Clay lost three times in his bid for the United States presidency. His estate covered several hundred acres just outside Lexington. Now restored on seventeen acres, Ashland welcomes visitors.

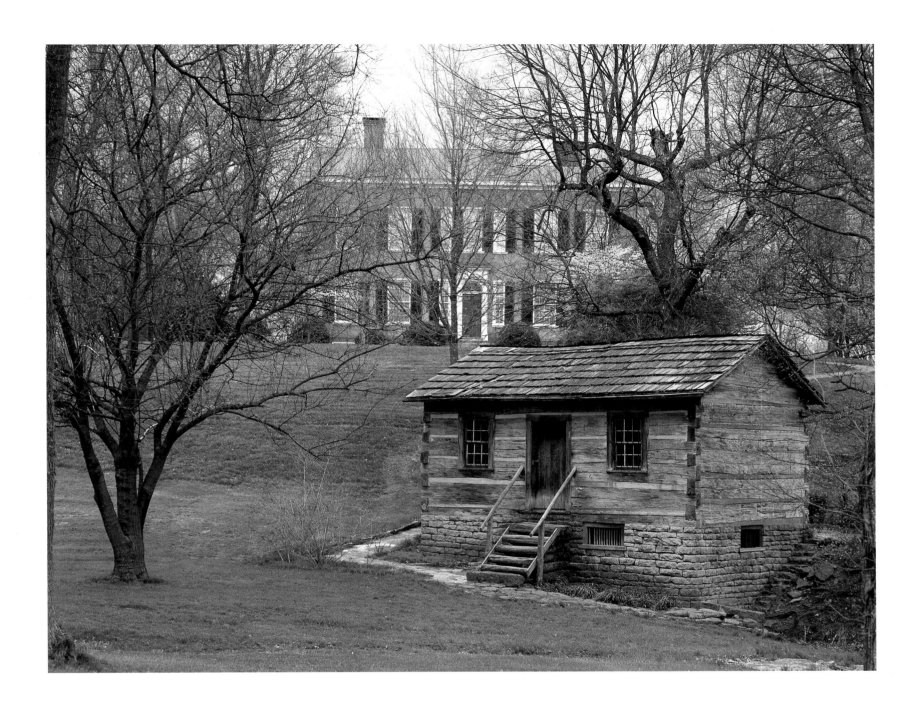

MY OLD KENTUCKY HOME, BARDSTOWN

The mansion named Federal Hill was built by attorney John Rowan around 1795. The house was made famous by Stephen Foster's 1853 song "My Old Kentucky Home, Good-Night." Whether Foster ever visited Federal Hill will always be debated. Whatever his inspiration, Foster's song was adopted as the official state song of the Commonwealth of Kentucky in 1928.

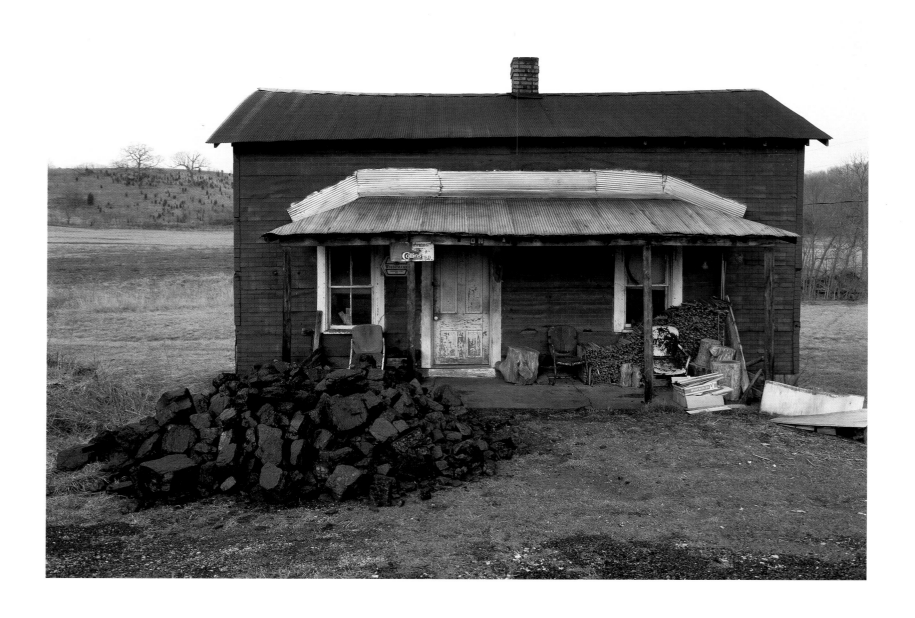

BASIC NECESSITIES, OWEN COUNTY, CIRCA 1984

Security in Kentucky's sometimes harsh winters means a pile of coal outside one's house. Just a few lumps will keep a small house like this warm for hours. Thousands of rural Kentuckians depend on coal for their heating.

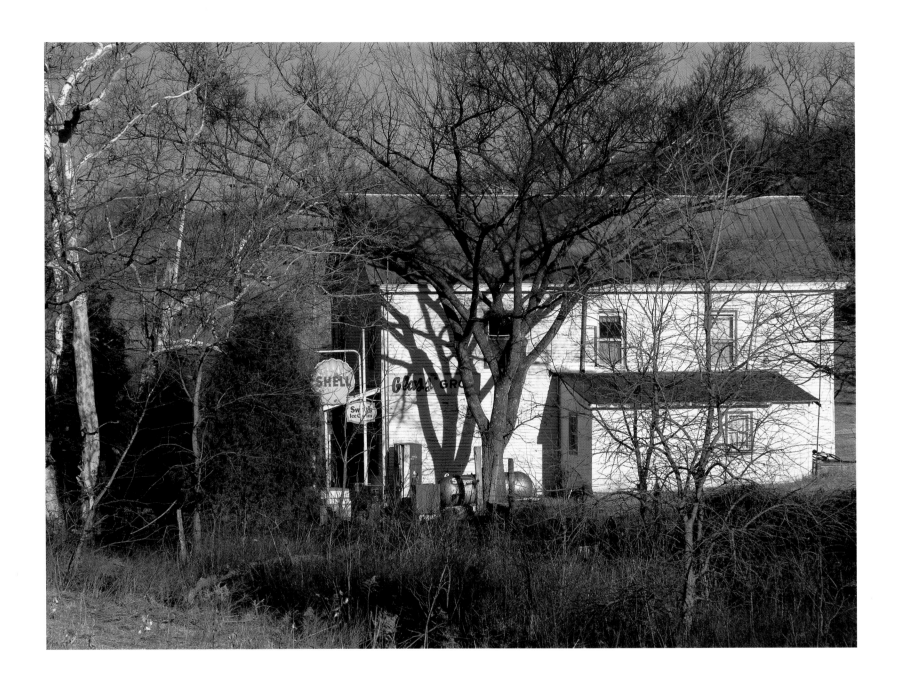

GLASS GROCERY, NORTHERN SCOTT COUNTY

Country stores served the immediate needs of a local rural population. Though they were once abundant throughout Kentucky, it is hard to find any stores that are still operating. Most, like the Glass Grocery, have closed, collapsed, or fallen into disrepair. This photograph was taken around 1981.

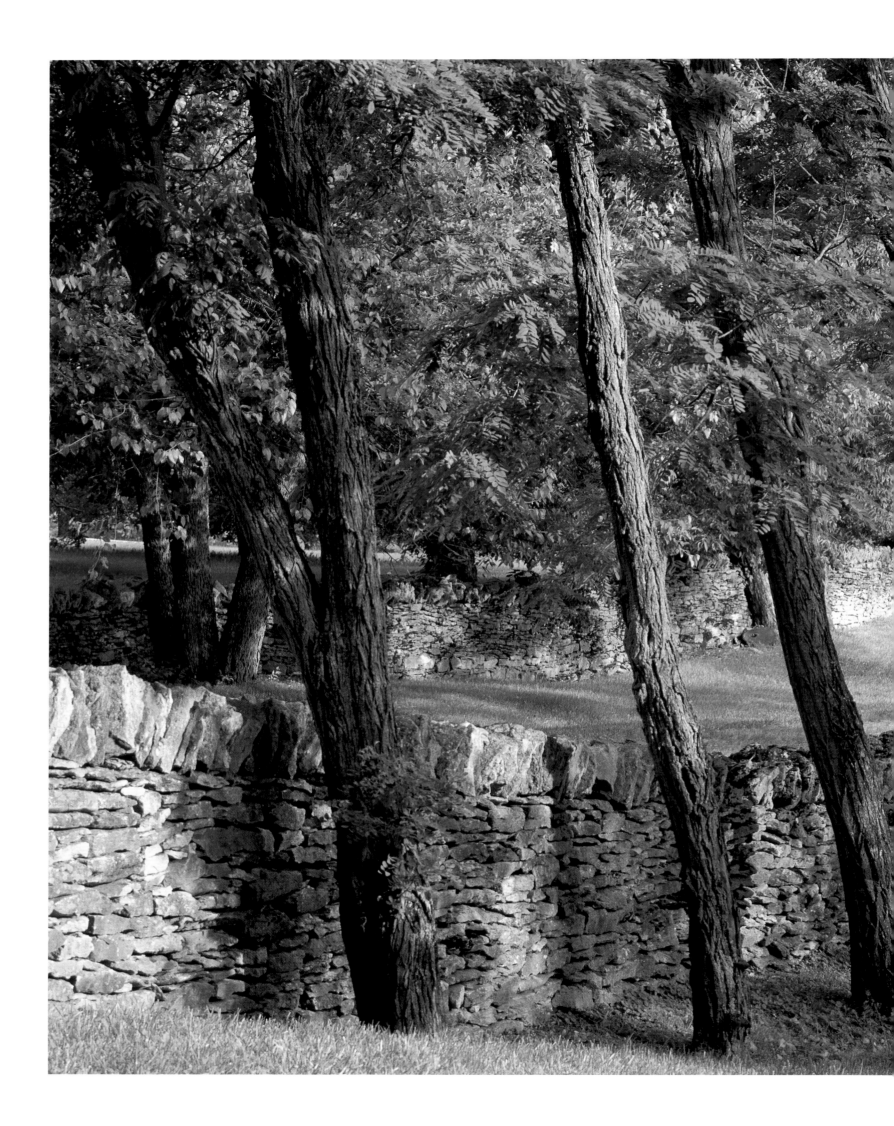

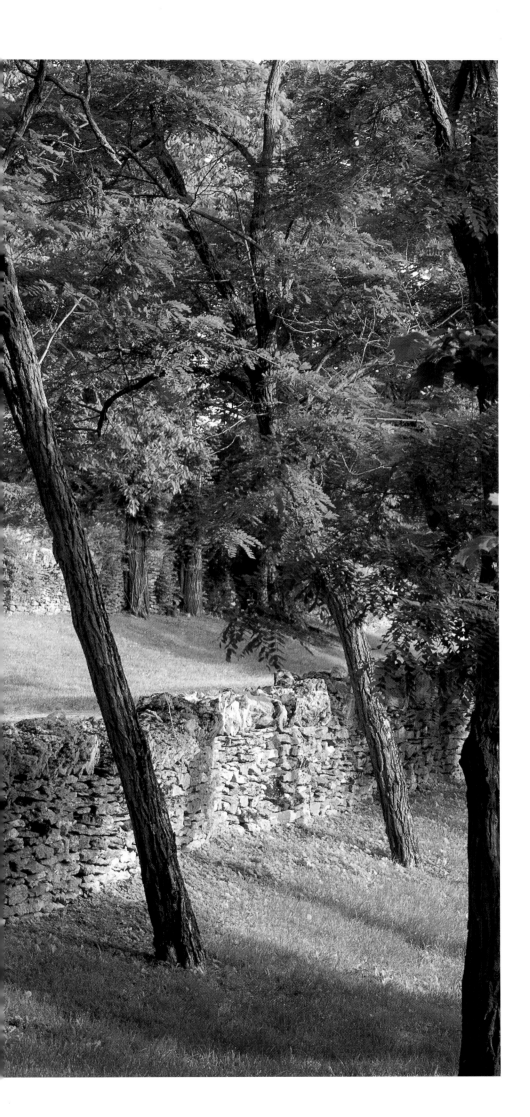

LIMESTONE FENCES, MERCER COUNTY

Kentucky's stone fences are cherished by its citizens and admired by visitors. Thousands of miles of these rock walls separate farm pastures and line rural roads and byways. Perhaps as much as horses and bluegrass, they have become an icon, holding fast in one's memory when one thinks of Kentucky. Much of the state's landscapes and stone fences are likened to those in Ireland and England.

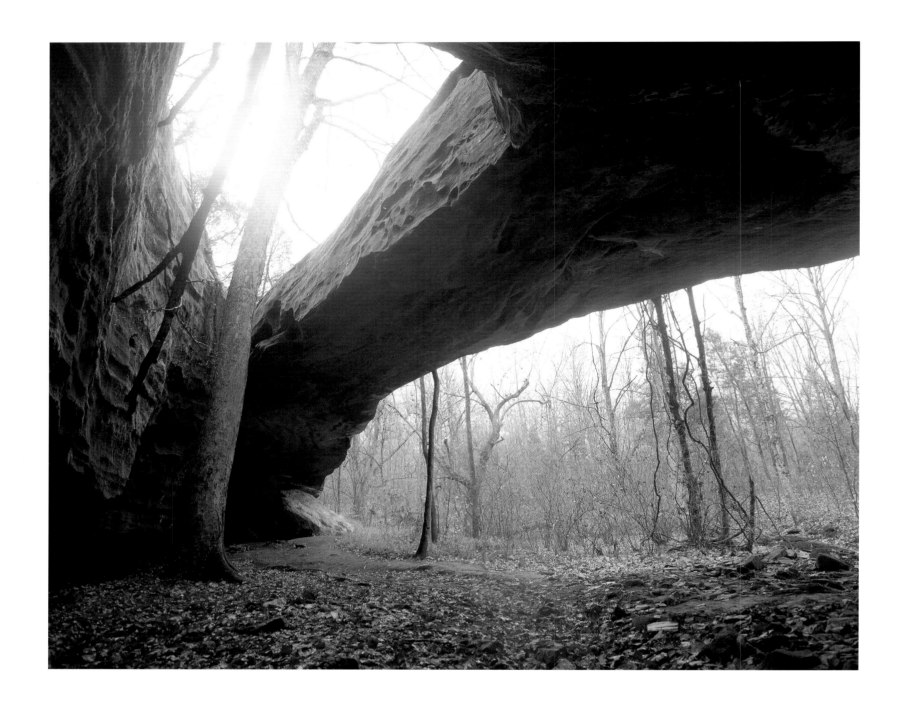

TRAIL OF TEARS, MANTLE ROCK, CRITTENDEN COUNTY

Beneath this arch and in other surrounding natural rock caves and shelters, thousands of Cherokee men, women, and children camped under the watchful eye of federal troops in the winter of 1838. The Cherokees were forcibly uprooted from their ancestral homes in the mountains of North Carolina and Georgia and made to march to a reservation in Oklahoma, a thousand miles away. The forced removal resulted in many deaths from disease, fatigue, and exposure.

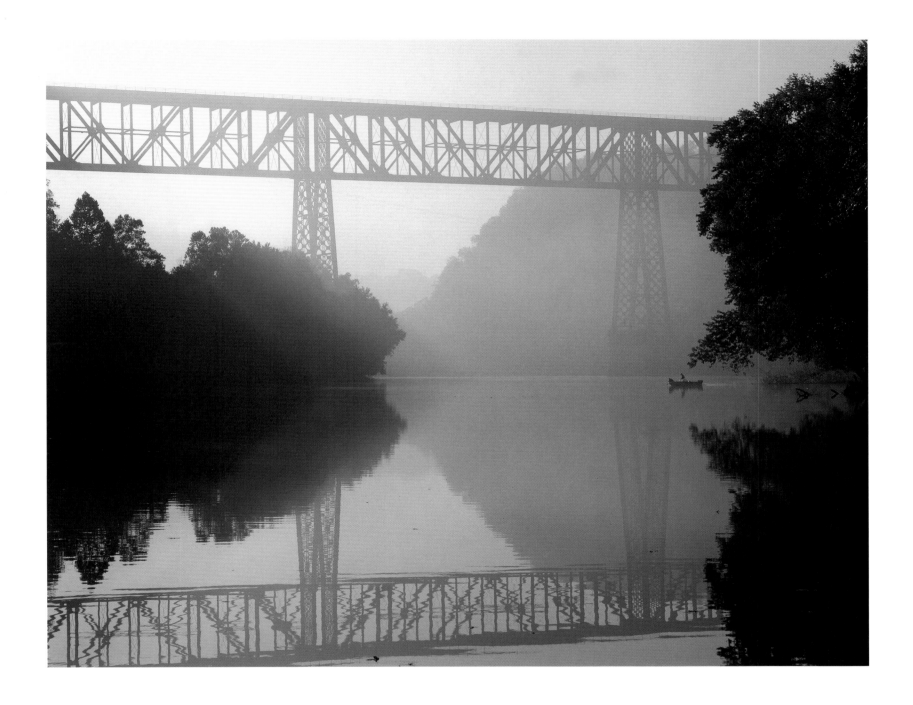

HIGH BRIDGE, JESSAMINE-MERCER COUNTIES

Completed in 1877 and rebuilt in 1911, this 275-foot-tall High Bridge spans the gorge of the Kentucky River near its confluence with the Dix River. At the time of its construction, it was the highest railroad bridge in the world. The structure is over 1,000 feet long and was dedicated by President Rutherford B. Hayes. It still carries trains several times a day. In the early twentieth century, the bridge site was a social gathering place for people in Jessamine County.

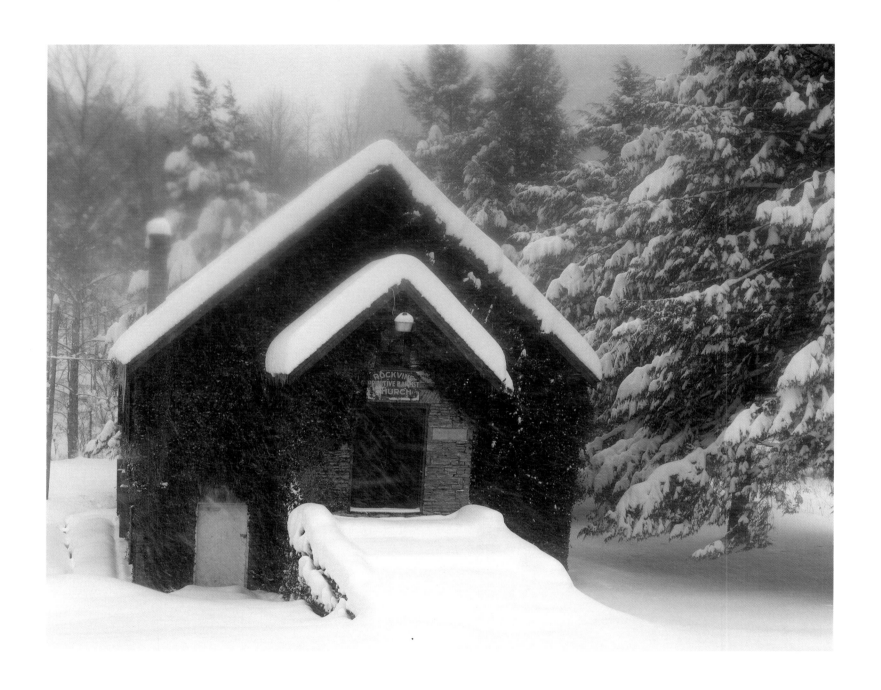

ROCKVINE PRIMITIVE BAPTIST CHURCH, LETCHER COUNTY

Like an illustration from *Grimm's Fairy Tales*, the Rockvine Primitive Baptist Church stands etched by a deep snow along the Cumberland River in the mountains of southeast Kentucky.

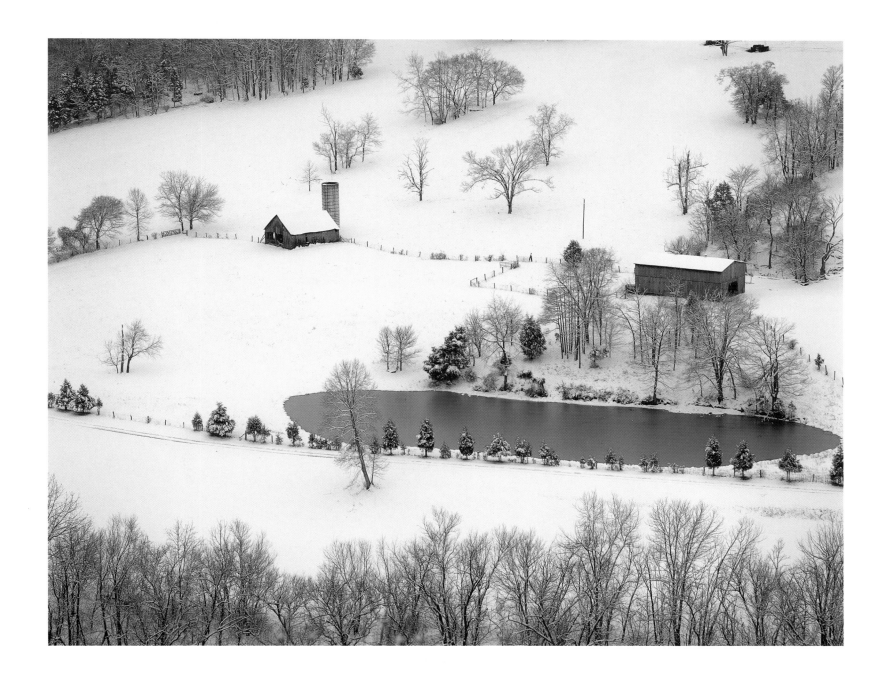

KENTUCKY RIVER FARM, MERCER COUNTY The Kentucky River's extensive system of tributaries drains a large part of the state's southeastern mountains. But the Kentucky's main influence lies in its journey through the heart of the Bluegrass Region, the destination of early settlers. Hundreds of small farms along the river form a link between the state's past and the ever-changing present.

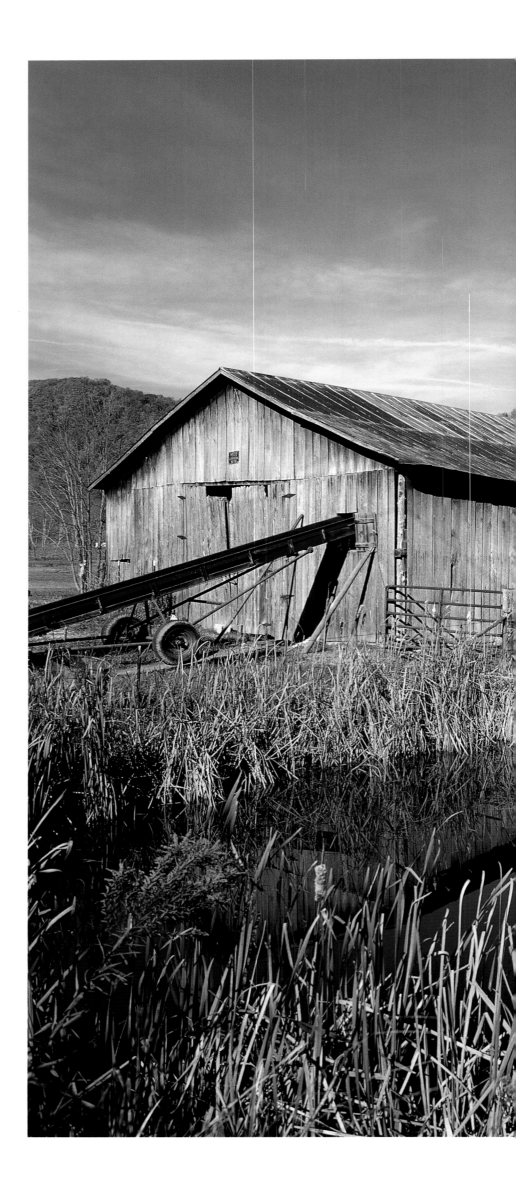

MOUNTAIN BARNS, ESTILL COUNTY

These barns are still in use on a remote valley farm in the mountains of Estill County. As in pioneer times, corn and hay are the main crops, with pastures devoted to cattle and smaller lots for sheep or hogs. For these farmers of east-central Kentucky, it is a hard but simple life, away from the demands of modern-day civilization.

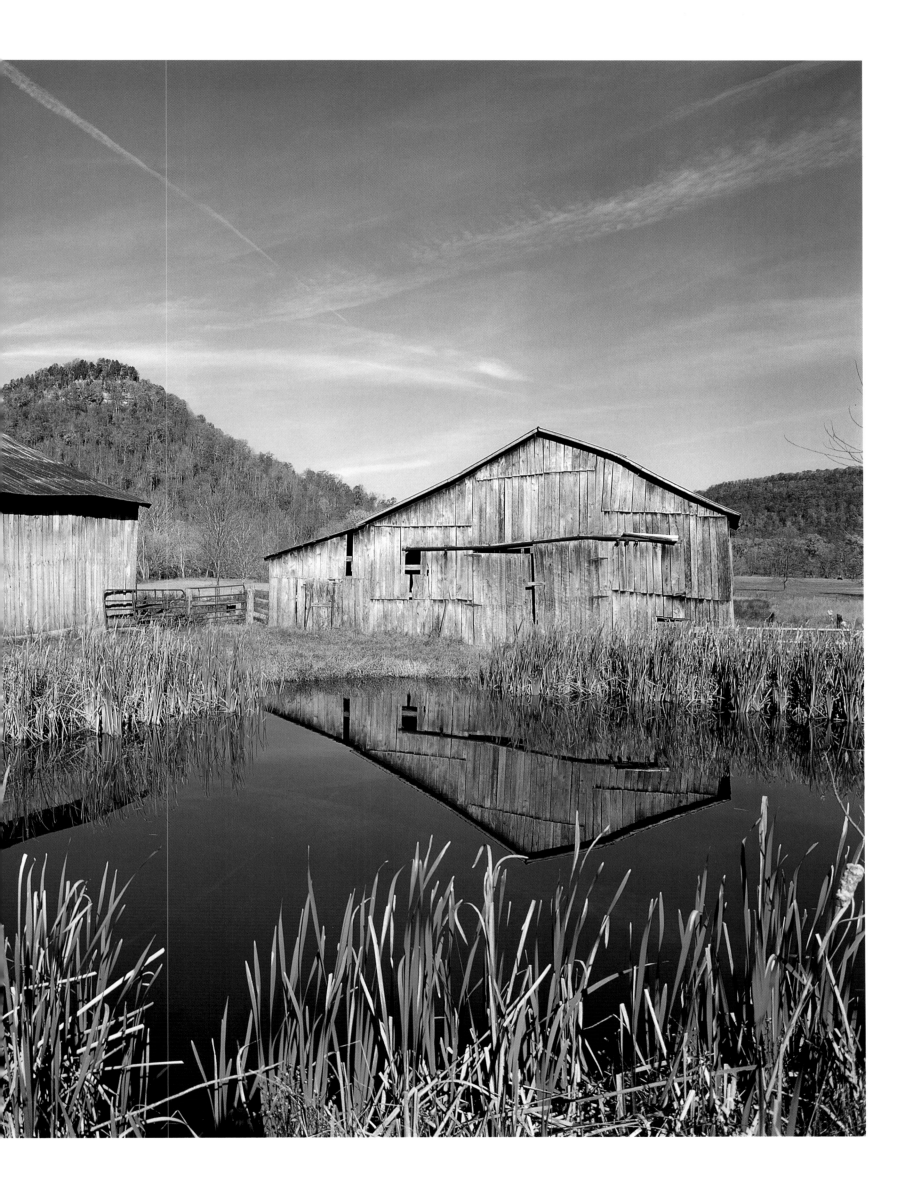

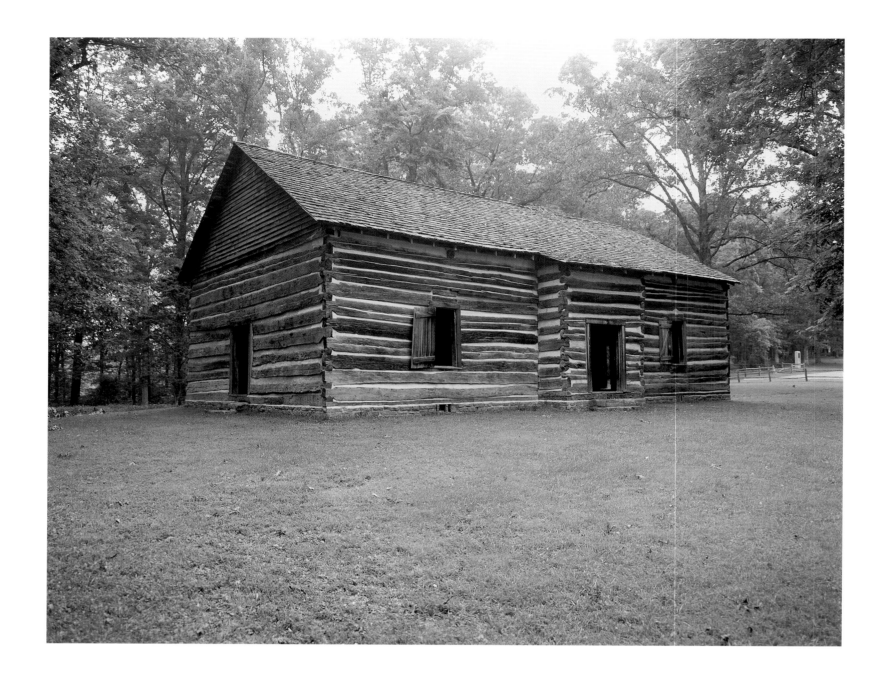

OLD MULKEY MEETINGHOUSE, MONROE COUNTY

Founded in the 1790s as a Baptist congregation, the meetinghouse was built in 1804 and was called the Mill Creek Church. It was seldom used after the Civil War. The building was restored in 1925 and is now a state historic site. Daniel Boone's sister Hannah is buried in the graveyard.

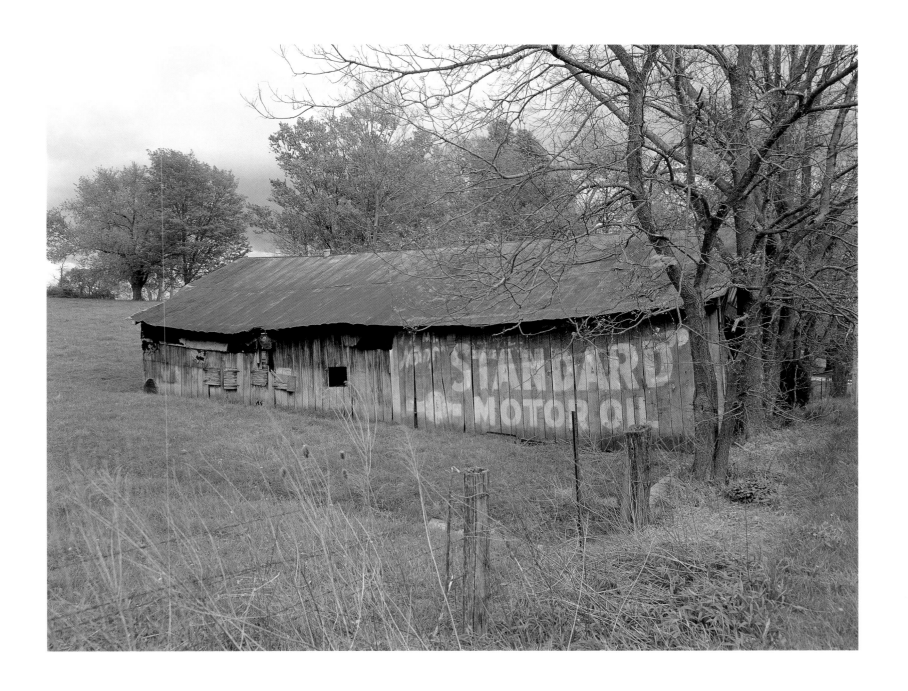

BARN ART, OLD U.S. 25, MADISON COUNTY

In the days before modern convenience stores, gasoline stations were few and far between. For decades, two-lane U.S. 25 was the main north-south route through Kentucky. This sign advertises the next Standard Oil filling station. Old U.S. 25 roughly follows the original path of the Wilderness Road, blazed by early pioneers pouring through the Cumberland Gap.

STONE SILO, NORTH-CENTRAL BLUEGRASS

Early Kentucky settlers used the abundance of local fieldstone to build the thousands of miles of stone walls that grace the Commonwealth. They also used stone to build small outbuildings such as springhouses and storage sheds. This round stone silo is rare and probably quite old. The photograph was taken in about 2000, but notes on its exact location are lost.

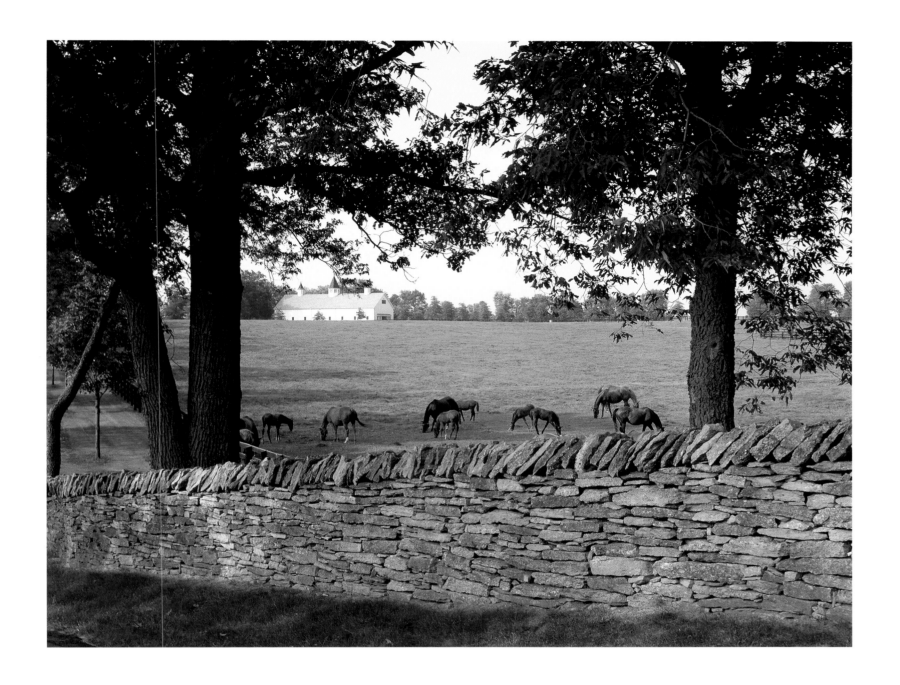

THOROUGHBREDS AND STONE FENCE, FAYETTE COUNTY

Thoroughbred mares and foals graze in an early summer pasture bordered by a limestone fence along North Yarnallton Pike in Fayette County. Owing to the natural abundance of limestone, thousands of miles of stone walls have been laid since early settlement. These fences crisscross the Bluegrass Region and are perhaps the most commonly recognized symbol of its heritage.

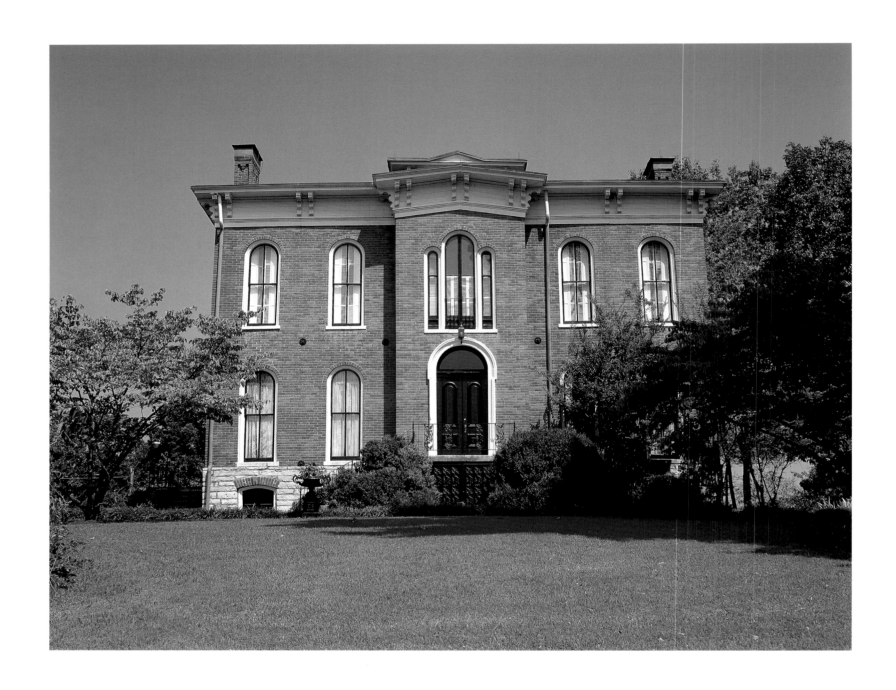

RIVERVIEW AT HOBSON GROVE, BOWLING GREEN

This restored Italianate house museum is located on a rise overlooking the Barren River in Warren County. Interpretive tours highlight the Victorian period and provide insight into the domestic life of African American servants at the time. The home is a stop on the Civil War Discovery Trail.

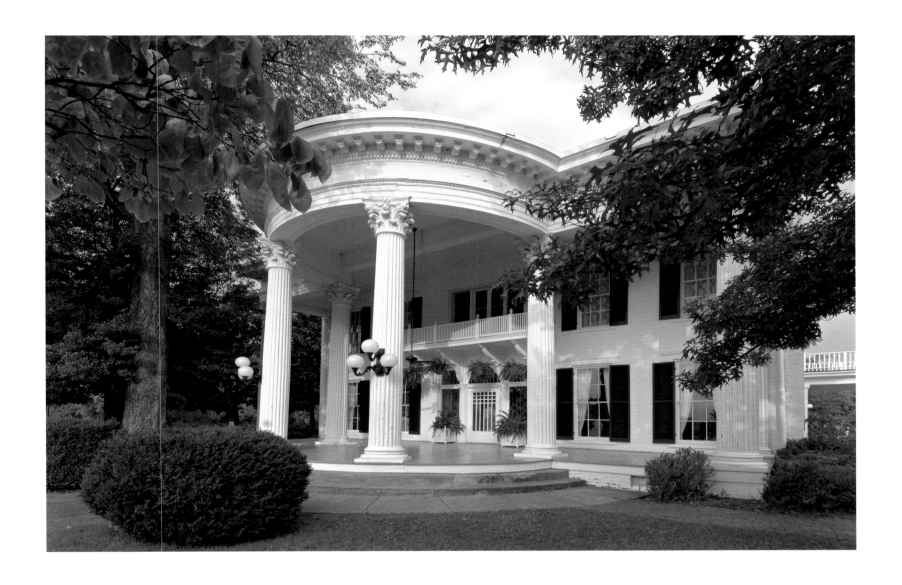

WHITEHAVEN, McCRACKEN COUNTY

The original home was built in 1866 by Edward L. Anderson on land just outside Paducah. Sold by Anderson's heirs in 1903, the house was extensively remodeled in the colonial revival style, including the semicircular Corinthian portico. The Smith family purchased the house in 1908 and renamed it Come Rest A While. The Commonwealth of Kentucky eventually bought and restored the mansion, which was opened to the public in 1983 as the Whitehaven Tourist Welcome Center.

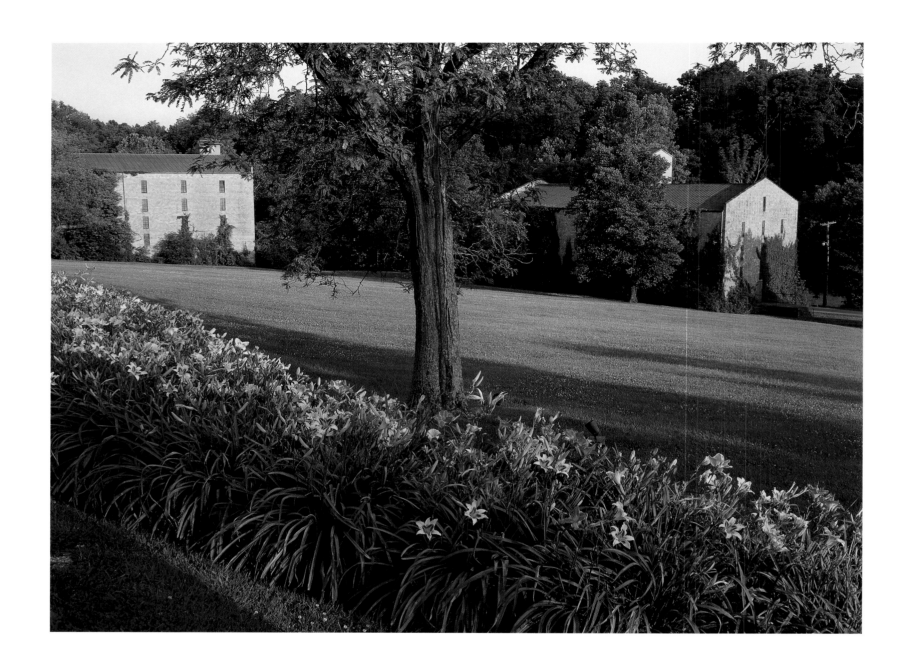

WOODFORD RESERVE DISTILLERY, WOODFORD COUNTY

Formerly known as the Labrot and Graham Distillery, these brick buildings date to 1812 and
have been placed on the Kentucky Registry of National Historic Landmarks. Woodford Reserve
still produces bourbon whiskey on this site along McCracken Pike in Woodford County.

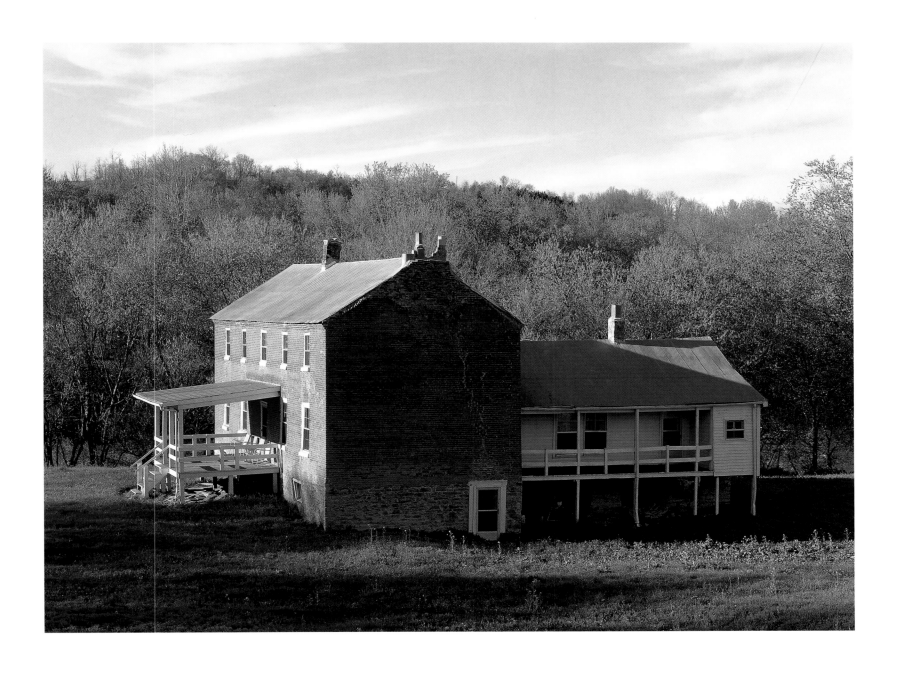

FARMHOUSE ALONG THE LICKING RIVER

Possibly dating to the early 1800s, this brick house anchored a farm along the Licking River in the area of Bath and Fleming counties in north-central Kentucky. Over the years, this old homestead has been well cared for and is in a remarkable state of preservation. Lacking even rudimentary maintenance, hundreds of similar houses across the Commonwealth have crumbled from neglect.

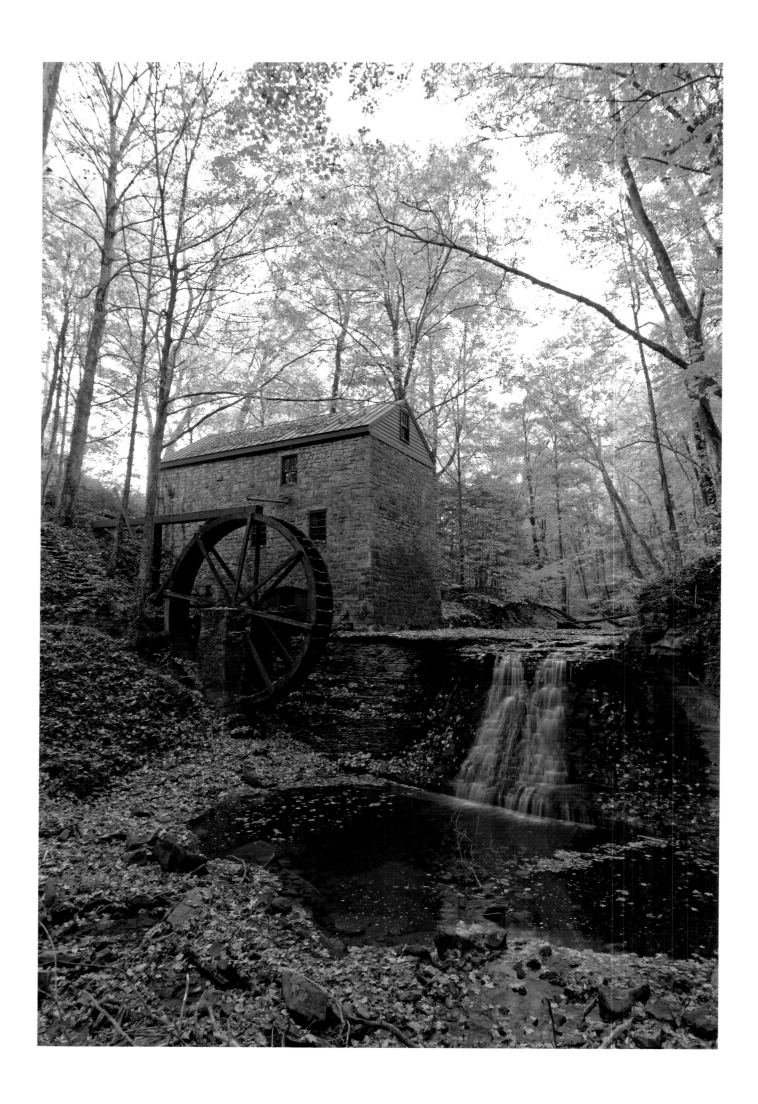

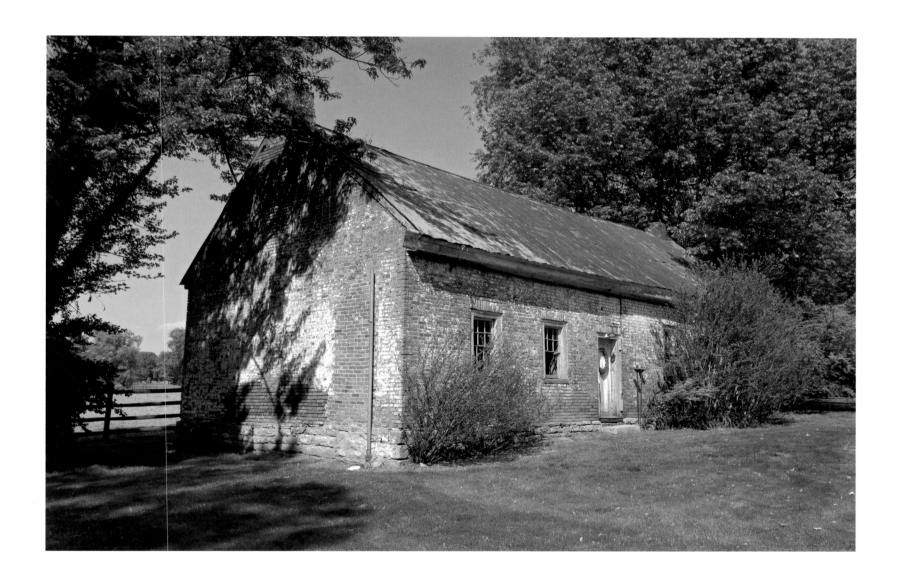

◄ MILL ON WOLF PEN BRANCH, JEFFERSON COUNTY Standing on private property in eastern Jefferson County, the old mill on Wolf Pen Branch has been carefully and lovingly restored. It is arguably the finest example of an early nineteenth-century gristmill in Kentucky. Through private donations, grants, and the dedicated work of many people, the mill stands at the head of a conservation/preservation easement that will perpetuate its existence and the surrounding area for all time.

▲ ESTATE OF ISAAC SHELBY, FIRST KENTUCKY GOVERNOR, LINCOLN COUNTY Kentucky's first governor (1792–96), Isaac Shelby, was a Revolutionary War hero. During his second term as governor (1814–16), Shelby fought against the British in the War of 1812. He built his estate, called Travelers Rest, on land given to him for his service in the Revolution. The building pictured housed Shelby's kitchen and slave quarters just outside the main residence.

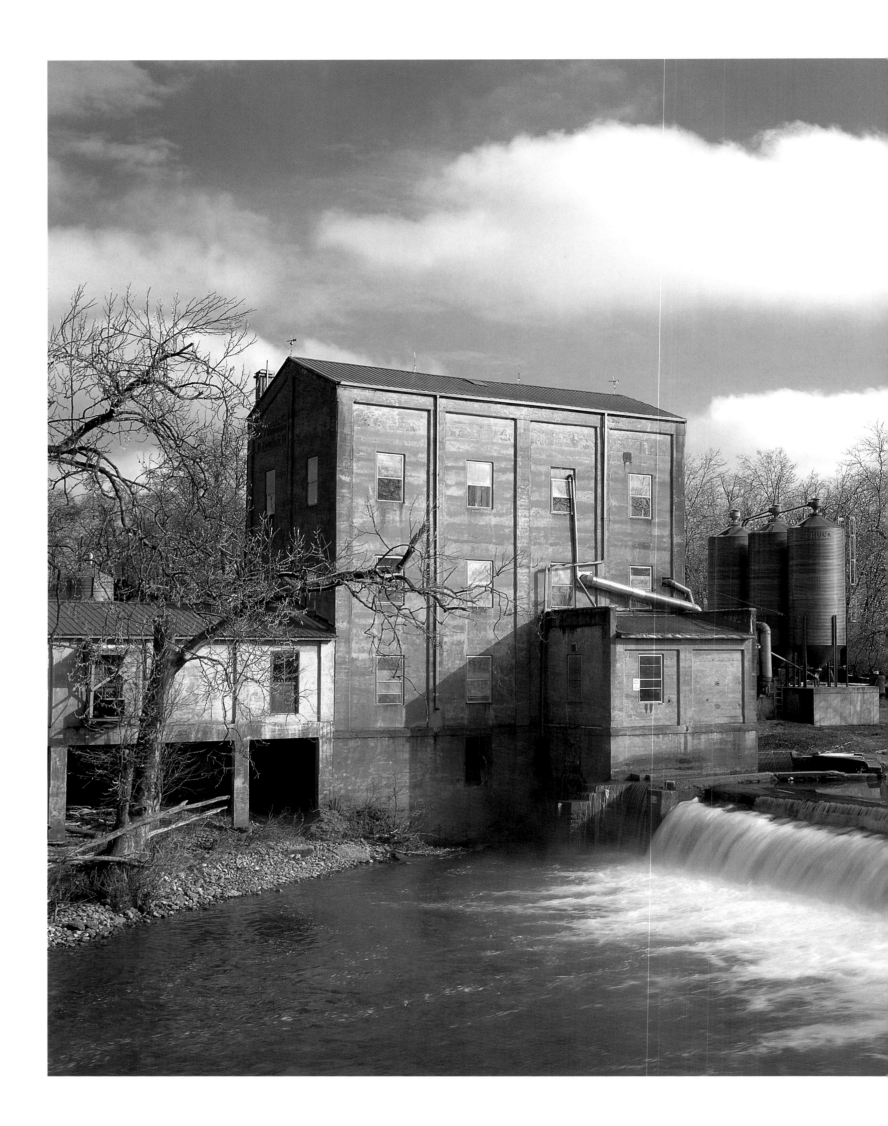

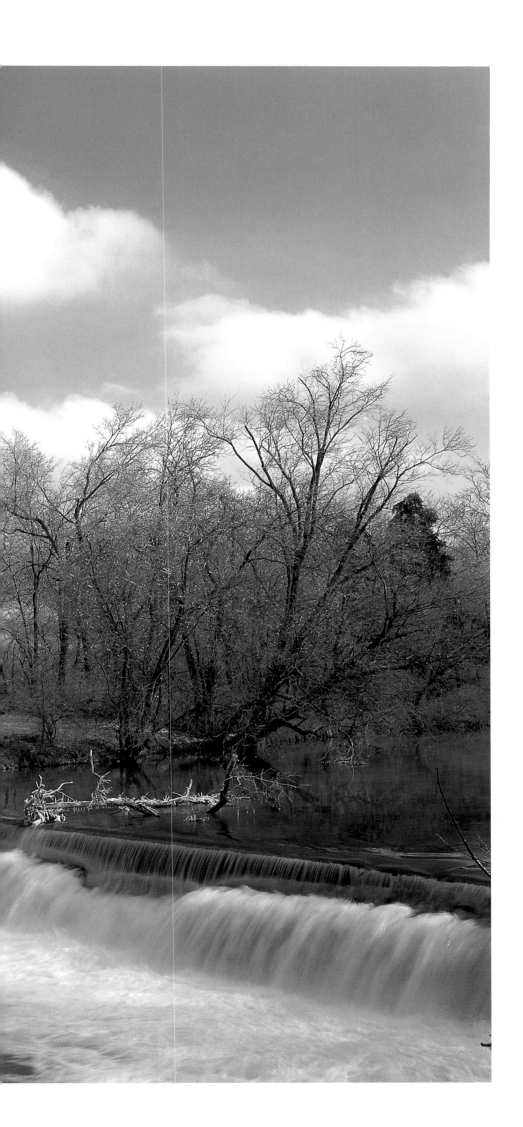

WEISENBERGER MILL ALONG SOUTH
ELKHORN CREEK The waters of South Elkhorn
Creek power the twin turbines of the Weisenberger
Mill in southern Scott County. The Weisenberger
family emigrated from Germany in 1862 and
purchased this existing mill in 1865. It is one of a
handful of small, family owned and operated mills
left in the state. The mill produces a variety of flour,
cornmeal, and other baking needs. Streams like the
South Elkhorn have powered Kentucky mills since
early settlement.

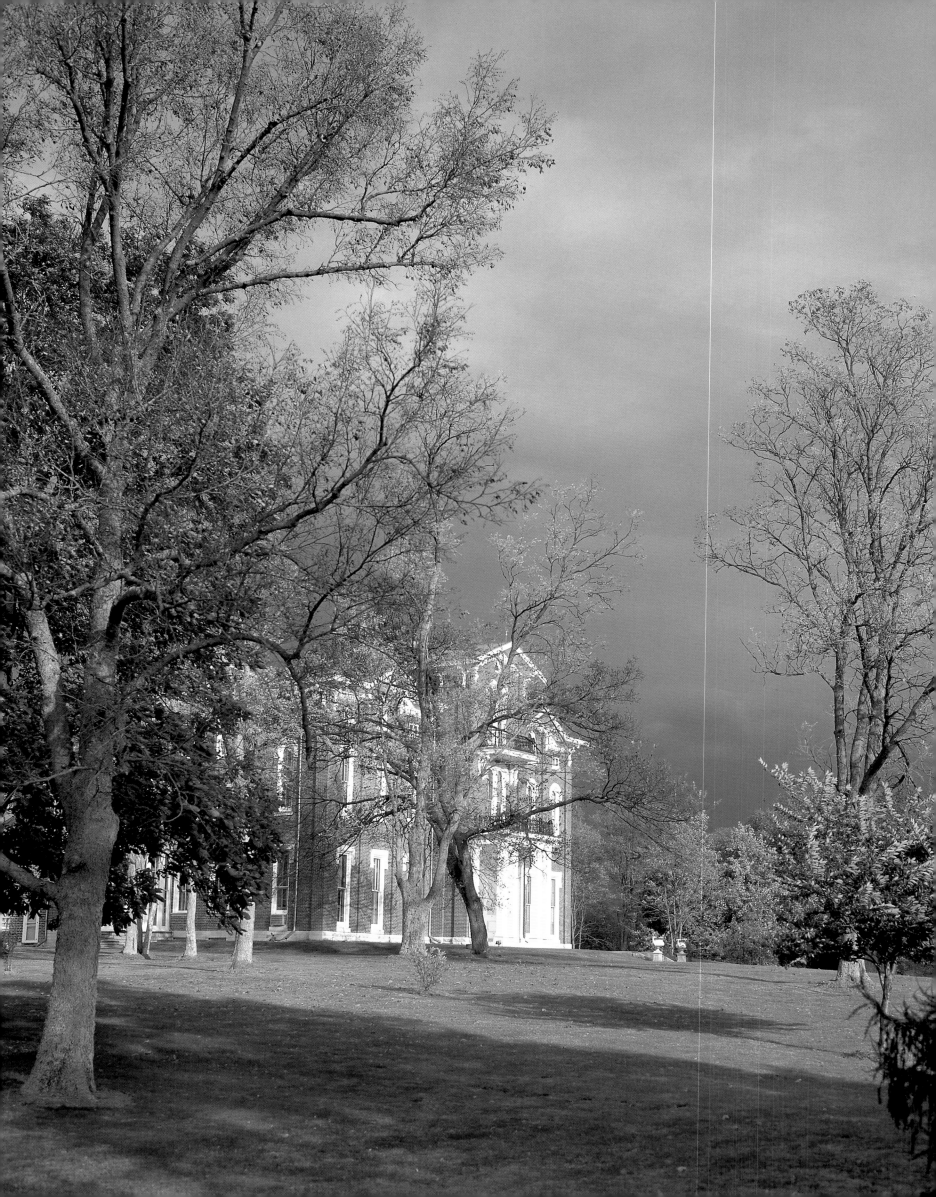

◄ WHITE HALL STATE HISTORIC SITE White Hall was the Madison County home of antislavery activist and diplomat Cassius Marcellus Clay (1810–1903). Clay published an antislavery newspaper; his outspoken opinions sometimes led to violence and to threats on his life. He was instrumental in encouraging Abraham Lincoln to issue the Emancipation Proclamation in January 1863. ▲ THOMAS HUNT MORGAN HOUSE, LEXINGTON Thomas Hunt Morgan was born in 1866 and spent his childhood in this house near downtown Lexington. He would become a giant in the biological sciences and genetics, following in the footsteps of Mendel and Darwin. Morgan won the Nobel Prize for medicine in 1933 and was honored throughout his life with prestigious honors and awards, including coveted medals from England's Royal Society. He died in 1945, having spent the last twenty years of his life leading biological research at the California Institute of Technology.

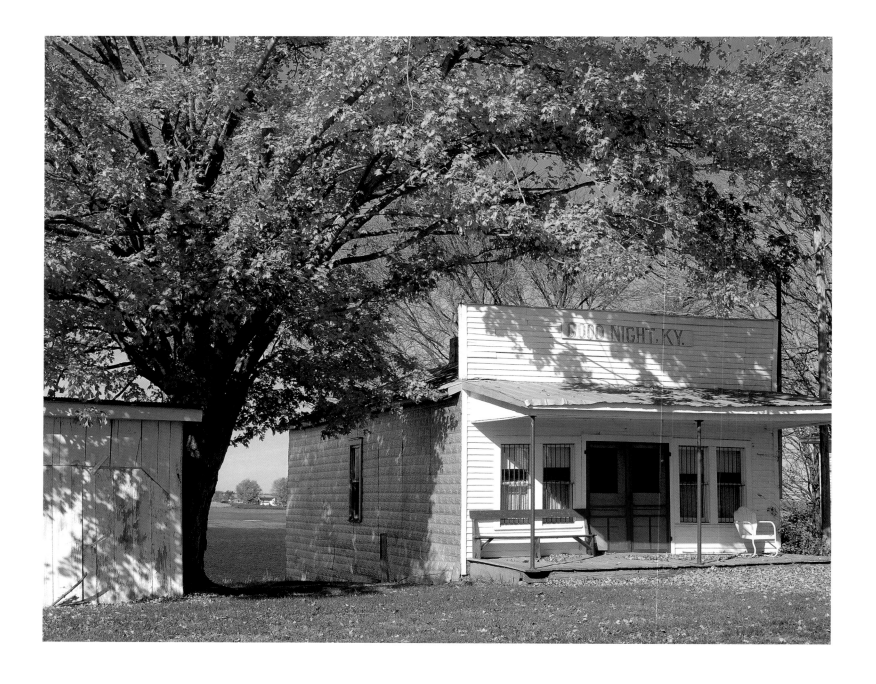

GOODNIGHT, KENTUCKY, BARREN COUNTY

This store in the village of Goodnight, just off U.S. 31E, has long since sold its last piece of hard candy and sack of flour. The building still stands and is maintained for posterity by the surviving owners.

▲ ESTILL COUNTY FARMSTEAD Located in the Appalachian foothills of east-central Kentucky, Estill County is steeped in pioneer history. In 1769, Daniel Boone, John Finley, and a few other frontiersmen camped along Station Camp Creek. From there they explored the country to the north, where they first viewed the rich land of the Bluegrass plateau. This farmhouse with its old well probably dates from 1900.

► SWITZER COVERED BRIDGE, FRANKLIN COUNTY Built by George Hockensmith in 1855, Franklin County's only covered bridge spans North Elkhorn Creek northeast of Frankfort. The bridge, 11 feet wide and 120 feet long, has been restored twice, once in 1906, and again in the late 1990s after devastating floods. It has been closed to traffic since 1954.

▲ IROQUOIS HUNT CLUB, FAYETTE COUNTY The Iroquois Hunt Club is at the center of fox and hound hunting in the rugged hill country of eastern Fayette and western Clark counties in Kentucky's Bluegrass Region. Hundreds of riders and their mounts converge on the club grounds in October for the annual Blessing of the Hounds and the official beginning of hunt season. The club is built along Boone Creek, one of central Kentucky's most beautiful streams. ► HARRIET BEECHER STOWE HOUSE, MASON COUNTY In 1833, novelist Harriet Beecher Stowe stayed in this house in the town of Washington (near Maysville) and observed slavery firsthand. This experience and other influences encouraged her to write the antislavery book *Uncle Tom's Cabin* in 1852. Within a year it had sold over three hundred thousand copies in the United States, second in sales only to the Bible. At a meeting at the White House with President Abraham Lincoln during the Civil War, Lincoln greeted Stowe, "So you're the little woman who wrote the book that started this great war!"

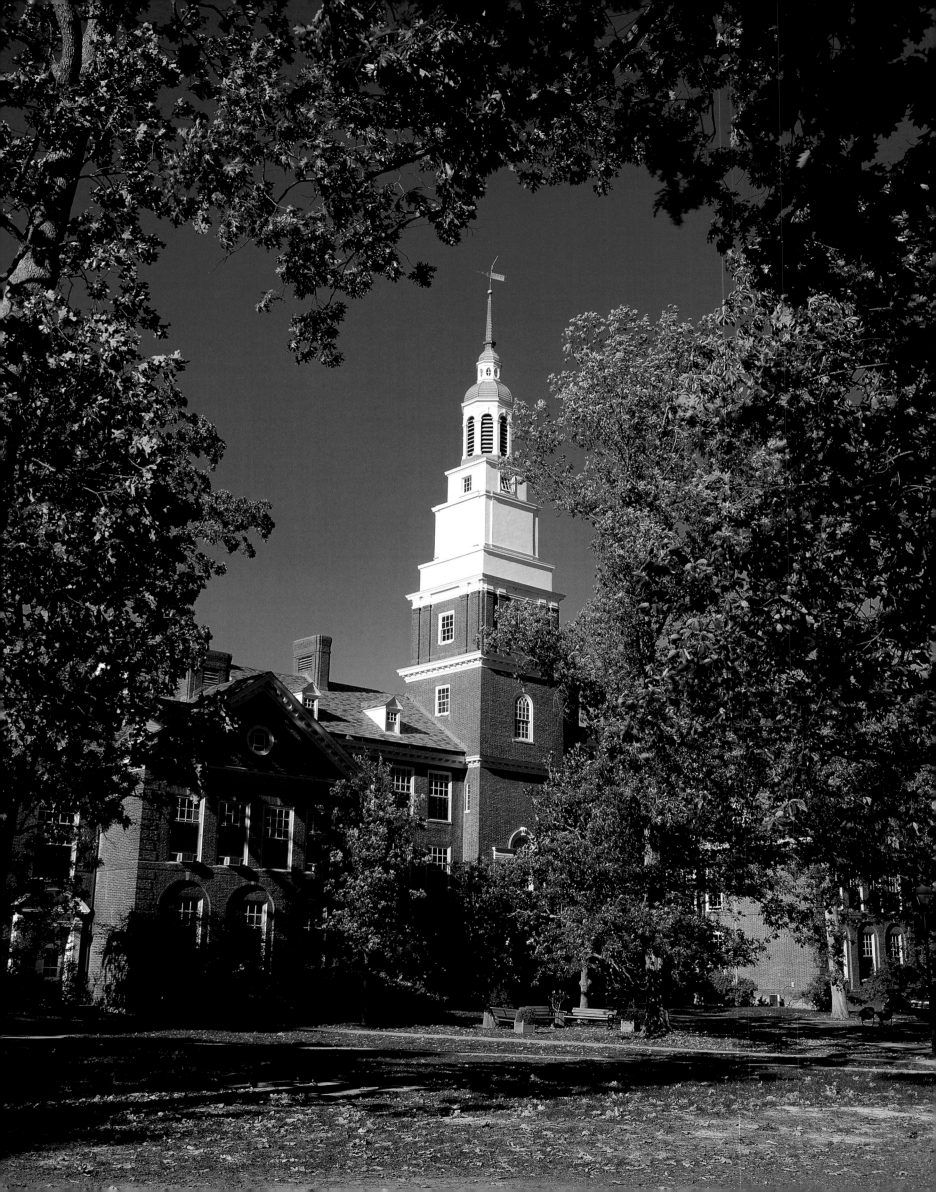

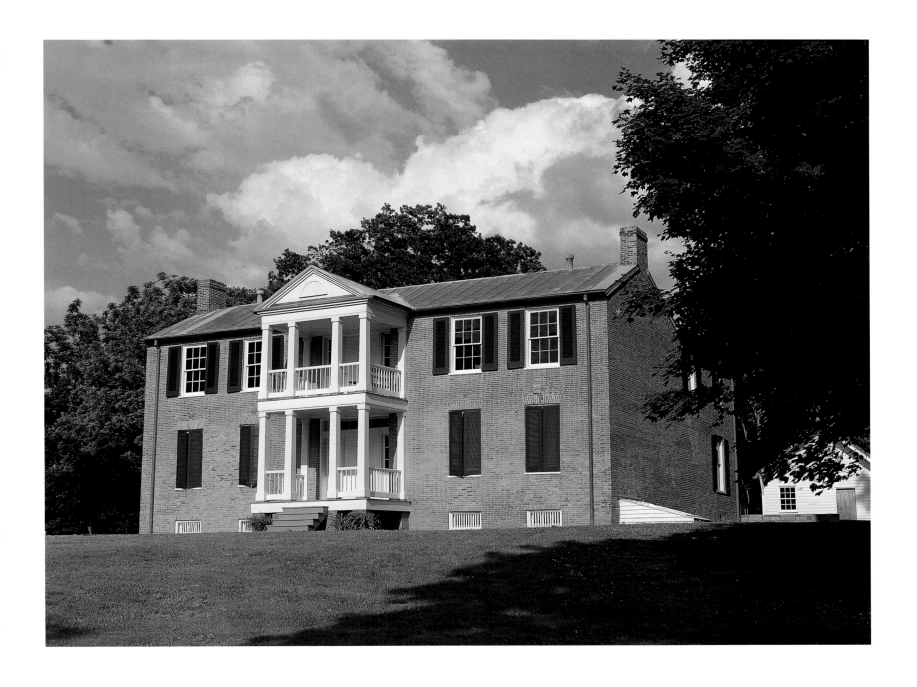

◄ BEREA COLLEGE, MADISON COUNTY Berea College opened in 1866 as an independent, nonsectarian Christian school, founded to provide education to former slaves and to children of the poor of Appalachia. During its 150 years of existence, the percentages of black and white student enrollment have varied with the times, but the basic founding principle of educating the poor has remained. Today, Berea College is acclaimed not only for its highly integrated student body, but also as a center for the preservation of traditional mountain crafts and culture. ▲ RIVERSIDE, THE FARNSLEY-MOREMEN LANDING Located directly on the Ohio River in southwest Jefferson County, Riverside, the Farnsley-Moremen Landing consists of this house (restored in 1989) and three hundred acres. Dating to the early nineteenth century, the original farm was one of the most prosperous in the area. Between 1820 and 1890, the farm operated a boat landing on the Ohio River, then a major American highway, to trade goods and to provide a rest stop for travelers. The historic house and grounds are open to visitors.

VALLEY OF THE ROLLING FORK RIVER, MARION COUNTY

In a state full of beautiful views, there is not one more stunning than that of the valley of the Rolling Fork River in western Marion County. The ridge rises several hundred feet above the valley floor to an overlook, which affords spectacular views in all seasons. On a good day, one can see for perhaps twenty-five miles eastward and clearly make out structures in the city of Lebanon, eight miles away. Here, in late afternoon, a field of winter wheat lies in the shadow of the ridge.

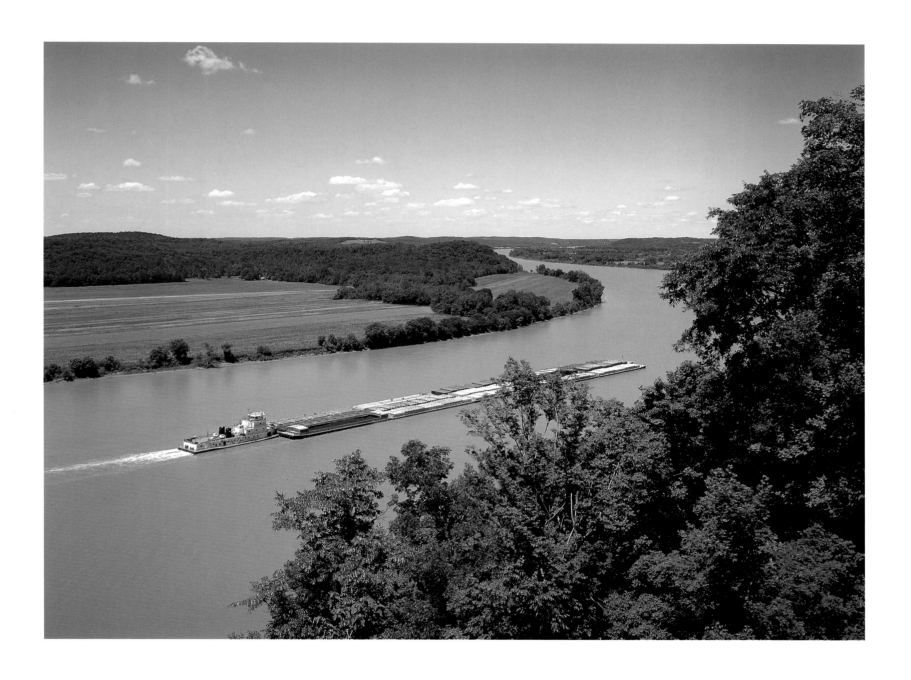

OHIO RIVER NEAR OWENSBORO

On a summer Sunday morning, this container barge made its way slowly (five miles per hour) up the placid Ohio River to Pittsburgh. Contrast this with the untamed Ohio River of three hundred years ago, when native people had the river to themselves. They fished and hunted along its banks and transported goods in canoes and dugouts. The early settlers (from 1775 to 1810) contended with the same untamed river, full of tree snags, boulders, gravel bars, and rapids. From western Pennsylvania they came in thousands of flatboats, carrying their families, livestock, and possessions, always subject to unpredictable water levels and Indian attacks.

STONE BRIDGE AT GLASS MILL, JESSAMINE
COUNTY Built in 1935, this bridge over Jessamine
Creek was a project of the federal government's work
programs during the Great Depression. The stone
span bears testimony to the skills of the English, Irish,
and Scots-Irish who first settled Kentucky. The bridge
resembles hundreds of older stone bridges found
throughout Ireland and Great Britain.

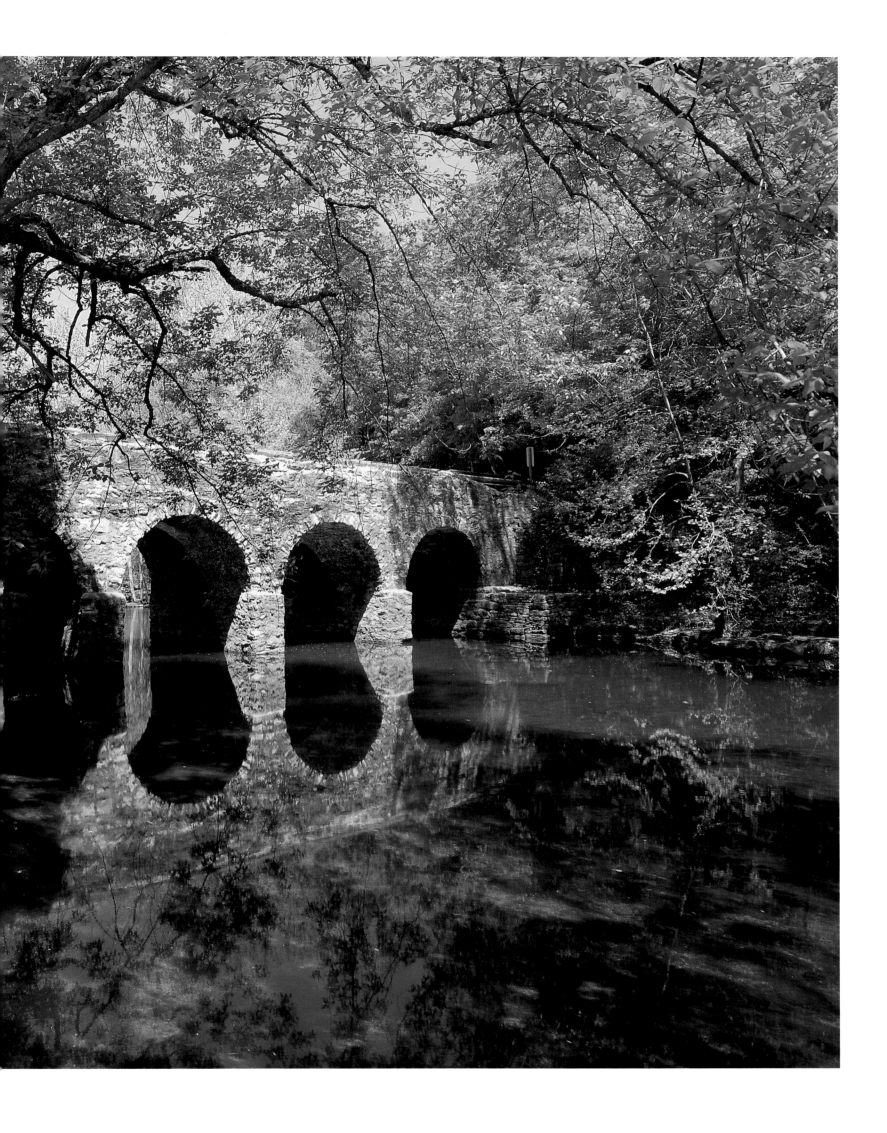

CONFEDERATE ENCAMPMENT, BATTLE OF PERRYVILLE, OCTOBER 1862, BOYLE COUNTY

Civil War battle reenactors have elevated their passion for authenticity to a high art form. Here, a Confederate officer instructs his staff on the eve of the largest Civil War battle (forty thousand men) fought in Kentucky. One can feel the intensity of the reenactors' conversation as they sip coffee by an open fire and can sense that the seriousness of their cause still lives in their minds after 144 years. The battle of Perryville inflicted more than seven thousand casualties with no clear victor. The Confederate army returned to Tennessee, never posing a serious threat to Kentucky during the rest of the war.

GRIFFITH WOODS, ORIGINAL BLUEGRASS SAVANNA, HARRISON COUNTY

Before early settlement, much of the inner Bluegrass Region of Kentucky was covered by giant oaks interspersed with native grasses. Somehow, over more than two centuries of settlement, this small acreage of original savanna was saved by the Griffith family in southern Harrison County. The land was recently purchased, in conjunction with the Nature Conservancy, by the University of Kentucky, which is managing the property.

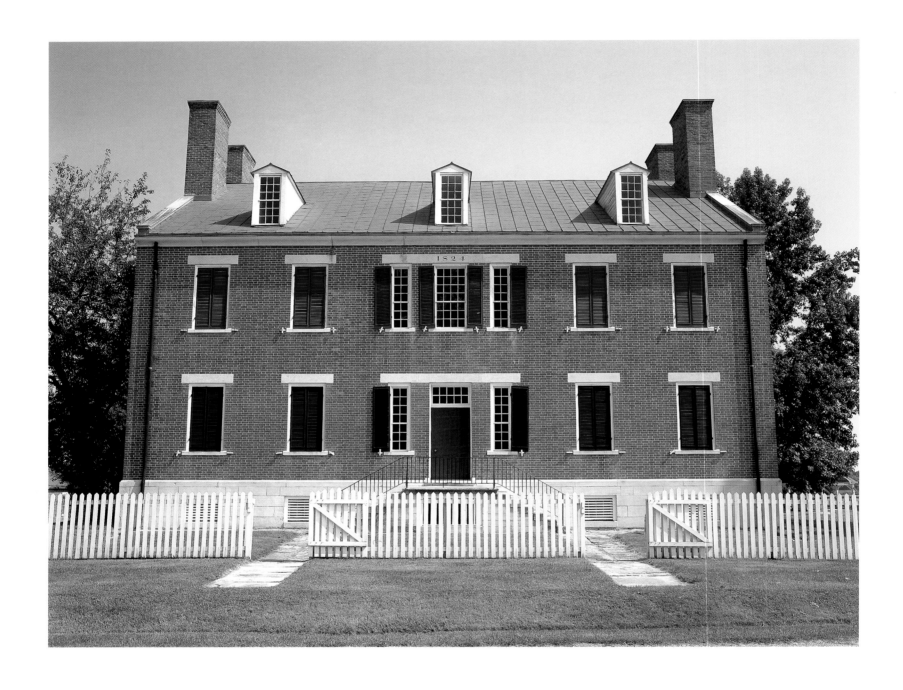

▲ SHAKER VILLAGE AT SOUTH UNION, LOGAN COUNTY This forty-room Georgian-style Centre Family Dwelling was at the center of the six-thousand-acre Shaker village near Bowling Green. Founded in 1807, South Union was the smaller, but no less impressive, of the two Shaker villages in Kentucky. Like other Shaker communities, the Believers at South Union were known for excellence in all their pursuits, including farming, building construction, and tool making. The few remaining buildings have been restored and are maintained by a nonprofit organization, Shakertown at South Union. ► TOWN OF AUGUSTA, BRACKEN COUNTY Historic Augusta dates its first settlement to around 1790. The main street is located on the south shore of the Ohio River and is lined with beautifully restored antebellum homes that have an unobstructed view of river traffic. A small ferry shuttles local vehicles back and forth to southern Ohio.

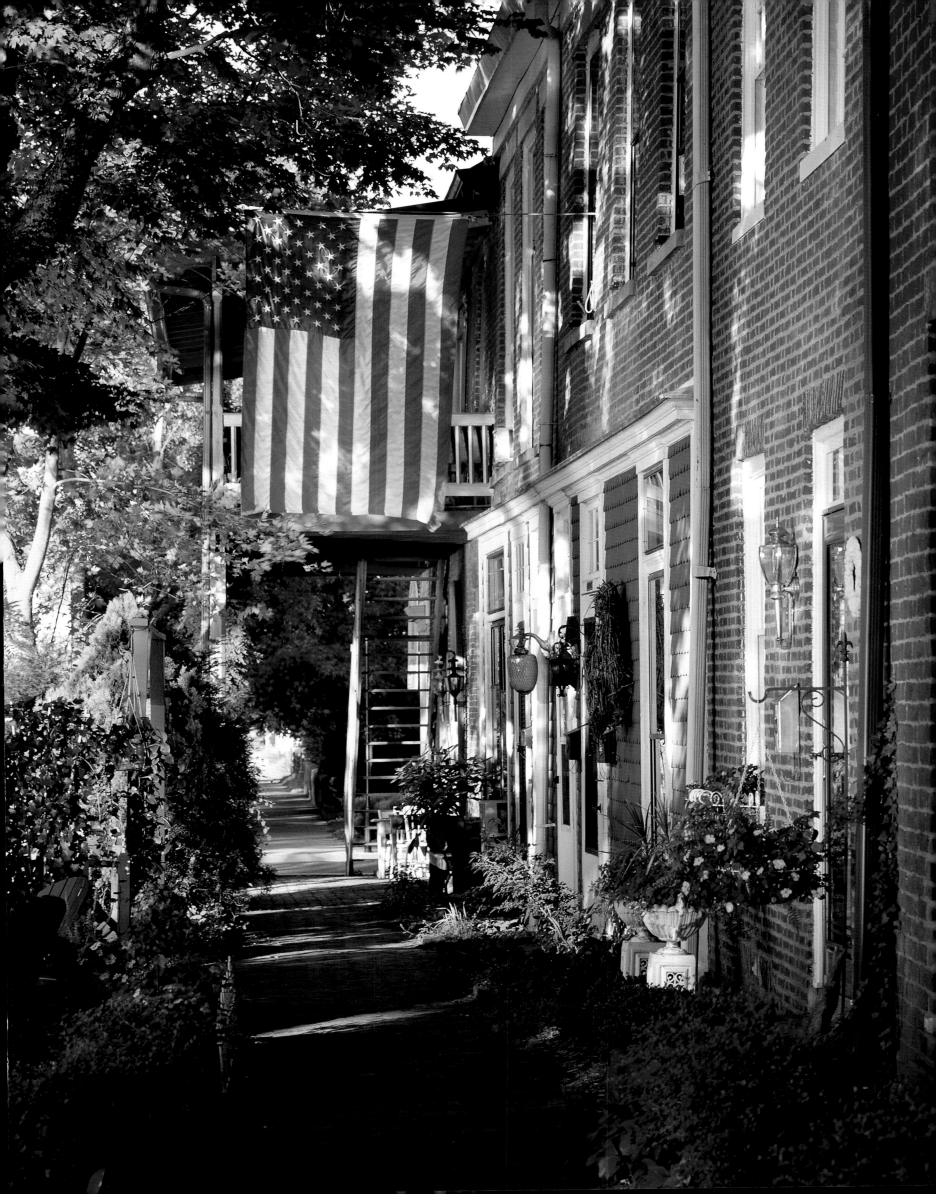

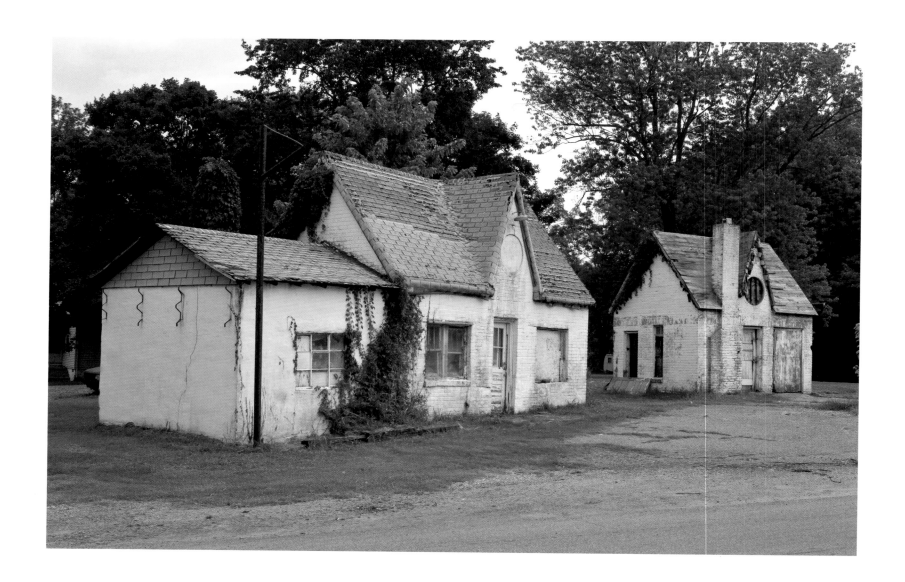

RESTAURANT AND SERVICE STATION, COLUMBUS, HICKMAN COUNTY

Probably dating from the 1920s, these buildings served highway travelers between Paducah and points south. Tourists would stop here to view the earthworks and other relics of the Columbus-Belmont Civil War Battlefield on the strategic bluffs overlooking the Mississippi River. The battlefield area is now a state park.

INTERURBAN RAILWAY, JEFFERSON COUNTY, CIRCA 1900

Before the advent of the automobile, public transportation thrived in America's larger cities. Located just off River Road in eastern Jefferson County, this building provided shelter for commuters who relied on the interurban railway to take them to and from work in downtown Louisville. The original railway was powered by steam before it was converted to electric service in 1904.

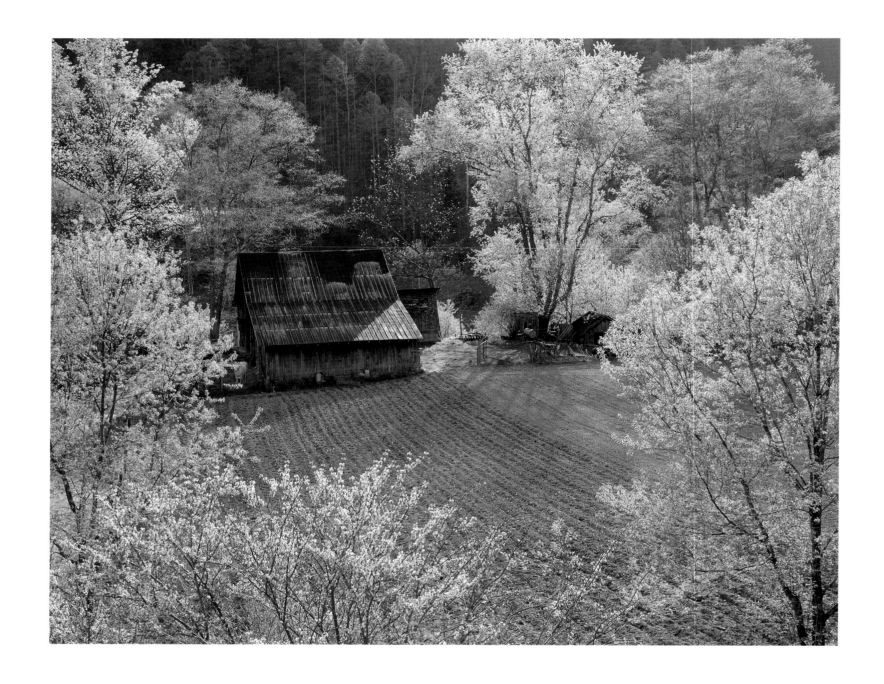

PERRY COUNTY FARMSTEAD, SOUTHEAST KENTUCKY

The bright trees of a new spring border this freshly plowed field in the mountains of Perry County near Hazard. Level ground is dear in eastern Kentucky, so small plots like this must be used wisely. This photograph was taken in 1990. The field was probably prepared for tobacco, at one time a mainstay of cash for mountain farmers.

▲ ROADSIDE PHLOX, NEAR HOPKINSVILLE, CHRISTIAN COUNTY Each spring and summer, phlox grow and prosper amidst the protection of old farm fences in thousands of places along Kentucky's rural byways. Christian County and western Kentucky were settled by pioneers both north and south of the Green River once land on the Bluegrass Plateau had been claimed. ► BATTLE OF WILDCAT MOUNTAIN, OCTOBER 1861, LAUREL COUNTY In one of the earliest Kentucky battles of the Civil War, about six thousand Confederate soldiers filled their canteens here in Shetland Creek before ascending Wildcat Mountain in an attempt to defeat more than seven thousand Union troops guarding the Wilderness Road. In two days of fighting, the Confederates were unable to dislodge the entrenched Union forces and retreated south to Tennessee.

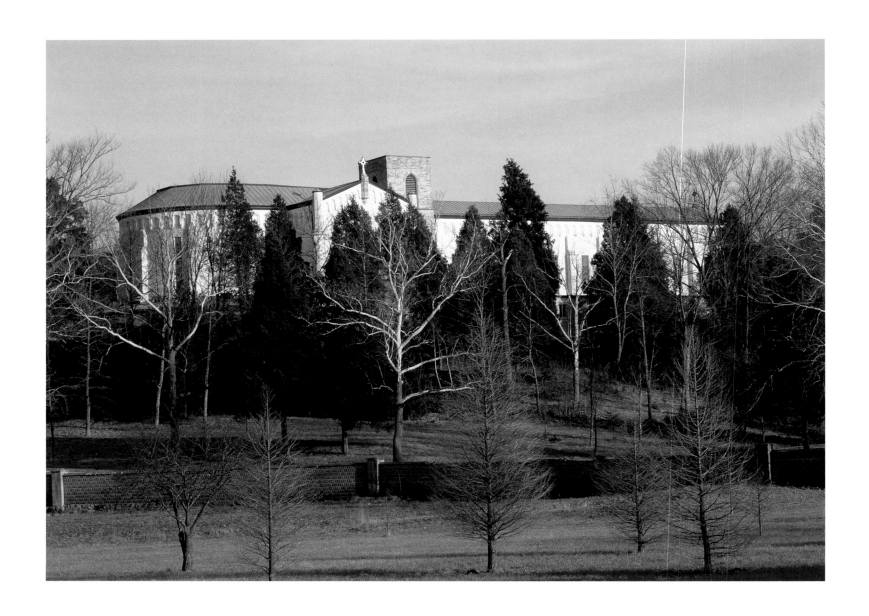

ABBEY OF OUR LADY OF GETHSEMANI, NELSON COUNTY

In December 1848, forty-four Trappist monks from western France founded the abbey of Our Lady of Gethsemani in the hills south of Bardstown. Trappists are a Roman Catholic order, living in silence, spending their hours in work, prayer, and meditative reading. Most of the Gethsemani income is from mail-order sales of cheese and other food products made by the monks. Gethsemani was home to Thomas Merton, who wrote more than sixty books on spirituality, including his acclaimed autobiography, *The Seven Storey Mountain*.

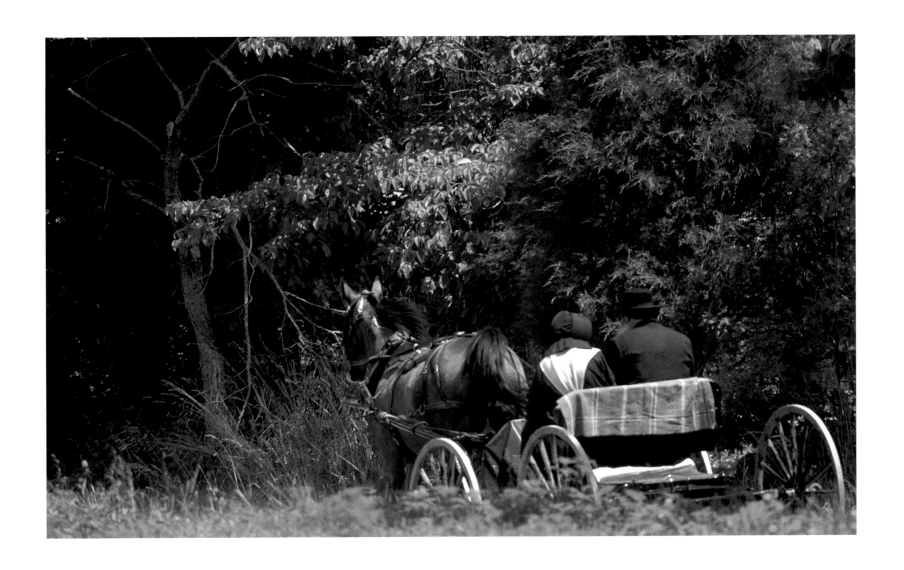

AMISH SUNDAY MORNING, CRITTENDEN COUNTY

Over the years, the Amish have secured a small but prosperous foothold in the life of rural Kentucky. From Maryland, Pennsylvania, Ohio, and Virginia, they have established solid communities away from the glare of modern life and are good neighbors to all.

MIDWAY, WOODFORD COUNTY

Founded in 1833, Midway is the first Kentucky town established by a railroad (Lexington and Ohio Railroad Co.). The town is built along both sides of the main line between Lexington and Frankfort. Its location on the railroad resulted in several skirmishes during the Civil War. Because of its historic background, Midway has become a flourishing tourist stop, with many shops and restaurants.

SYMBOLS OF LOUISVILLE

The *Belle of Louisville* steamboat, the Water Tower, and the Ohio River are historic symbols of Kentucky's largest city. The *Belle* carries hundreds of sightseers daily, while the Water Tower houses the Louisville Visual Art Association. Louisville was chartered in 1780 at the Falls of the Ohio River, the one natural barrier preventing an uninterrupted flow of river traffic between Pittsburgh and New Orleans. Still a heavily traveled river, the Ohio was the major pioneer waterway, carrying thousands of families on flatboats to Kentucky and the western frontier.

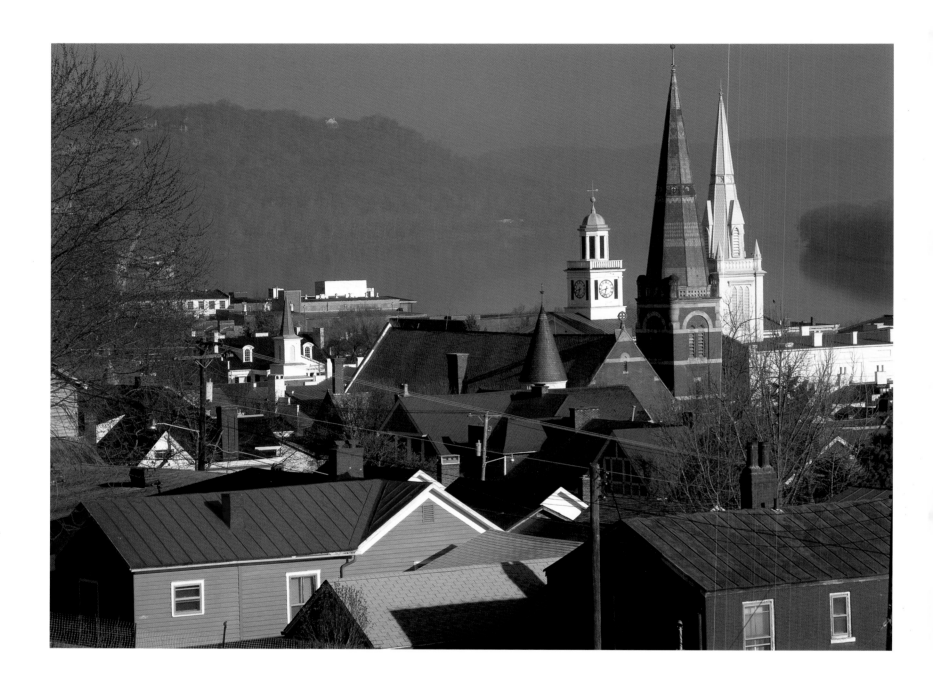

▲ MAYSVILLE, ON THE OHIO RIVER, MASON COUNTY Originally known as Limestone, the site was strategically located along the Ohio River. The early settlers used this settlement as a jumping-off point to the rich lands of the Bluegrass. Crude flatboats floated by current from Pittsburgh carried families, their livestock, and personal belongings. The flatboats were sometimes dismantled and used in the construction of forts and cabins. ► MEMORIAL HALL, UNIVERSITY OF KENTUCKY The University of Kentucky at Lexington was founded in 1865. It was originally called the Agricultural and Mechanical College of Kentucky University. During the first several years, the campus and classes were located at or near Ashland, the estate of Henry Clay. In 1882, the college was moved to South Limestone Street, where it remains to this day. Memorial Hall stands on the original South Limestone Street campus.

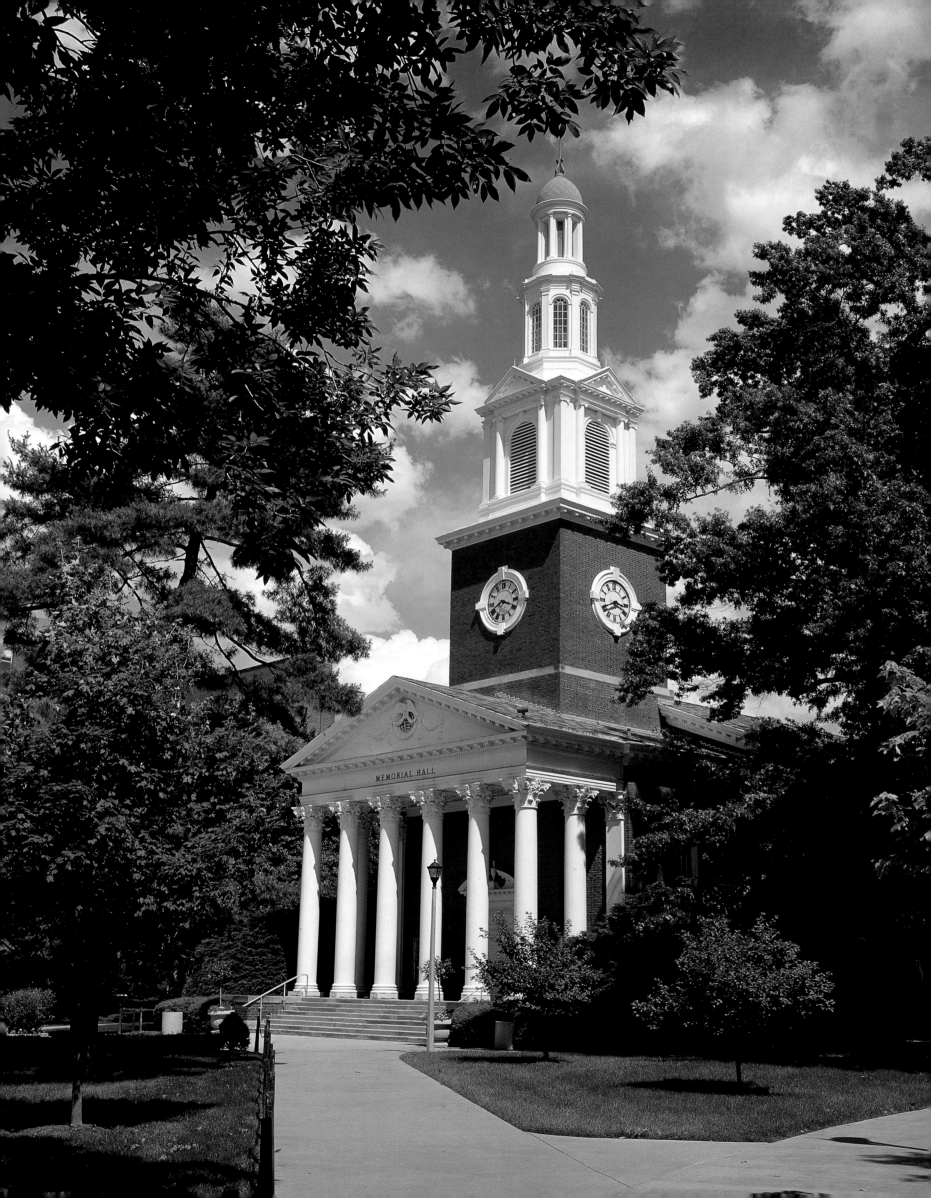

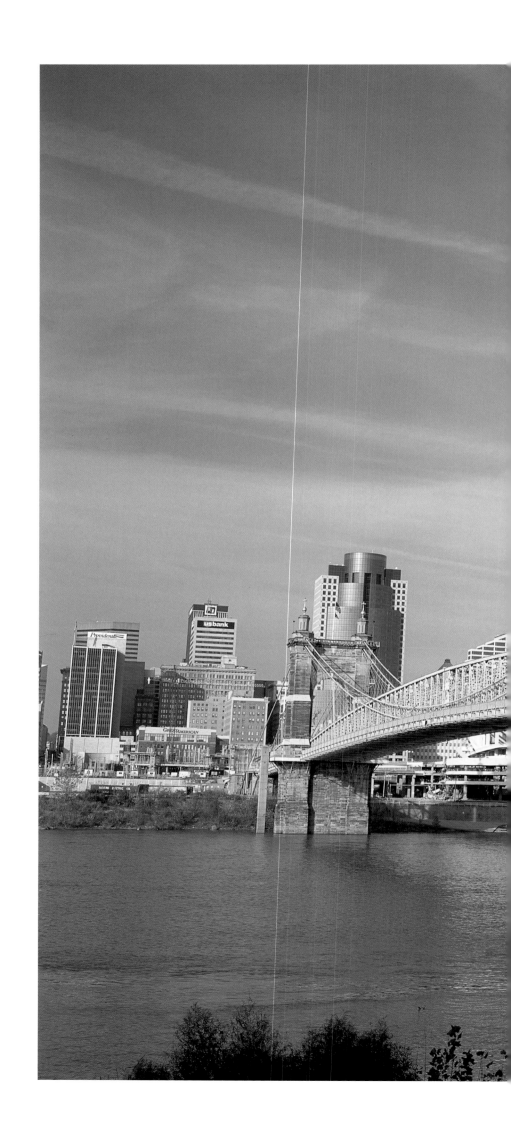

ROEBLING SUSPENSION BRIDGE, NEWPORT John Roebling designed and supervised the construction of this early suspension bridge over the Ohio River between northern Kentucky and Cincinnati. Opened to traffic on January 1, 1867, it became the model for the larger Brooklyn Bridge, also designed by Roebling and completed in 1883. In spite of its age and narrow two-lane roadway, the Roebling Bridge still carries daily traffic between Kentucky and Ohio.

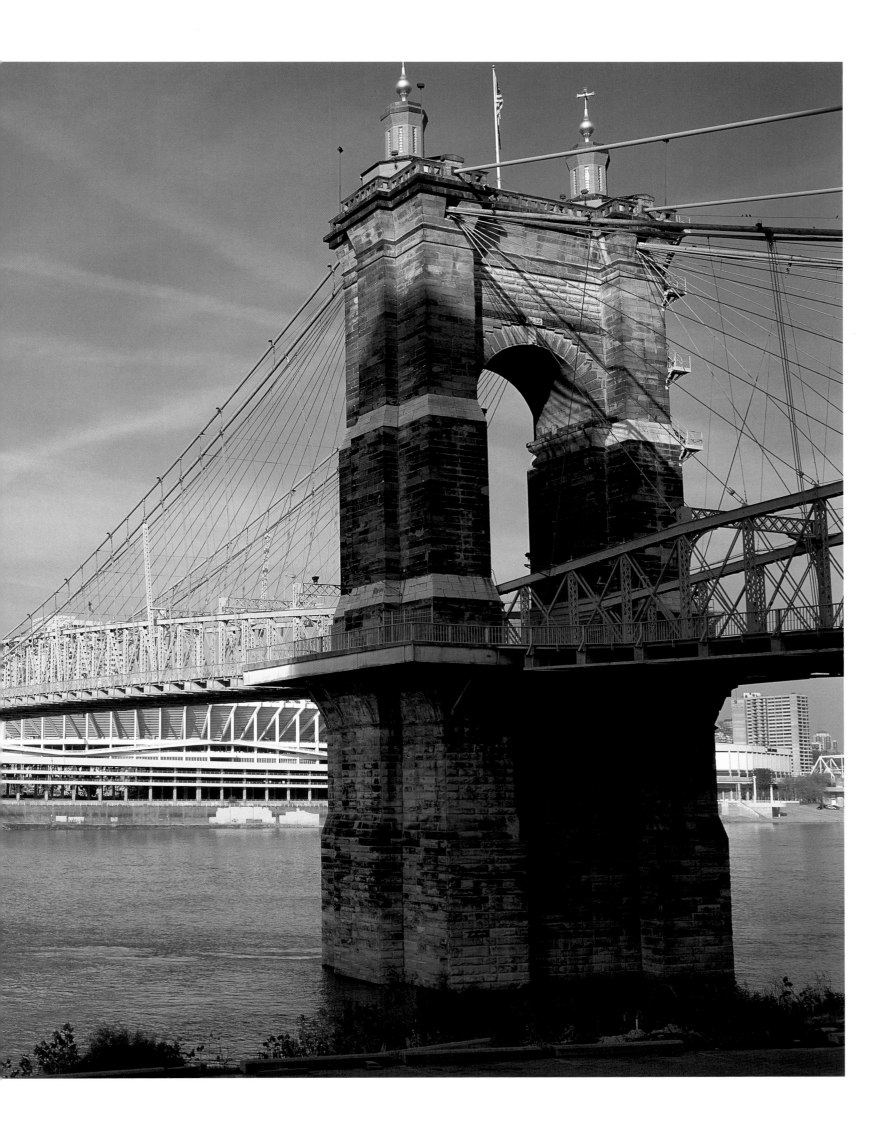

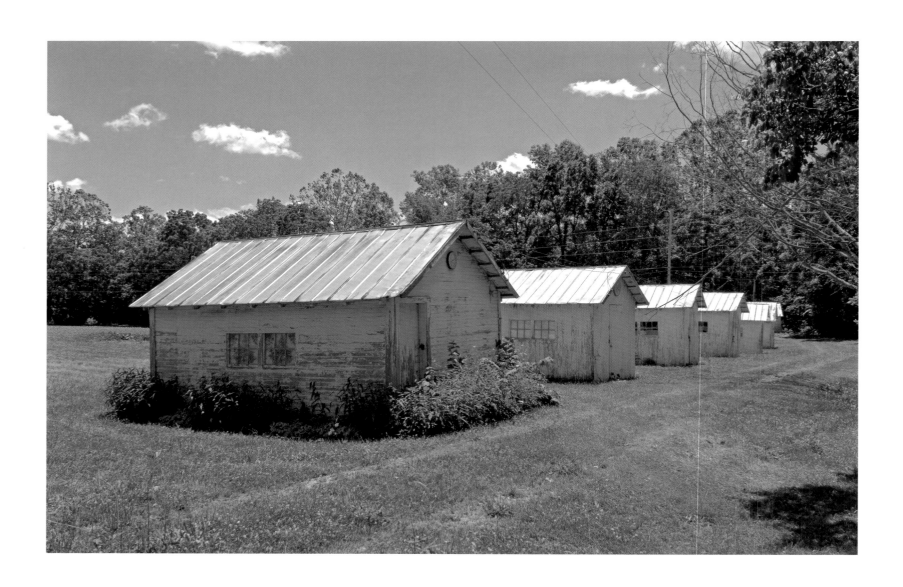

TOURIST CABINS, TRIMBLE COUNTY

These seven cabins and a communal shower house were built in 1935 along U.S. Highway 42, halfway between Cincinnati and Louisville. During Kentucky Derby week, the cabins were filled by patrons who would then drive the forty miles to Louisville to see the races. An adjacent restaurant served food and beer to cabin guests. The cabins and restaurant closed in 1940 when Trimble County residents voted to go dry.

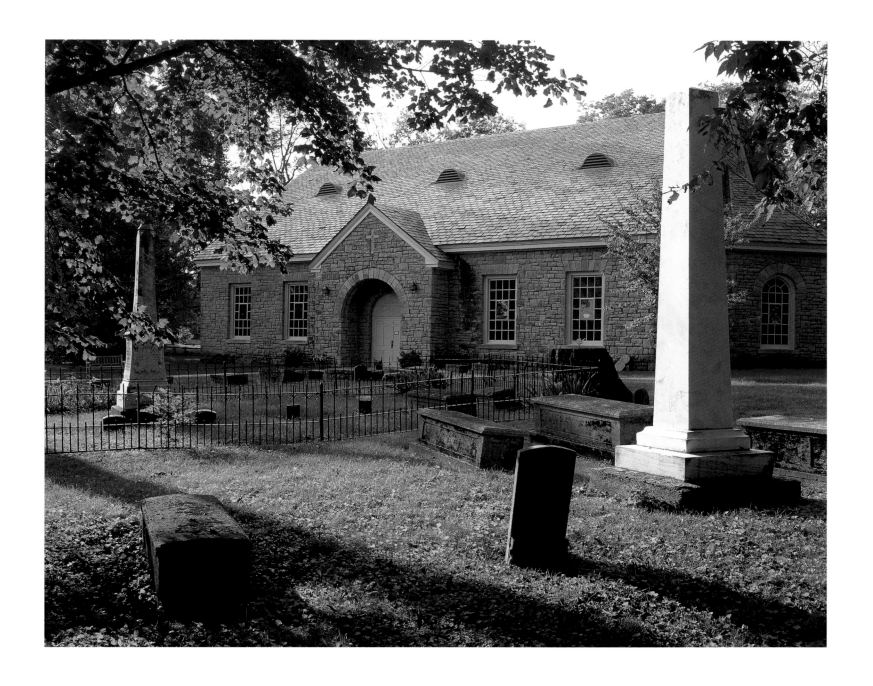

CANE RIDGE MEETINGHOUSE SHRINE, BOURBON COUNTY

This limestone shrine was built in 1957 to house and preserve the original log meetinghouse constructed on the site in 1791 by Scots-Irish Presbyterians from North Carolina. In 1801, Christian churches on the western frontier hosted a series of religious revivals, the largest of which was held at Cane Ridge. During the week of August 6, 1801, more than twenty ministers from different denominations preached in and around the log meetinghouse. It is estimated that twenty to thirty thousand people attended the revival and dispersed only because of a local shortage of food for themselves and for their horses.

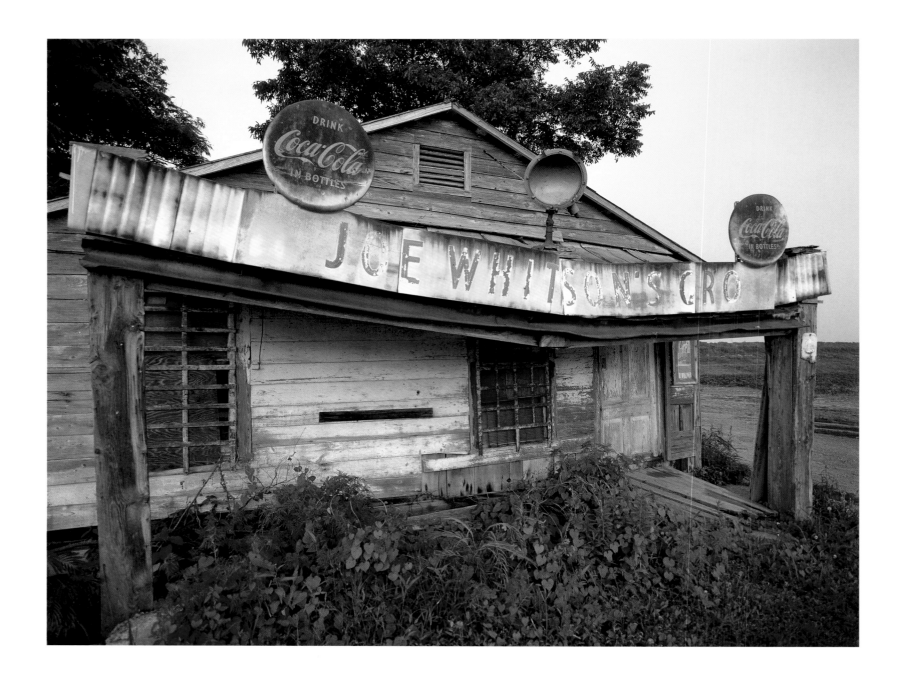

WHITSON GROCERY, NEW MADRID BEND, FULTON COUNTY

Surrounded by corn and soybean fields at the great loop of the Mississippi River, Whitson Grocery served the farm families of the far New Madrid Bend for generations. The store building, no longer standing, once held the distinction of being the westernmost store in the state. This photograph was taken about 1979.

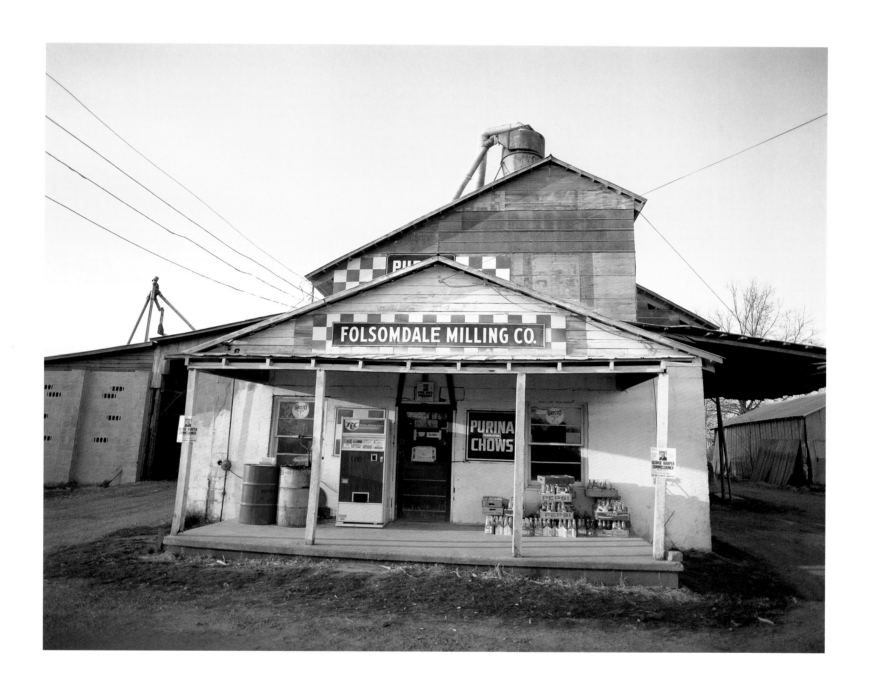

FOLSOMDALE MILLING COMPANY, GRAVES COUNTY

Southwestern Kentucky's Graves County lies not far from the Mississippi River. Its relatively flat terrain resembles the farmland of the Midwest. Not surprisingly, farming is the word here, with corn and soybean fields stretching to the horizon in all directions. The Folsomdale Milling Company is closed, having been supplanted by large feed-and-grain enterprises. The photograph was taken in 1986.

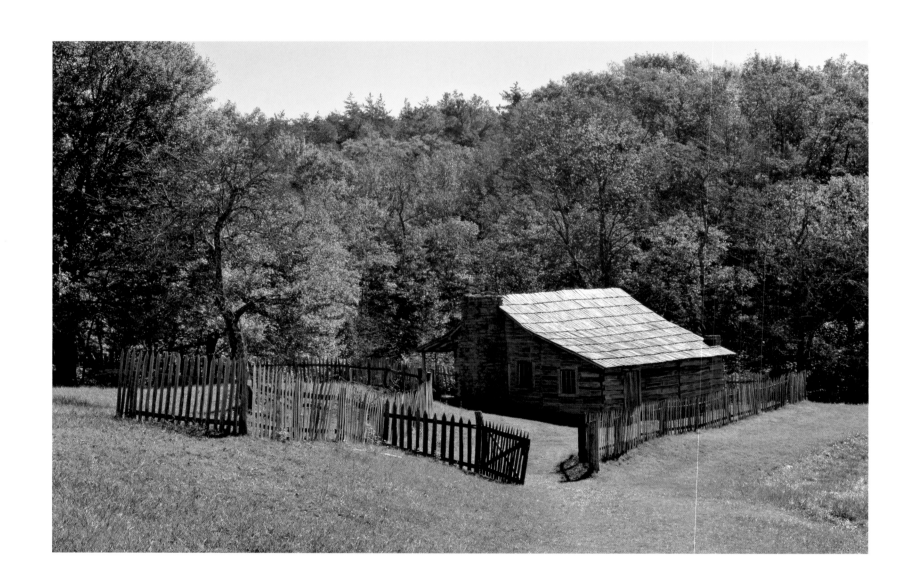

FARMHOUSE AT HENSLEY SETTLEMENT,
CUMBERLAND GAP NATIONAL HISTORICAL PARK

From 1903 to 1951, the Hensleys and other families farmed the five-hundred-acre high,
rolling plateau 3,300 feet above the Cumberland Gap in Bell County. The families were,
for the most part, completely self-sufficient, raising all their own corn, vegetables, and
livestock. Even without electricity, the families maintained a sorghum mill, blacksmith's
and carpenter's shops, two water-powered gristmills, and a few whiskey stills. By the 1940s,
better-paying jobs off the mountain led to the demise of the settlement.

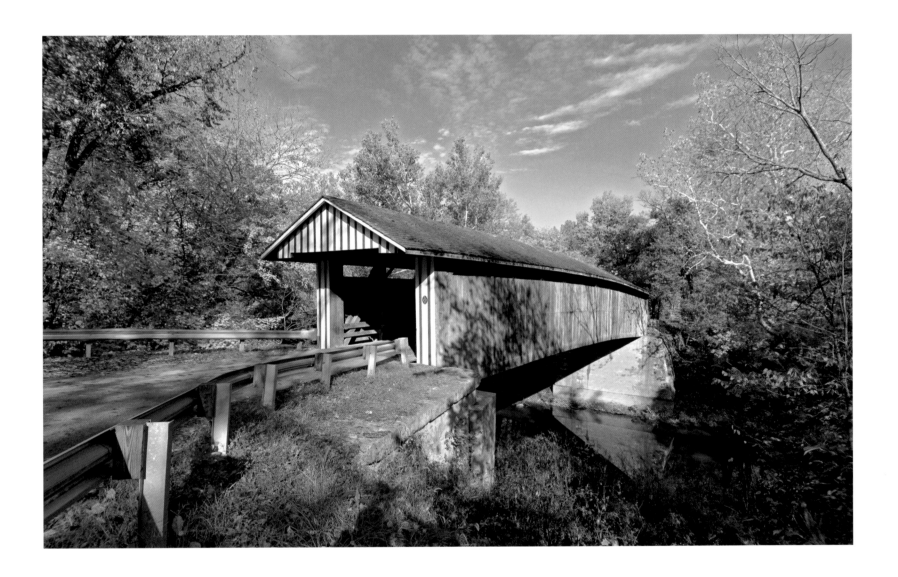

▲ COLVILLE COVERED BRIDGE, BOURBON COUNTY Kentucky's only covered bridge that still carries traffic, Colville spans Hinkston Creek north of Paris. It was built in 1877 and was restored in 1913 and again in 2000. At one time, there were more than four hundred covered bridges in the state. There are now thirteen. ► COAL COUNTRY, EASTERN KENTUCKY A rusting railroad bridge that once carried coal trains spans the Russell Fork of the Big Sandy River at Marrowbone in Pike County. Tucked into the distant hills, a working tipple processes coal from an underground mine. For over one hundred years, coal and related industries have been the largest employers of men and women in eastern Kentucky.

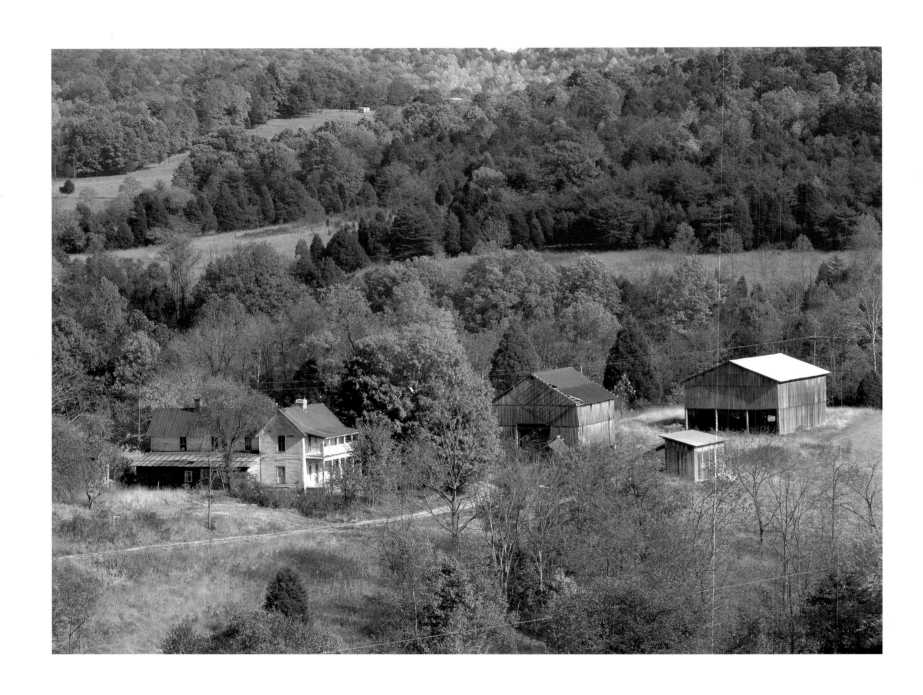

FARMSTEAD, ROCKCASTLE COUNTY, CIRCA 1880

The stone-strewn hills of Rockcastle County seem an unlikely place to settle and build what appears to have been a prosperous small family farm. Like thousands of similar farms, these abandoned enterprises are falling down due to neglect and natural decay. This photograph was taken about 1985.

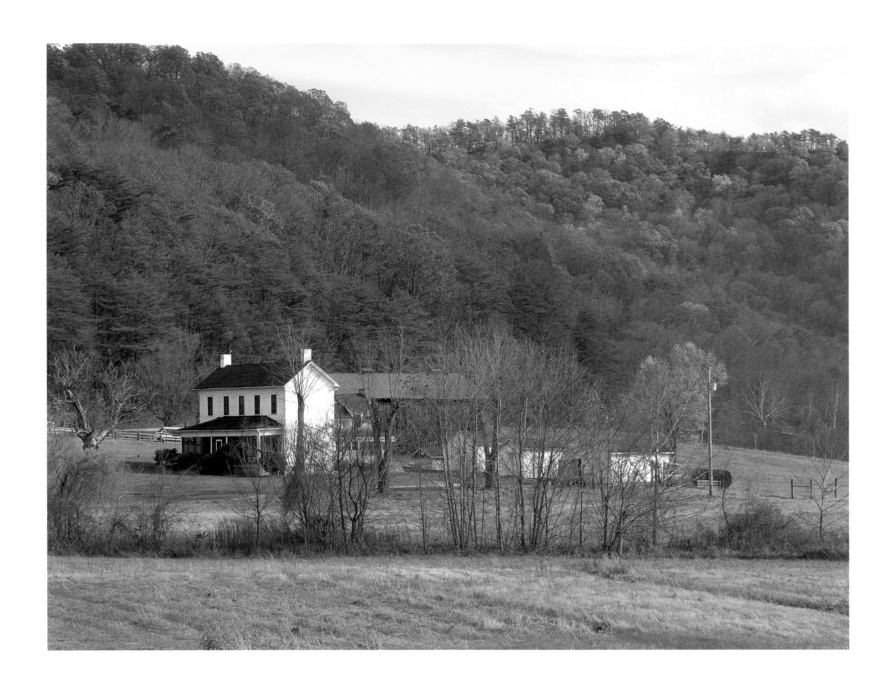

MOUNTAIN FARMSTEAD, POWELL COUNTY

The North Fork of the Red River cuts a narrow swath through the Appalachian foothills of east-central Kentucky, helping to create the Red River Gorge. In its lower reaches, the river forms small alluvial plains, suitable for modest farmsteads. This farm probably dates from the late 1800s.

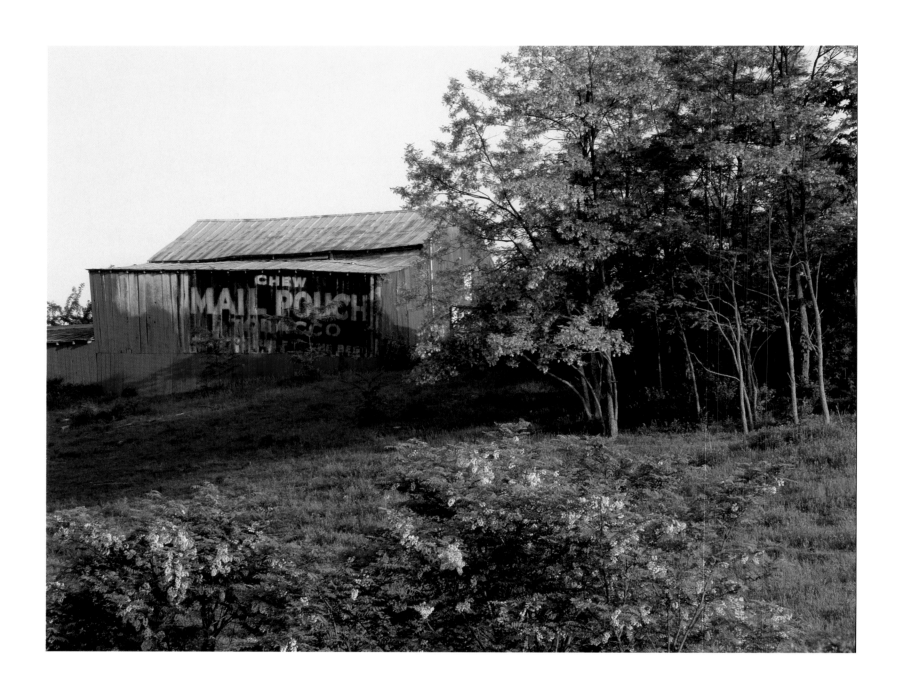

BARN ALONG OLD U.S. 25, SCOTT COUNTY

Harley Warrick of Belmont, Ohio, worked for the Mail Pouch Company for forty-five years, painting hundreds of barns in thirteen states. In 1998, too old to travel, he painted his last sign on plywood sections and had it installed on a barn in Pendleton County, Kentucky. In 1900, the Mail Pouch advertising idea initially paid farm owners a token $20 per year for the use of their barns.

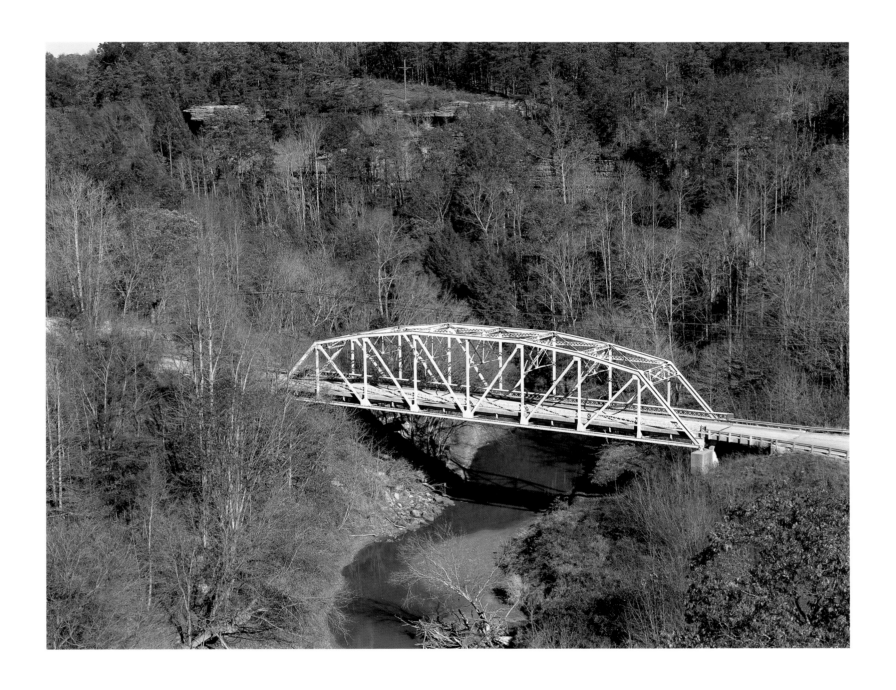

IRON BRIDGE, LITTLE SANDY RIVER, ELLIOTT COUNTY

Iron bridges, some dating back to the 1890s, were once plentiful in Kentucky. In some cases, they replaced wooden covered bridges that had succumbed to time and weather. While some of these relics have been replaced by concrete spans, many iron bridges are still in use, serving sparse, rural communities off the beaten path.

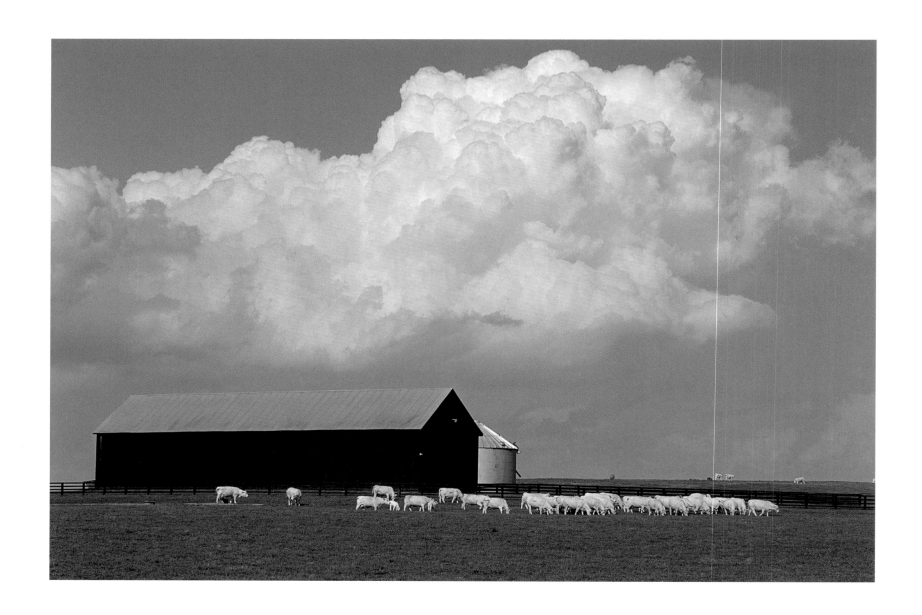

GOING TO PASTURE

Cattle are Kentucky's number one livestock, and it is no wonder. These docile beasts are made of tough stuff and generally know how to take care of themselves. The earliest pioneers brought their cattle over Cumberland Gap, along a path almost too narrow for humans. The pioneers pushed and prodded them through swollen rivers. The cattle hardly complained, contenting themselves with whatever they could find, from streamside grasses to the fruits of the forest floor.

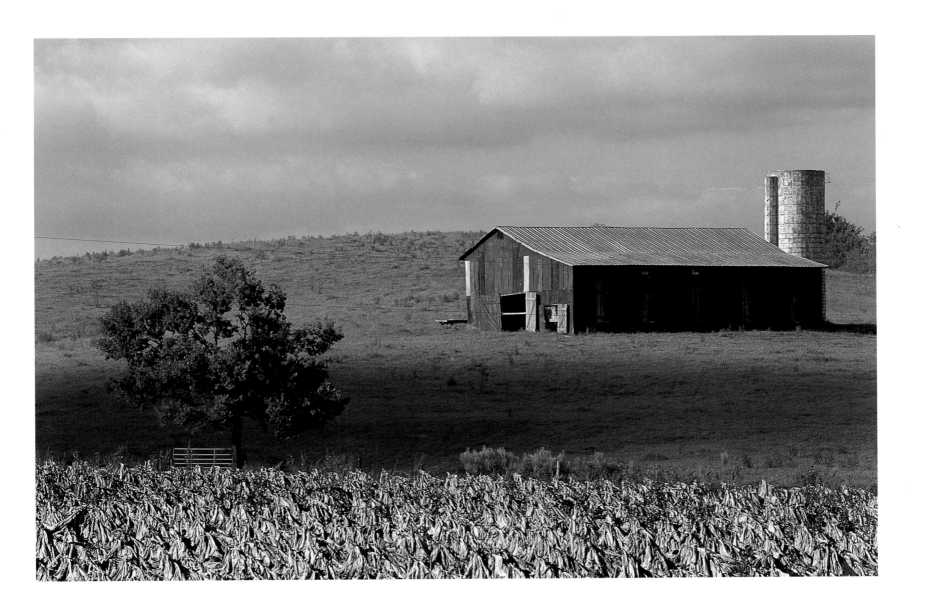

BURLEY TOBACCO, FLEMING COUNTY

Ripe burley tobacco leaves are cut and staked in the field prior to being trucked to the barn for hanging and curing. Until recently, tobacco was displayed and auctioned in full leaf, where quality could be determined and the price per pound adjusted accordingly. Now, all tobacco is compressed in hay-like bales and sold to tobacco companies on contract.

CUMBERLAND RIVER VALLEY NEAR BURKESVILLE

Fog rises from the cool waters of the Cumberland River as it twists its way through Cumberland
County on Kentucky's southern border with Tennessee. One of the state's significant rivers,
it drains extreme southeast Kentucky and was the first major river crossed by the early pioneers.
Its broad, sweeping channel has created some of the most scenic valleys in the Commonwealth.

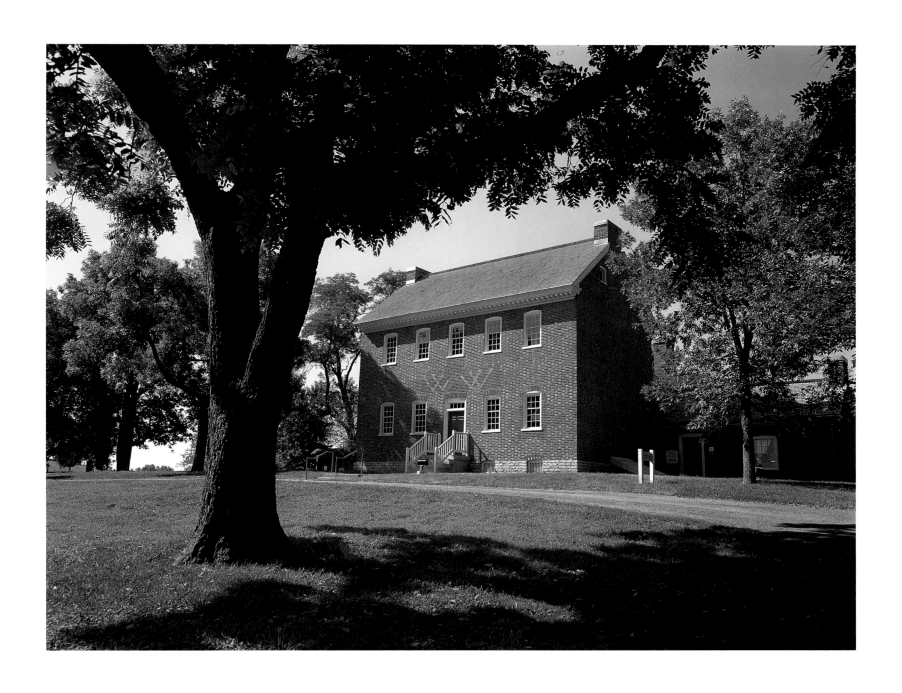

THE WILLIAM WHITLEY HOUSE, LINCOLN COUNTY

One of Kentucky's first settlers, William Whitley led an amazing life as a pioneer, soldier, and Indian fighter. In 1775, Whitley, his wife, and two daughters traveled alone from Virginia to Kentucky over the nearly impassable Wilderness Road. The journey took over a month. Whitley established a pioneer station near present-day Stanford. He eventually constructed this brick house in 1785 and built a circular racetrack nearby. His estate became known as Sportsman's Hill. Whitley was killed by Indians at the Battle of the Thames, near Detroit, in the War of 1812.

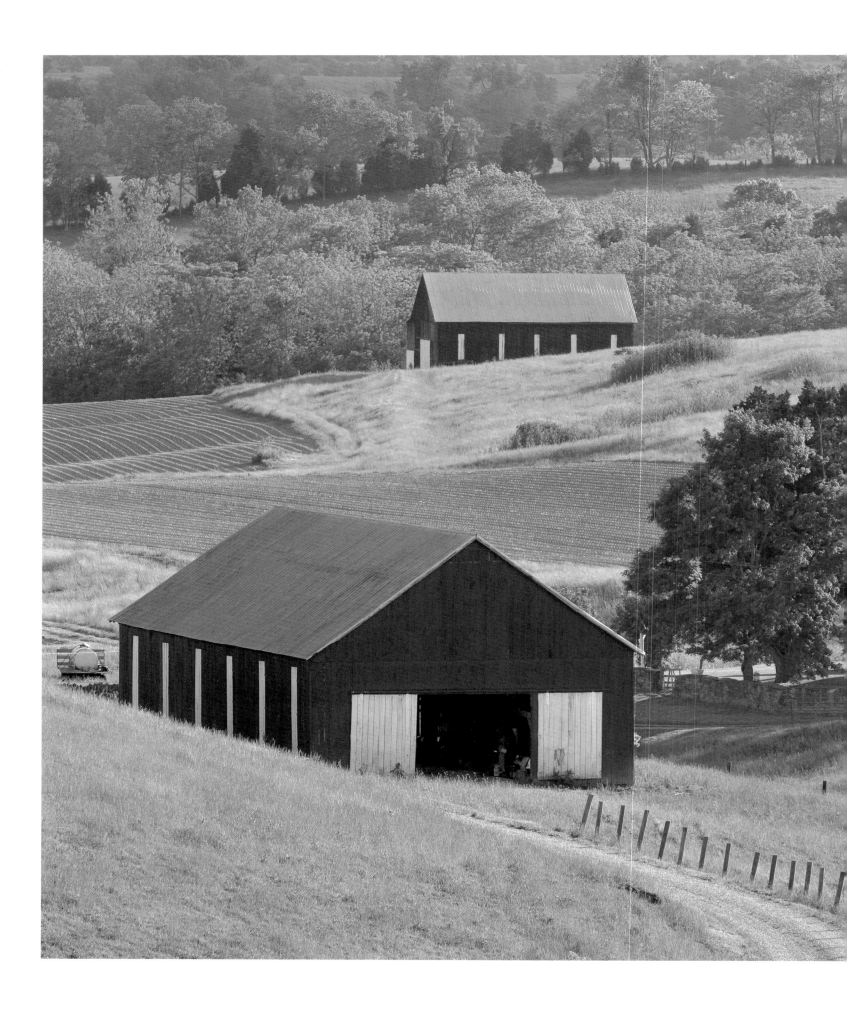

FARMSTEAD, NICHOLAS COUNTY
In the fertile hills and valleys above Hinkston Creek, small farms still prosper when tended and cared for by dedicated families with skillful agrarian practices. For many reasons, farms like this are disappearing rapidly.

THE BOILS AT McCONNELL SPRINGS, FIRST PIONEERS AT LEXINGTON, JUNE 1775

William McConnell and a few early pioneers camped at this spring in the Kentucky wilderness and heard of the patriots' victory over the British at Lexington, Massachusetts. The pioneers named the site Lexington in honor of that battle. In 1777, a blockhouse was built and then a fort along a stream named Town Branch. Lexington would soon be called the Athens of the West and would become the center of Kentucky's Bluegrass Region.

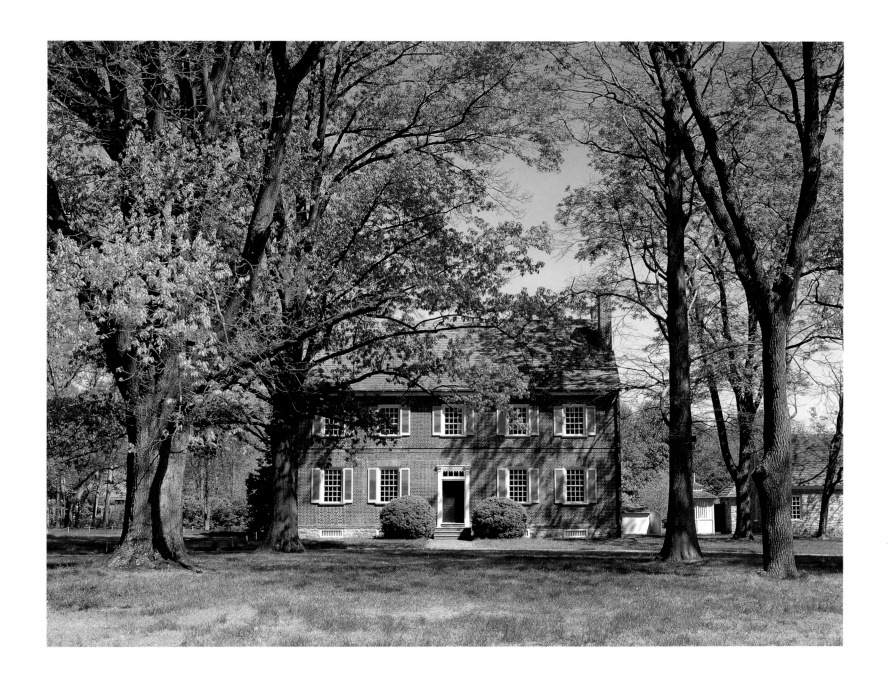

LOCUST GROVE, LOUISVILLE

A National Historic Landmark, the Locust Grove Estate (circa 1790) includes the house and outbuildings located on fifty-five acres above the Falls of the Ohio River. Revolutionary War hero George Rogers Clark stayed here with his sister and her family during the last years of his life. Clark was visited by Meriwether Lewis and William Clark following their triumphant journey to the Pacific, 1803–6. The home and grounds are open to the public.

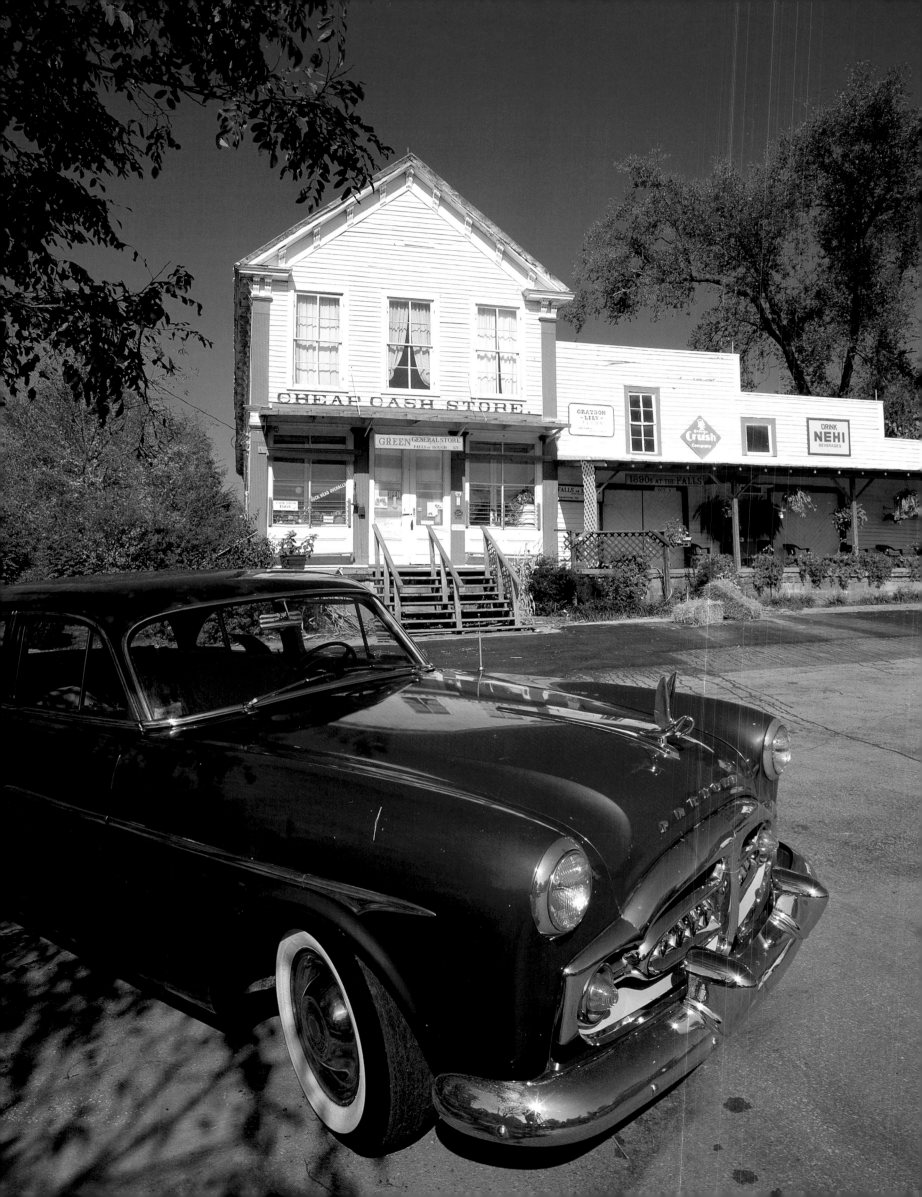

◄ CHEAP CASH STORE, FALLS OF THE ROUGH A vintage Packard adorns the parking lot of the Cheap Cash Store in Grayson County, western Kentucky. For more than a century, the store was a gathering place for farmers of the Rough River valley. A nearby gristmill, Greens Mill, provided milling and transportation services for area produce. This store is now closed. The location of the Packard is unknown. ▲ CREAMY WHIP, JAMESTOWN, RUSSELL COUNTY This locally owned stand stills serves ice cream, hamburgers, and tater tots to fishermen and boaters who flock to Lake Cumberland every summer. Kentucky's small towns tenaciously hang on to their old traditions, with "mom and pop" businesses still competing with ever-increasing chain stores.

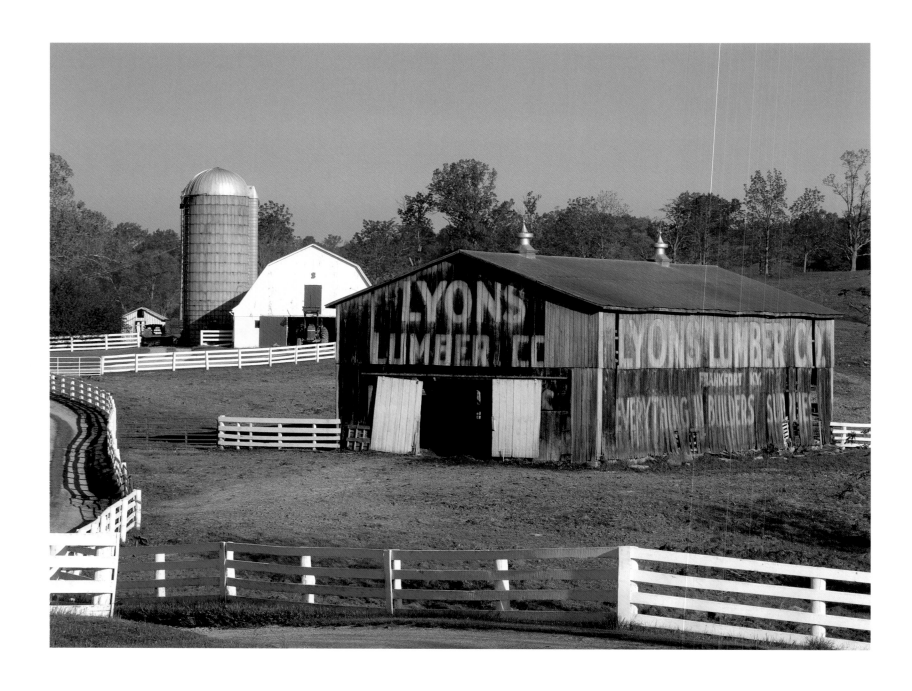

LOCAL ADVERTISING, FRANKLIN COUNTY

Since the first Mail Pouch signs began to appear around 1900, barns have been used to advertise everything from insurance to soap, automobiles to motor oil. With the advent of high-tech communications, modern highways, and the widespread demise of small farms, barn advertising is nearly extinct. This photograph was taken around 1983. The barn has since been painted, the message gone.

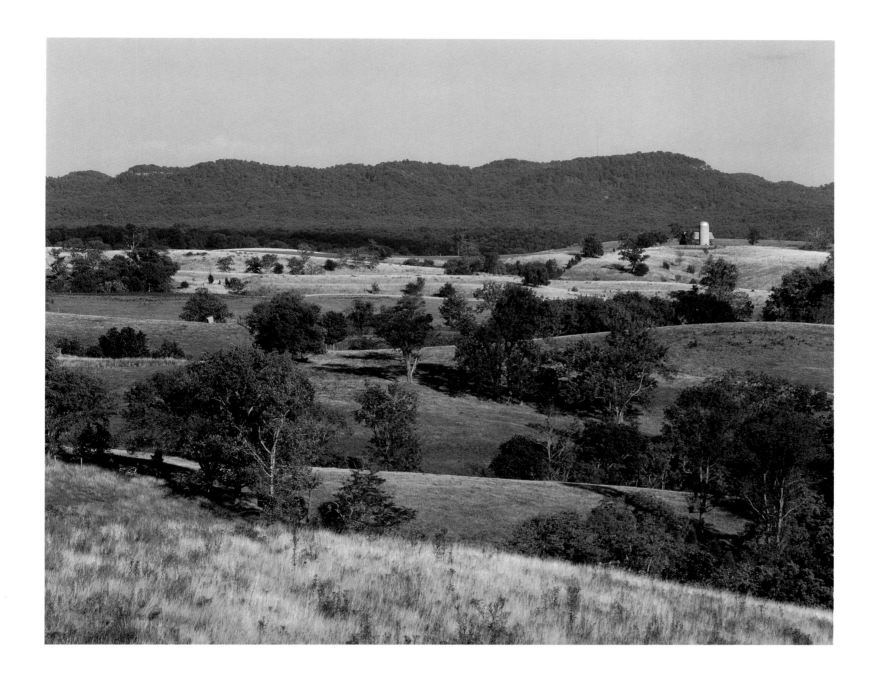

PILOT KNOB, POWELL COUNTY

Beyond the distant silo is Pilot Knob State Nature Preserve, at 1,440 feet the highest point in Powell County. It is believed to be the spot where Daniel Boone, John Finley, and their companions first viewed "the great level of Kentucke" on June 7, 1769. Boone may have climbed other hills to scan the horizon, but from the author's experience, none afford a better view of the Bluegrass than this overlook.

Historic Preservation Organizations

THE BLUE GRASS TRUST FOR
HISTORIC PRESERVATION, INC.
253 Market Street
Lexington, KY 40507
(859) 253-0362
www.bluegrasstrust.org

BLUEGRASS CONSERVANCY
Dudley Square
380 South Mill Street, Suite 205
Lexington, KY 40508-2560
(859) 255-4552
www.bluegrassconservancy.org

CIVIL WAR
PRESERVATION TRUST
1331 H Street NW, Suite 1001
Washington, D.C. 20005
(202) 367-1861
(800) 298-7878

THE FILSON
HISTORICAL SOCIETY
1310 South Third Street
Louisville, KY 40208
(502) 635-5083
www.filsonhistorical.org

KENTUCKY CENTER
FOR AFRICAN-AMERICAN
HERITAGE
315 Guthrie Green, Suite 400
Louisville, KY 40202
(502) 583-4100
www.kcaah.com

KENTUCKY DEPARTMENT
FOR LIBRARIES
AND ARCHIVES
300 Coffee Tree Road
Frankfort, KY 40601
(502) 564-8300
www.kdla.ky.gov

KENTUCKY HERITAGE
COUNCIL
300 Washington Street
Frankfort, KY 40601
(502) 564-7005
www.kyheritage.org

KENTUCKY HISTORICAL
SOCIETY HEADQUARTERS
THOMAS D. CLARK
CENTER FOR
KENTUCKY HISTORY
100 West Broadway
Frankfort, KY 40601
(502) 564-1792
www.history.ky.gov

KENTUCKY STATE UNIVERSITY
THE CENTER OF EXCELLENCE
FOR THE STUDY OF AFRICAN
AMERICANS (CESKAA)
400 East Main Street
Frankfort, KY 40601
(502) 597-6315
www.kysu.edu/about_ksu/
heritage/ceskaa

NATIONAL PARK SERVICE /
HERITAGE PRESERVATION
SERVICES
PRESERVATION BRIEFS
[*Easy-to-read guides on
preserving and rehabilitating
historic buildings for home-
owners, preservation profes-
sionals, organizations, and
government agencies*]
1201 "Eye" Street NW (2255)
Washington, D.C. 20005
(202) 513-7270
www.cr.nps.gov/hps/tps/briefs/
presbhom.htm

NATIONAL PARK SERVICE /
NATIONAL REGISTER OF
HISTORIC PLACES
1201 "Eye" Street NW
8th Floor (MS 2280)
Washington, D.C. 20005
(202) 354-2213
www.cr.nps.gov/nr

NATIONAL TRUST
FOR HISTORIC
PRESERVATION
1785 Massachusetts Avenue, NW
Washington, D.C. 20036-2117
(800) 944-6847
www.nthp.org

PRESERVATION KENTUCKY, INC.
P.O. Box 262
Hodgenville, KY 42748
(270) 358-9069
www.preservationkentucky.org

RIVER FIELDS, INC.
643 West Main Street, Suite 200
Louisville, KY 40202-2921
(502) 583-3060
www.riverfields.org

The Kentucky Heritage Council
can provide information and direc-
tion regarding the Certified Local
Government (CLG) preservation
program and the State Historic
Preservation Office's (SHPO)
technical assistance program.

Governments currently involved
with the CLG program are
Bardstown, Bowling Green–
Warren County, Covington,
Lexington, Louisville, Paducah,
and Shelbyville.

Index of Places